DAVID

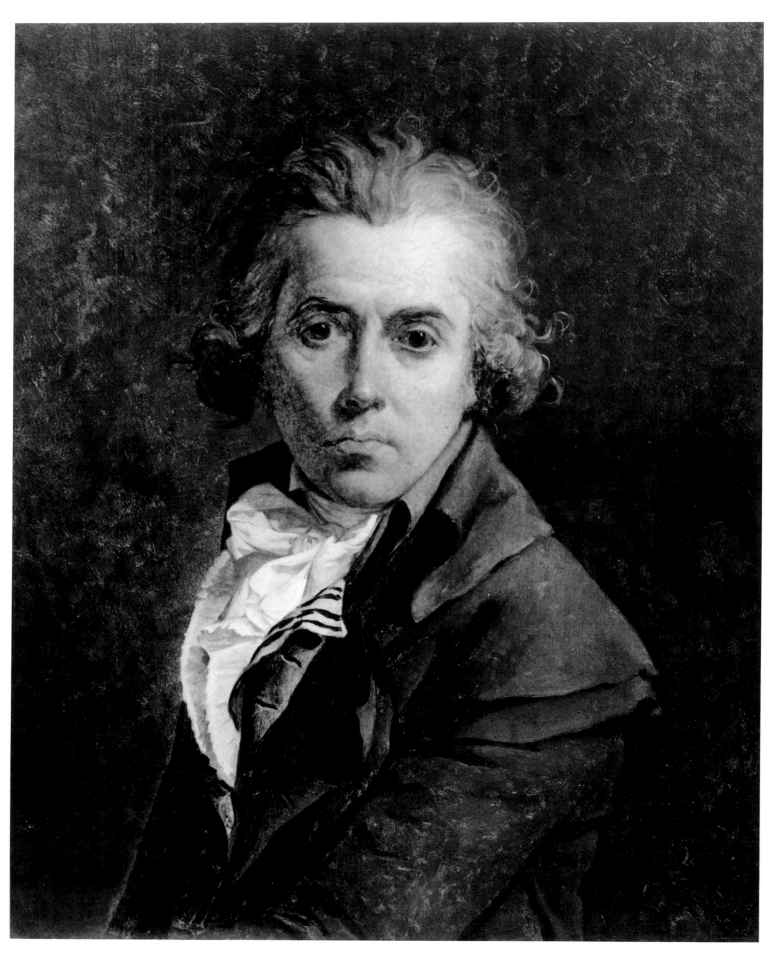

1. *Self-Portrait.* 1790–91. Oil on canvas, 25¼ x 20⅞".
Galleria degli Uffizi, Florence

JACQUES-LOUIS

DAVID

LUC DE NANTEUIL

HARRY N. ABRAMS, INC., PUBLISHERS, NEW YORK

Library of Congress Cataloging-in-Publication Data

Nanteuil, Luc de.
 Jacques-Louis David / Luc de Nanteuil.
 p. cm.—(Masters of art)
 Includes bibliographical references.
 ISBN 0–8109–3201–6
 1. David, Jacques-Louis, 1748–1825. 2. Painters—France—
Biography. I. Title. II. Series: Masters of art (Harry N.
Abrams, Inc.)
ND553.D25N18 1990
759.4—dc20
[B] 89–39121
 CIP

A Times Mirror Company

Printed and bound in Japan

CONTENTS

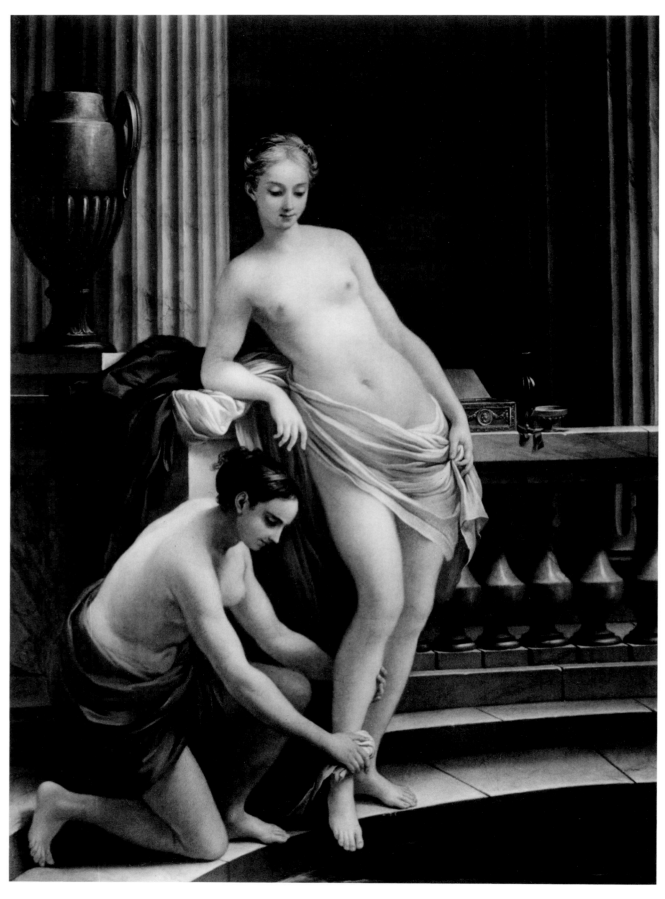

2. Joseph Marie Vien. *Greek Woman at the Bath*. 1767. Oil
on canvas, 35½ x 26½". Museo de Arte de Ponce, Puerto Rico.
(Fundacion Luis A. Ferré)

David

Origins

The artist who was to become one of the most important reformers of French painting, and the founder of a new classical school, was born in Paris into a family of merchants and tradesmen, at the beginning of an age of profound aesthetic and social change.

Louis-Maurice David and Marie-Geneviève Buron were married in 1746. She was only eighteen years old; he was nineteen and had just succeeded his father in the family business. They would have only one child, Jacques-Louis, the future painter, who was born on August 30, 1748.

Louis-Maurice came from a well-to-do family already secure in their social standing; they were *marchands-merciers,* dealing—among other things—in various forms of decoration. Marie-Geneviève's family occupied a more modest social position, but included certain men of considerable artistic talent. Her father, Jacques Buron, was a contractor employing several masons; her mother (who could neither read nor write) was the cousin of Boucher, First Painter to the King. Her brother-in-law, Jacques-François Desmaisons, became a member of the Académie d'Architecture in 1762 and was ennobled in 1769.

Thus, on his father's side, David came from the Parisian bourgeoisie that sought to improve their position in the world through hard work and talent—but was still only the Third Estate—and, on his mother's side, from the milieu of artisans where there was no separation between artistic creation and the actual manual labor involved in its execution.

David's father, who was hot-headed and quick to take offense, was killed in a duel in 1757, after which his mother (who did not seem overly concerned about her son) retired to Normandy. David was only nine years old at the time and he was entrusted to the care of his uncles Buron and Desmaisons. Perhaps these circumstances may explain why the boy showed early signs of being uncommunicative and headstrong.

Artistic Vocation

David went to a succession of schools but, as he later wrote about himself, he "was always hiding behind the instructor's chair, drawing for the duration of the class." His studies suffered accordingly and he remained a mediocre student.

At an early age he announced that his vocation was to be a painter. He wanted to study with his grandmother's cousin, but Boucher was too old and no longer wanted to accept pupils. He sent David to Vien, a professor at the Académie Royale de Peinture, noting that he, himself, would have tried to encourage "the ardor he sensed" in the boy, if Jacques-Louis were his pupil. The year was 1764 and David was sixteen years old.

Vien, whose studio David entered, had a number of new ideas about art. Rejecting the brilliance and artifice of the imitators of Boucher and Fragonard, he recommended studying from nature and striving for a natural sort of light. He was one of the first to espouse the return to classical antiquity as a source of moral inspiration and artistic purity, although his own painting displayed a style of Neoclassicism that was more elegant than austere. A good-natured man, and

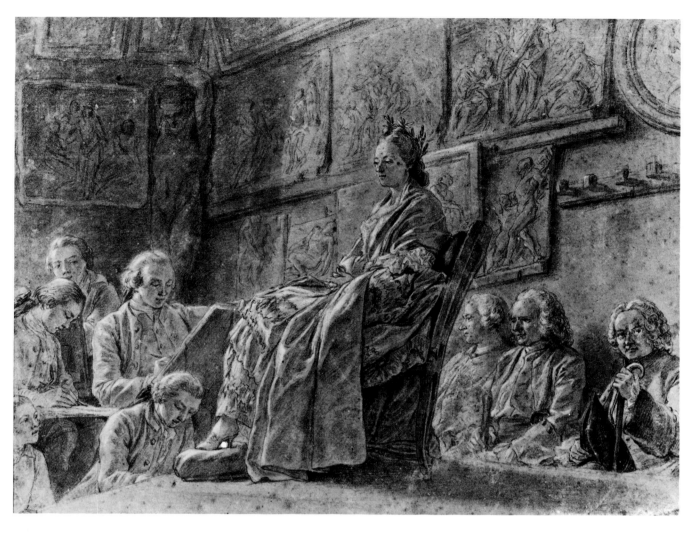

3. Charles-Nicolas Cochin. *The Competition for the Prize in Drawing Heads and Expression.* 1761. Black chalk heightened with gouache on beige paper, 9 x 12″. Musée Carnavalet, Paris

a strong advocate of academic teaching, he had married a woman painter who specialized in flowers and butterflies. Vien doted on his students and they returned his affection in full measure.

French Painting in David's Time

In the late 1700s, painting in France was a highly centralized, hierarchical profession whose structure was a legacy from the conceptions of the previous century. The authoritative body, the hub of the entire system, was the Académie Royale de Peinture et de Sculpture, more commonly known simply as the "Academy" which had been founded in 1648 by Mazarin, and endowed by Colbert in 1663 with its definitive structure.

Despite the existence for a time of a parallel institution, the Académie de Saint-Luc (which included only minor painters and was abolished in 1776), the Académie Royale de Peinture et de Sculpture enjoyed a de facto monopoly on the selection and training of painters. It was the only body able to assure its members of a secure reputation and substantial commissions. A painter who wished to succeed was obliged to apply for membership.

After a period of instruction under a painter who was himself well-known and, in most cases, a member of the Academy, an apprentice would become a student at the Academy, located in the Louvre. There, he would take courses in drawing, progressing by degrees from making copies of engravings and plaster figures and models to working from live models, under the direction of a master who would change every month, and who was a member of a group of twelve instructors selected from among the members of the Academy by their colleagues. Elements of history, perspective, and anatomy were taught to all pupils. The Academy touched on the rudiments of painting, but the actual instruction would take place in the private studios where the pupils completed their apprenticeships.

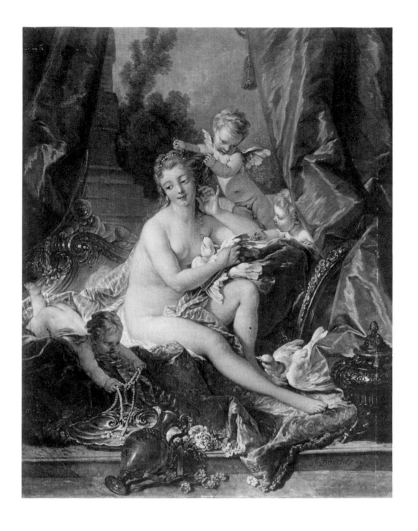

Left:
4. François Boucher. *The Toilet of Venus*. 1751. Oil on canvas, 42⅝ x 33½". The Metropolitan Museum of Art, New York (Bequest of William K. Vanderbilt)

Below:
5. Jean-Honoré Fragonard. *The Bathers*. c. 1765. Oil on canvas, 25⅝ x 31⅞". Musée du Louvre, Paris.

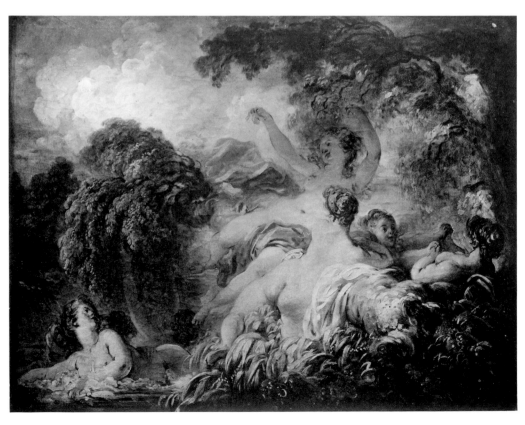

The Academy, which as a teaching institution offered courses only in drawing, also constituted a jury for the purpose of judging its pupils' paintings. To this end, it regularly organized competitions for which it chose the subject and awarded the prizes—the "First Prize," in theory, entitled the student to three years of study at the Académie de France in Rome, hence its name, "Prix de Rome." It offered young students the opportunity to complete their training by studying classical and antique masterpieces but, once again, the student would spend most of his time drawing or making copies.

After his sojourn in Rome, the painter would submit another work to be judged by the Academy, which chose the subject, and if his work was "approved" he would later be received into the Academy as a member. As an *académicien* he became eligible for those royal commissions distributed by the Directeur des Bâtiments du Roi, who acted as a sort of General Superintendent of the Arts and was, in effect, the head of both the Académie Royale and the Académie de France in Rome. The *académicien* also enjoyed the privilege of displaying his works at the Salon (a very important exhibition which had been held every two years since 1751), enabling him to acquaint the general public with his work.

Within the Academy itself a very rigid hierarchy prevailed, conferring upon "the officers" the essential powers of decision. It was the officers, in effect, who determined the Academy's aesthetic orientation. Moreover, they were the only members who could sit on the juries.

The painters themselves were classified according to categories that corresponded to their specializations in a hierarchical order of decreasing importance: first came history painting, followed by genre painting, portraiture, landscape painting, and lastly, still life.

History painting centered upon actions taken from mythology ("fable," as it was called in those days), or the classics, with an approach to these subjects that was not only noble but also large-scale—from whence came the expression *grand goût* associated with this category. By contrast, genre painting concerned itself, on a smaller scale, with familiar, intimate subjects, which it treated with greater license—the expression *petit goût* was often used in connection with this kind of painting. Still life was considered an inferior category.

The Academy always sought to preserve the primacy of history painting. Among the Academy's members, only history painters could attain the rank of officer. Moreover, the Church needed them to execute its countless commissions for religious works. La Direction des Bâtiments du Roi, which, under Marigny, the Marquise de Pompadour's brother, had somewhat neglected history painting, began to promote it vigorously once more under D'Angiviller, who succeeded Marigny in 1774.

Although talented artists such as Restout, Carle van Loo, and Pierre continued to reign supreme in history painting, the public favored genre painting by Boucher and Fragonard—and even still life, such as those painted by Chardin, gained in prestige. This corresponded to the reaction of the aristocracy and the bourgeoisie against the autocratic nature of the preceding period, as well as to a taste for the intimate and decorative arts that was so characteristic of the reign of Louis XV.

A reaction in the opposite direction to prevailing trends had begun to make itself felt in French painting as early as the 1750s. This response was directed against the excesses of a style that seemed to have no object other than to pander to the luxurious habits of a society whose mores were increasingly being called into question. The *Philosophes* attacked the frivolity of this elegant art. Diderot attributed political, social, and moral ends to painting, denouncing Boucher and singing the praises of Greuze. He was indulging in a form of sentimentalism, of course, but he was also paving the way for a new conception of austerity in painting. The heightened enthusiasm for archaeological excavations, in turn, furthered the development of archaeology, as well as a body of literature on aesthetics that had historical and pedagogical aspirations. A new conception of art and morality was evolving; it would triumph during the reign of Louis XVI in a Neoclassic form that actually proved to be true to the essence of Classicism.

David's First Paintings: Winning the Academy's Approval

Nothing was further from David's mind than these artistic developments when, as Vien's protégé, he entered the Academy as a pupil in 1766. He did not question the Academy's role, nor did he question the hierarchy of categories in painting. His goal was to become a history painter and this aim would shape his entire artistic career.

At the Academy, David continued to study drawing. It was the crucial foundation of pictorial art. The first requirement of a painter was that he be an accomplished draftsman. One must also understand that line (via engraving), not color, was the principal means through which beginners could become familiar with that artistic heritage wherein they would have to seek examples and inspiration.

Museums did not exist. The royal or princely collections—as well as the important private ones—were not, in many cases, readily available to the public at that time. Aspiring painters could see paintings primarily in churches which constituted, as it were, permanent art galleries displaying works from the past,

and at the Salons, which offered them the opportunity every other year to become familiar with the most recent works of living painters.

It is thus not surprising that David's first two paintings in 1767, when he was eighteen years old (*Heracles Bringing Alcestis Back from Hades*, and *Jupiter and Antiope*), reflect the affected mannerisms of the age and are not of great interest.

But at an early age, David was also drawn to portraiture: he painted portraits of his aunt and uncle, the Burons, as well as of their friend, Sedaine, his wife and his daughters. In his first portraits he did not try to follow the dictates of fashion but strove instead—and with felicitous results—to convey simplicity and truth.

The dual orientation of his career as a painter had already manifested itself: on the one hand he was drawn to grandeur, and on the other to reality. Above all, however, his main aspiration at that time was to make a career for himself at the Academy.

After an unsuccessful attempt in 1770, David was admitted to the final rounds of the Academy's

6. *Madame Buron*. 1769. Oil on canvas, 25⅝ x 21½". The Art Institute of Chicago (Gift of Mrs. Albert J. Beveridge)

painting competition in 1771. The subject selected by the jury was: "The Combat of Minerva against Mars when Venus Comes to the Aid of Her Lover." Despite his efforts to produce something original, David painted a theatrical picture in which the borrowings from Boucher and Fragonard are quite apparent.

Responding to the challenge, he started afresh the following year with a subject no less classical: "Apollo and Diana piercing Niobe's children with their arrows." But he did not change his style; he simply tried to surpass his previous efforts. Once again, his work was rejected. His despair was so profound that he shut himself away, planning to starve himself to death. His host at the time, Sedaine, finally persuaded him to emerge from this seclusion, and consoled the disappointed artist. Sedaine, the Secretary of the Académie d'Architecture since 1770, was also a

Right:
7. *Head of Minerva*. Undated. Black chalk heightened with white, 13 x 10⅜". Musée Bonnat, Bayonne

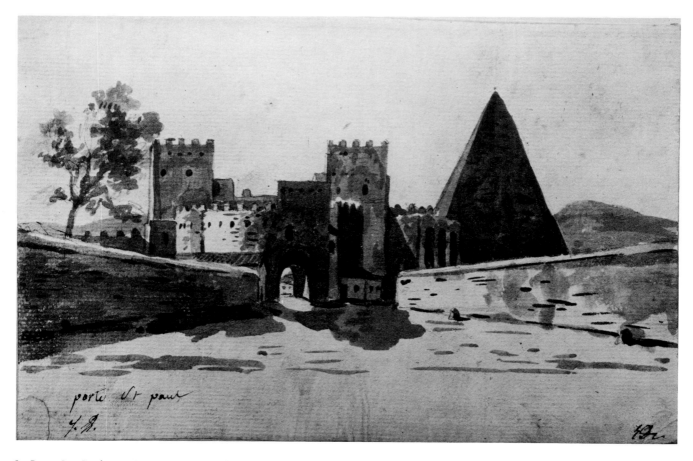

porte St paul

8. *Porta San Paolo*. c. 1775–80. Gray wash over thin pencil sketch, 4⅞ x 8¼". Nationalmuseum, Stockholm

12

poet as well as a devotee of the theater, and it was at Sedaine's home that David began to encounter a different circle of people. He developed a love of music, especially that of the violin (which he practiced for the rest of his life), and a taste for the theater.

In 1773, David made his fourth attempt to win the Academy's prize with *The Death of Seneca* as the subject. The jury rejected him yet again.

David's intense resentment of the Academy's successive rejections would remain with him for the rest of his life. He could never quite forgive the Academy for failing to recognize a superiority he did not then actually possess.

It was only on his fifth attempt, in 1774, that David was awarded first prize for a painting entitled *Antiochus and Stratonice* (see colorplate 1). It was, indeed, the first work in which he manifested the special gifts upon which his reputation would eventually come to rest—vigor of composition and brilliance of colors—although the painting still suffered from a certain theatricality and an exaggerated display of dramatic effect.

The First Trip to Italy: Discovery of the Antique

First prize entitled David to a sojourn in Rome as a boarding student at the Académie de France. Before he left for Rome, he declared, "The Antique will not seduce me; it is lifeless and it does not move." He was twenty-six years old. Although a hard-working, determined, studious pupil, it is obvious that David took his prejudices with him to Rome, together with the banality of a pictorial education distinguished solely by a precocious admiration for Poussin. He would return from Italy a true painter, having matured under the influence of a world of new impressions and after much serious reflection. The only other element required was talent—*that* he had in full measure, and its scope would be revealed to him in Rome.

David left Paris in the autumn of 1775 with Vien, who had been appointed Director of the Académie de France. On the way to Rome they stopped in Parma, Bologna, and Florence, where David developed an enthusiasm for Correggio. He discovered the Italian painters—their fresh and luminous style, their simple, strong compositions. He began to question his own

9. *Roman Monuments.* c. 1775–80. Pen, ink, and wash, 5⅞ x 8¼". Musée Bonnat, Bayonne

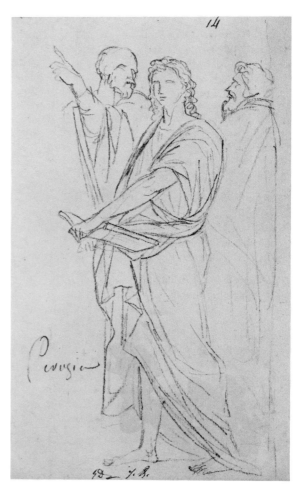

admiration for the masters of the French school of the eighteenth century. In Rome he found a city bursting with history, the only true museum of Antiquity at that time; it was also a marketplace for artworks, and a sort of never-ending art class attended by art lovers, historians, scholars, and critics from every country.

The Académie de France in Rome, where David's illustrious predecessors had included Boucher, Hubert Robert, and Fragonard, was primarily a place to work. The students were never idle; they rose at five o'clock and worked all morning. Then they spent their afternoons visiting churches, palaces, or other monuments from the past, returning to their lodgings late in the evening. David immersed himself in his work, painting very little but executing hundreds of drawings. He used antique bas-reliefs and statues as his models, as well as the works of the old masters, but he did not neglect studies from nature. His aim was to amass a store of documentation, as well as sketches from life.

His excursions and walks enabled him to see a

12. *Nude Study of Hector*. 1778. Oil on canvas, 48⅜ x 67¾".
Musée Fabre, Montpellier

great many paintings, since major works were on dis-
play in churches and palaces throughout Rome. He
was captivated by Michelangelo's grandeur, and the
perfection of Raphael. He discovered Veronese and
Titian, then rediscovered Poussin—whose early at-
traction for him he now fully understood. He was also
impressed by the work of many painters from the ear-
ly seventeenth century whose sense of light and strong
colors he admired—in particular, the Carracci and
Caravaggio, as well as Correggio, Domenichino, and
Valentin.

David was very strongly affected by what he saw,
but he wanted to control his sensibility; he needed
time to reflect and mature. The paintings he executed
during his first sojourn in Rome (*Patroclus, Hector,
The Funeral of Patroclus,* and *Saint Jerome*), drew
their anatomical realism, the directness of the model-
ing, their clean colors, and the strength of their con-
trasts from his new Italian models, but compositionally
they still echo eighteenth-century French baroque
tastes.

13. *Nude Study of Patroclus*. c. 1779. Oil on canvas, 49¼ x
66⅞". Musée Thomas-Henry, Cherbourg

15

The discovery of Antiquity was an essential element in David's development as a painter. He studied its monuments, statues, bas-reliefs, and frescoes with passion, with the ardor of a student determined to learn the lessons they could teach him: lessons of austerity, virtue, and moral strength, of which Antiquity furnished scores of beautiful examples to a generation that had drawn intellectual and artistic sustenance from its history.

His brief stay in Naples in August 1779 enabled him to see the frescoes recently discovered during the excavations at Pompeii. This trip set in motion a sort of artistic revolution in David's psyche. Later, in recalling his return to Rome at the end of August, he wrote: "The scales fell from my eyes. . . . I understood that I could not improve my style because its underlying principle was false and that I had to begin by repudiating everything I had once thought to be beauty and truth." The passion for simplicity and strength that had been germinating in him, burst into full flower beneath the Neapolitan sun and would remain with him the rest of his life.

He was thirty-one years old. His period of study and maturation had come to an end; master of his own talent, from that point on he would assert his originality—his double originality, one might say, since he never ceased to follow two parallel paths, those of portraiture and history painting.

The flowering of his genius was accompanied by feverish activity. It was at this time that he conceived the idea for the portrait of *Count Potocki* (see colorplate 4). Fresh and vibrant, it resonates with youth and enthusiasm. He also accepted a commission from the lazaretto in Marseilles for a painting depicting *Saint Roch* interceding for the plague-stricken (see colorplate 3), a solemn subject that he painted in a tormented fashion against a somber sky.

In both works we can observe new qualities: the solidity of the drawing, the balance of the colors, the vigor of the composition, the study from life for the bodies, and the expressive power of the draperies.

Return to Paris: Success and Admission to the Academy

The success of *Saint Roch* was considerable. Attempts were made to keep David in Rome, but he was determined to return to Paris to display his talent. He left Rome in July 1780, and stopping frequently en route, made his way back to Paris. He thought that *Saint Roch* would give him the right to exhibit at the Salon, but the Academy demanded that he produce another painting in Paris. This cost him an additional year, but the delay proved beneficial. He had the time to complete both *Count Potocki* and *Belisarius* (see colorplates 4 and 5).

He was thus able to exhibit ten works at the Salon of 1781, including three major paintings—*Count*

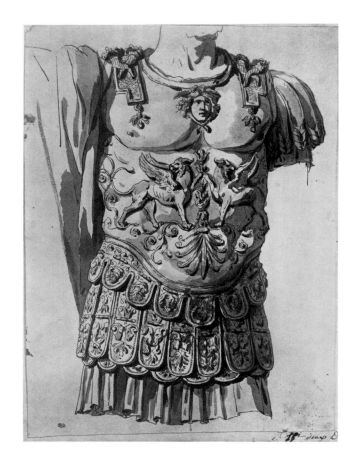

14. *Roman Armor.* c. 1775–80. Pen and ink, 12½ x 9¼". Musée du Louvre, Paris (Cabinet des Dessins)

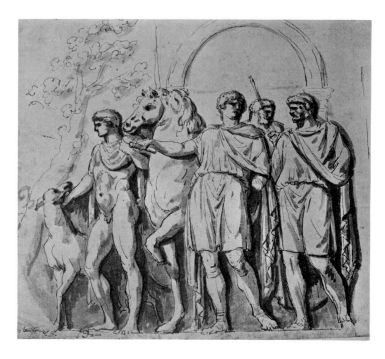

15. *Study after a Relief (The Triumph of Constantine).* Undated. Pen with gray and black ink and brown wash, 6½ x 7". Nationalmuseum, Stockholm

Potocki, Belisarius, and *Saint Roch*—as well as an important sketch, *The Funeral of Patroclus. Belisarius* won him the Academy's unanimous and official "approval." David's particular strengths as a painter asserted themselves in this picture: sobriety, power, authentic emotion, and nobility. He became famous virtually overnight. Diderot praised his work. The public rushed in great numbers to see the painting, and the critics applauded. David was considered to have surpassed his rivals, and was immediately ranked among the greatest painters of all time. His reputation spread beyond France's borders—Duke Albert de Saxe-Teschen bought *Belisarius* for the palace he had commissioned a French architect to build for him in Coblentz.

From that point on, the ambitious and anxious young man relished the rewards of success. He obtained a studio in the Hôtel de Ville near the Louvre. It was now his turn to take pupils, among whom were Hennequin, Jean-Germain Drouais, Wicar, and Girodet.

The painter who had been reproached by certain critics for the somberness of the light in *Belisarius* and *Saint Roch,* traveled to Flanders to study Rubens and his mastery of luminous coloring. It was an opportunity for him to become acquainted with the great Flemish painters and to add their lessons to those of the great Italians. He was thus able to experience directly two of the greatest European schools of painting. The Dutch, English, German, and Spanish schools, however, were to remain largely unknown to him.

A Marriage of Convenience

Upon his return to Paris, he obtained lodgings at the Louvre near his studio. He now had a position, an apartment, and a promising career. All he needed was a wife—the next step in the process of settling down.

He is thought to have had only one love affair before his marriage—with one of Madame Vien's housemaids—and even that is uncertain. None were attributed to him subsequently. He was no doubt more sensitive to the beauty of the male body than to that of the female body, although he did paint a number of charming female nudes as elements of larger compositions. His admiration for the human body, however, was rather more conceptual than physical, and, if he can be said to have had a passionate nature, it was aroused primarily by ideas and by heroes, real or imaginary.

The story of his marriage is a fairly ordinary one. Monsieur Pécoul, a rich contractor with the Bâtiments du Roi, whose son was one of David's friends, decided that David would be a suitable husband for his daughter. Taking advantage of his professional activities at the Louvre, Monsieur Pécoul forced the issue, and David married Charlotte in May 1782. She

16. *Head of a Plague Victim.* 1780. Pen and brown ink, 8¼ x 5⅞". École Nationale Supérieure des Beaux-Arts, Paris

was seventeen, he was thirty-three. One of his wife's sisters, Emilie, married a magistrate, Charles Seriziat. David would paint their portraits (see colorplates 20 and 21). Another sister, Constance, married an architect, Antoine Hubert. David became very fond of Emilie, but he detested Constance.

That Monsieur Pécoul's wealth had some bearing on this match is quite obvious, but David was marrying a devoted young woman who would become his trusted companion and would bear him four children, two boys and two girls. By all accounts, except for a period during the Revolution, the union was a harmonious one.

David pursued his career. He painted his Uncle Desmaisons' portrait; he worked on another mythological subject, *Andromache Mourning Hector* (see colorplate 7). With this painting of *Andromache* he became a full member of the Academy. The most felicitous expression of his talent during this period, however, was in his portraits of Monsieur and Madame Pécoul, executed in 1784.

17

17. *Jacques-François Desmaisons*. 1782. Oil on canvas, 35⅜ x 28⅜″. Albright-Knox Art Gallery, Buffalo (General Purchase Funds, 1944)

The Second Sojourn in Rome and the First Oath

David, however, was looking less to mythology than to history for a subject worthy of a composition on a grand scale. He chose the subject of the Horatii. To carry out his project, he felt the need to return to Rome in order to immerse himself once again in Antiquity. He delayed plans for the trip until he had been officially accepted into the Academy, which took place in the summer of 1783. Then the birth of his two sons (in 1783 and 1784) delayed the trip further. Finally, in September 1784, he left Paris with his wife and two students, Drouais and Wicar. The trip was financed by Monsieur Pécoul who, together with his wife, also assumed responsibility for the care of their grandchildren during the Davids' absence.

Thus David returned to Rome. In October 1784, however, he was a man with an established reputation who had come to Rome to verify the soundness of his intuition and to reestablish contact with Antiquity on a basis of equality. Vien was no longer in Rome, having been replaced in 1781 by Louis-Jean-François Lagrenée, and David's life was less restricted.

He discovered that his tastes were now better defined. He swore by Raphael, the Carracci and, of

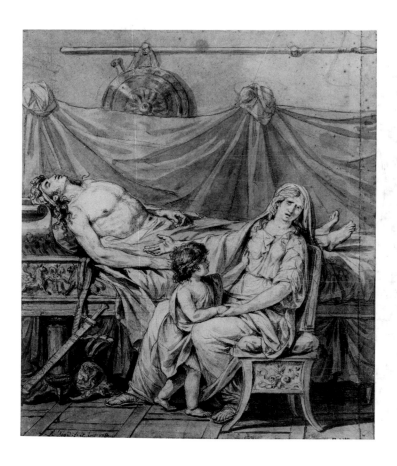

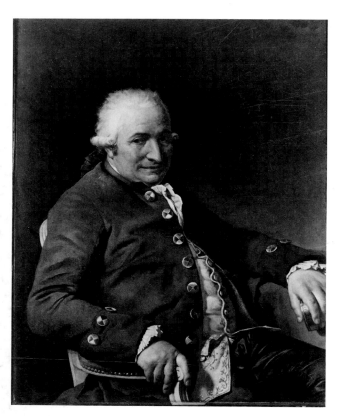

Left:
18. *Andromache Mourning Hector*. 1782. Black pencil and gray wash, 11⅜ x 9½″. Musée du Petit Palais, Paris

Above:
19. *Monsieur Pécoul*. 1784. Oil on canvas, 36¼ x 28⅜″. Musée du Louvre, Paris

18

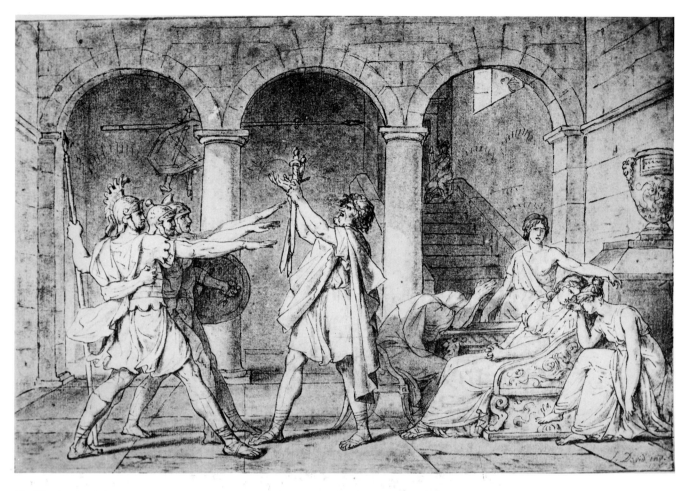

20. *The Oath of the Horatii.* 1782. Pen and black ink with gray·wash and highlights of white over black pencil, 8⅝ x 13″. Musée des Beaux-Arts de Lille

course, Michelangelo, but above all he worshiped Antiquity. He was now completely sure of himself and his direction. He began to work on the *Horatii.*

It was in Rome that he painted this work (see colorplate 8), whose freshness and authority were to have a profound impact upon all who saw it. The work was completed in the summer of 1785, and enjoyed an immense success. The stark simplicity, the clarity of the arrangement, the authority of the attitudes, the strength of the colors, as well as the intensely emotional contrast between the sacrifice and the grief dazzle the eye and speak to the soul. It was a triumph. The art lovers from every country who thronged to Rome sang the painter's praises.

Paris Triumph

David, however, could think only of Paris and what its verdict would be. He sent the painting on ahead and then returned posthaste for its exhibition at the Salon. The painting was received as successfully there as it had been in Rome. There were cries of "sublime" from every quarter. Even a majority of painters joined in the general enthusiasm.

From the heroism of Antiquity, David had drawn his subjects and the vigor of his inspiration. From the Italian masters and from Poussin, came the intensity of the colors, the contrasts of light, and the vigor of the composition. For technical skill and masterful draftsmanship, he was obviously indebted to the eighteenth century. But he owed some of his rigor and his exalted conception of art to the seventeenth century. He was the direct descendant of Corneille and Poussin, even though he aspired to return to their ancient masters.

David was so sure of his standing that he applied for an appointment as Director of the Académie de France in Rome, to succeed Lagrenée. This official ambition seems rather strange, since it declared itself at the very moment when he had been recognized as the leader of the Neoclassical School. In any case, he was considered too young for this position; it may be that David's lifelong hostility toward the Academy, which did not actually become explicit until sometime later, began to coalesce after this particular rejection.

However, for the moment, David was absorbed in his glory and in making the most of his success. The

21. *Profiles of Talleyrand*. Undated. Graphite, 7½ x 5½". Musée Carnavalet, Paris

22. *Young Male and Female Nudes*. c. 1779. Graphite, 4⅜ x 2¾". Musée Bonnat, Bayonne

Court, the aristocracy, and men of finance, all gave him commissions for history paintings and portraits. His pupils were more and more numerous—on the eve of the Revolution he had about forty students.

He continued to pursue his career as a portrait painter, one might even say as a society portrait painter. He was about to enjoy his first great period of success in high society.

A friend of the Duke d'Orléans, David gave drawing lessons to the Duke's oldest son, the Duke de Chartres (the future Louis-Philippe), and his younger brother, the Duke de Montpensier, who would himself become a painter. He enjoyed the society of men from the world of finance, as well as writers, and poets. He was André Chénier's friend and he knew Talleyrand. The fashionable women of his time posed for him. He was very close to Madame Vigée-Lebrun, Marie-Antoinette's portraitist. The list of portraits he painted during this period is a clear indication of how important a personage he had become.

His models were all successful people, for example, Fermier-Général Lavoisier and his wife (see colorplate 10), who exemplified both intellectual and material success, and Philippe-Laurent de Joubert, the extremely wealthy treasurer of the Estates of Languedoc and patron of the arts. Unquestionably, these portraits were painted in a vivid and candid manner which is in striking contrast to the studied solemnity of official portraits, but one cannot fail to note that nearly all of his models were rich, well-known, and elegant individuals.

The Myth of Greek Art
David was now so famous and so much in vogue that members of the Court were captivated by him. The Count d'Artois, the future Charles X, who was known to be a libertine, commissioned a painting in keeping with his tastes, *Paris and Helen* (see colorplate 11). The subject was taken from Homer, but it was only a pretext for painting nude adolescent bodies. David composed a charming idyl with such facility and success that one might be tempted to question the depth of his moral convictions and his admiration for historical figures if one were to overlook in this painting the idealism and grace, which belong more to the order of the intellect than to that of the senses. It is

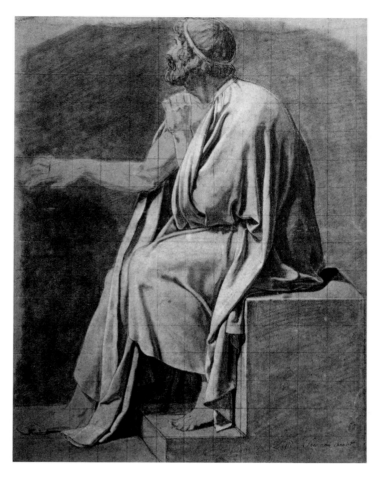

23. *Study for the Figure of Crito in "The Death of Socrates."* c. 1787. Black chalk, gray wash heightened with white on brownish paper, squared off in black chalk, 31¹⁄₁₆ x 16⁵⁄₁₆". The Metropolitan Museum of Art, New York (Rogers Fund, 1961)

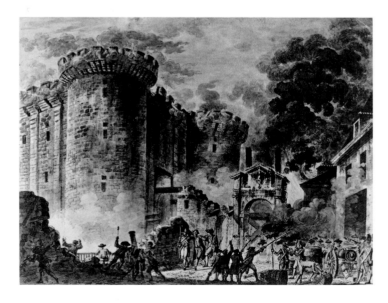

24. Jean-Pierre Houel. *The Taking of the Bastille, July 14, 1789.* Undated. Gouache, 15⅜ x 20⅛". Musée Carnavalet, Paris

apparent that David was trying, for the first time, to achieve the perfection of Greek art.

For David, in effect, as for many of his contemporaries, the representation of ancient Rome was not an end in itself. Tracing this art back to its origins led inevitably beyond Rome to Greece, the source of the arts or, in any case, of Roman art. Furthermore, research projects and studies were being produced in abundance. Greek vases—many of them found intact—were becoming known, and through them one could glimpse an art more refined and purer than that of Rome.

This deepening study and appreciation of Antiquity was still, however, in its early stages. With its taste for rationalism, France favored an idealized vision of Rome and above all, Republican Rome, depicted as a model society in which greatness, self-denial, love of country, and sacrifice of particular interests were the virtues of ordinary citizens. These Roman virtues were held up in stark contrast to the licentiousness of contemporary French mores.

David painted another important, large-scale picture, *The Death of Socrates* (see colorplate 9), in which he tried to apply what he had learned from the breakthrough represented by the *Horatii;* he also wanted to reply to criticism that his compositional arrangements were too schematic by reintroducing continuity and suppleness into the concatenation of forms and colors.

The Appeal of a New Era: Another Oath

David then painted the picture of "Brutus showing his indifference towards the bodies of his sons whom he had allowed to be condemned for having conspired for the return of the Monarchy." Everything is there—a meditation upon the homeland, impassiveness in the face of drama, as well as the grief and curses of the women. The elements of the painting feed into a kind of sentimentality; they also foster a feeling of exaltation. The painting was immediately read as a political manifesto, the harbinger of a new age.

David, as a member of a privileged class and as a protester, rushed headlong toward this ideal society that he longed for, that he believed he could shape by his efforts, and that would sweep him along in a whirl of madness and bloodshed: The Revolution had begun. It was something new, without precedent, and France furiously—and blindly—plunged into it.

At the beginning of 1789, David was still dreaming about Italy and the joy of returning there. The storming of the Bastille overruled this desire. Led to the Bastille by his curiosity, David drew the head of the Governor, Monsieur de Launay, impaled on a pitchfork. The Salon also held him back; he exhibited *Brutus* (see colorplate 12), the Republican hero, whose patriotism was in sharp contrast to the weakness of Louis XVI, who had allowed his brothers to

25. *Study for a Portrait of Louis XVI and the Dauphin.* 1791–92. Graphite, 5⁵⁄₁₆ x 4⁹⁄₁₆ (Cabinet des Dessins)

Right:
26. *Countess de Sorcy-Thélusson.* 1790. Oil on canvas, 50¾ x 38⅛". Bayerische Staatsgemäldesammlungen, Munich

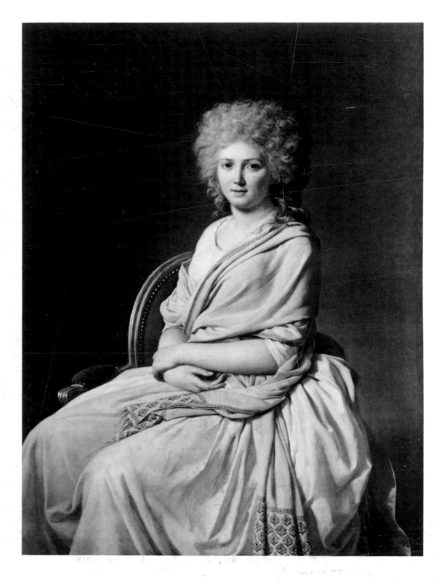

emigrate. The painting made David the leader of the "patriotic" artists.

Just as he had wanted to reform the decadent art of his youth by a return to nature, he followed the men who were trying to replace the outdated political and social principles of the monarchy with the democratic principles of the Greek and Roman Republics.

In his own sphere of influence, he led the fight against the cultural and artistic institutions of the Ancien Régime—in other words, against the Academy, which had offered him certain opportunities for a successful career, but where he had not risen to the highest levels. Having worked, with devotion and success, to supervise the personal training of the pupils in his own studio, he now encouraged the young dissident artists to rebel against the Academy. In turn, the Academy excluded him from its deliberations. The minor war between them grew more bitter and David began to take very seriously his new role as organizer and leader of the dissident faction.

This new role, however, did not prevent him from painting the two daughters of a rich banker from Geneva who was a friend of Necker's, the *Countess de Sorcy-Thélusson* and the *Marquise d'Orvilliers* (see colorplate 13), from painting the portrait of *Madame Pastoret* (see colorplate 15), or from going to Nantes to render a portrait of its patriotic mayor. The treatment in these works is increasingly stark, but the models are still aristocrats. The portrait of *Madame Trudaine,* painted in 1792, however, prefigures in its odd, deep shadows the haggard march of destiny that would carry this woman's husband to the guillotine and impel David himself to certain excesses.

Revolutionary Commitment

Almost imperceptibly, David became more radical; the Academy's resistance drove him to seek support from more advanced circles. The Club des Jacobins welcomed him at the end of 1789. In June 1790, a so-

22

ciety was founded to invite David to paint a picture commemorating the Tennis Court Oath. The proposal was brought up again in October by the Club des Jacobins and a subscription was established to collect funds for this purpose. This appeal flattered and excited David.

He began with a large-scale drawing (see colorplate 14) which is simultaneously an admirable gallery of portraits and a vibrant composition, uniting a sharpness of perception to a kind of lyricism. It was, in fact, his first painting of a modern historical event and he would not find a subject equally worthy of him until much later, when he painted *The Coronation of Napoleon and Josephine* (see colorplate 29). The earlier work, however, already vibrates with the enthusiasm and emotion characteristic of great epics. André Chénier wrote an ode in honor of *The Tennis Court Oath*. In reality, the poet was celebrating the future

27. *Head of Kervelegan.* Undated. Oil on canvas, 19¼ x 13″. Musée du Louvre, Paris

28. *Study for "The Tennis Court Oath."* 1791–92. Graphite, 5⁵/₁₆ x 4⁹/₁₆″. Musée du Louvre, Paris (Cabinet des Dessins)

29. *Head of Prieur de la Marne.* Undated. Oil on canvas, 21⁵/₈ x 21¼″. Musée des Beaux-Arts et d'Archéologie de Besançon

23

painting, rather than the completed sketch. Although the drawing was finished by 1791, and exhibited at the Salon of that year, David barely sketched the outline for this painting, including depictions of several individuals which are all that remain (see colorplate 16).

David was soon swept away by the political events that followed each other in rapid succession. By 1789, he had met Robespierre, whose austere and passionate republicanism he was to find so fascinating. (In 1792 he sent a portrait of himself to "Citizen and Friend Robespierre," and began work on a portrait of Robespierre.) As his wife became increasingly alarmed at the evolution in David's thinking, he distanced himself from her. In September 1790, he made a final break with the Academy and set up the Commune des Arts with some of his fellow dissidents. The gauntlet had now been thrown down and the decisive battle began.

In February 1792, Robespierre spoke publicly of the idea of a national holiday during which such great men as Rousseau (who had died in 1778) or David "would have been crowned by the hands of the ancients, or, perhaps even better, by the hands of Beauty." Applauded by Robespierre, David—who had already been selected the previous year by the Constituent Assembly to organize a procession for the transfer of Voltaire's ashes to the Pantheon—now organized a festival "of the people and of liberty," the Fête des Suisses de Châteauvieux. André Chénier promptly denounced "the shocking madness of the fool David of whom I once sang."

France was aflame. Everyone sensed that the Revolution had reached a critical turning point. The foolishness of the Girondists had propelled the country toward war, which, in turn, brought about a radical transformation in the very nature of the Revolution. No longer a reform movement, it became extreme in character. France was in danger. On one side, there was the Ancien Régime, whose supporters were branded as a collection of traitors and oppressors; on the other, the people who rose up as a group to defend the Nation and Liberty. That summer, the Marseillaise was born. In August the Monarchy was overthrown and the Legislative Assembly was replaced by the Convention. David was becoming increasingly hotheaded. On September 6th, at the Electoral Assembly of Paris, Marat proposed David's candidacy

30. Study for "The Tennis Court Oath." c. 1791. Graphite, 11¹¹⁄₁₆ x 9³⁄₁₆″. Musée Bonnat, Bayonne

31. Joseph Ducreux. Portrait of Louis XVI. Undated. Charcoal on blue paper, 19¼ x 11¾″. Musée Carnavalet, Paris

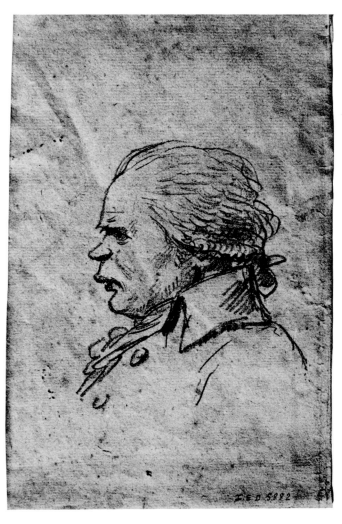

32. *Portrait of Danton.* c. 1793. Graphite, 5⅞ x 3⅞". Musée Carnavalet, Paris

33. *Project for the Costume of a French Citizen.* 1793. Pen, ink, and watercolor, 11¹³⁄₁₆ x 7⅞". Musée National du Château de Versailles

as deputy to the National Convention. He was elected on the 17th and immediately took his place among the extremists known as the *montagnards,* side by side with Marat, Danton, and Robespierre.

David enthusiastically voted for the execution of the King in January 1793. This was no doubt the reason behind the separation (which was to prove temporary), from his wife, who remained a Royalist.

The Organizer of the Arts
David's artistic activity up to the time of Robespierre's fall from power was considerable. He proposed the establishment of a complete inventory of all national treasures, the creation of museums in each *département,* and the collection of "the major masterpieces of the Arts in the Center of the Republic." In light of this activity, he emerges as one of the founders of France's museums. In addition, he played an active role in the organization of the Museum, the embryonic form of the future Louvre.

He became the director of all revolutionary festi-

vals. He invented extraordinary pageants for those festivities he supervised. The pageant of August 10, 1793 is worth describing in detail. David's program for the event provided for the erection of a Fountain of Regeneration on the site of the Bastille. "From her fecund breasts squeezed by her own hands will flow in abundance the pure and health giving water from which the eighty-six representatives of the Primary Assemblies will drink in turn; one goblet will serve for all: a salvo of artillery fire, each time a representative has drunk, will announce the consummation of the act of paternity." The procession was to parade down the boulevards to the Champ de Mars; the members of the Convention and the representatives from the eighty-six *départements* would be followed by "the respectable mass of the sovereign people." In the last group, one would see "the black African who differs only by his color and who will walk beside the white European. You will also be there, tender babes from the Foundling Home, carried in white bassinets, you will begin to enjoy your civil rights only too justly

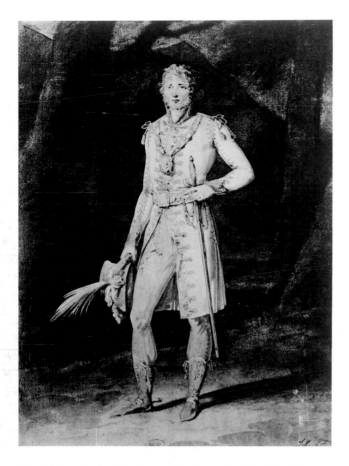

34. *Project for the Costume of the Consuls of the Republic.*
1794. Pen, ink, and watercolor with highlights of gold on a
charcoal and sepia background, 13¼ x 9⅝". Musée National
du Château de Versailles

recovered." Thus did David express himself in his
program.

Later, he proposed making a statue with the
bronze from the melted-down cannons taken from the
enemy; the pedestal would be made from the broken
fragments of the statues torn from the facade of
Notre-Dame. He proposed to the Convention the or-
ganization of a national holiday in memory of the vic-
tories of the French armies, and one celebrating the
storming of Toulon. He did not know this would be
merely the first time he would pay homage to Bona-
parte, then a captain in the artillery, whose skill had
enabled the French to liberate the city besieged by the
British.

In May 1794, he organized the Festival of the Su-
preme Being which was held with great pomp the fol-
lowing month. This had been Robespierre's idea.
Robespierre had wanted to establish a new, revolu-
tionary religion founded upon the belief in a divinity
called the Supreme Being and upon the immortality of
the soul. This religion was to glorify the virtues of the
family and of patriotism, while uniting the citizens in
a fervent fellowship within a regenerated Republic.
David, although himself an unbeliever, became enthu-
siastic about Robespierre's project and arranged a
magnificent pageant to parade from the Tuileries to
the Champ de Mars. He was responsible for the songs
and the music. He composed a discourse to husbands
and wives, a hymn to charity, another to motherhood,
and the "free man's declaration to the Supreme Being,
author of Nature."

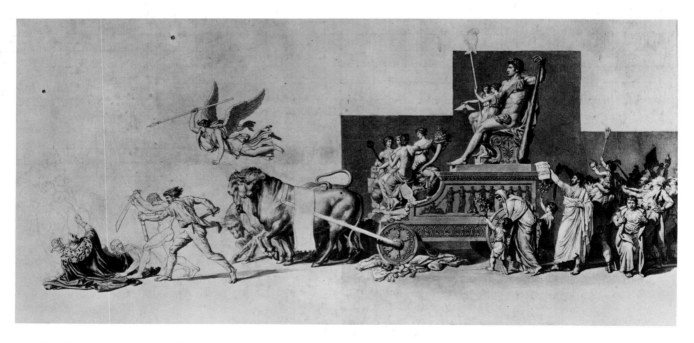

35. *The Triumph of the French People Over the Monarchy.*
Undated. Pen, ink, and wash, 12⅝ x 27⅝". Musée Carnavalet,
Paris

In July, he also proposed a lyrical pageant in honor of two young revolutionary victims, Barra and Viala.

At the same time, David relentlessly pursued his battle against the Academy—hardly a glorious one, since the members of the Academy were virtually defenseless. He struck the final blow in August 1793 by asking the Convention to do away with all the académies. The Convention accordingly abolished the académies but, shortly thereafter, set up a jury to supervise the awarding of prizes in the painting, sculpture, and architecture competitions. David, of course, was promptly made a member of this jury.

However arbitrary and brutal his methods against established institutions may have been, he never ceased to show consideration to the artists themselves. Thus, he intervened on behalf of Fragonard. In reality, David had become, if not a dictator as some have claimed, at the very least an organizer and supreme protector of the arts. His activity in this domain, although sometimes frenzied, was, on the whole, beneficial insofar as the establishment of the first museums in France was concerned, as well as in the organization of Salons open to all. He had been, and still was, a reformer of French painting. He freed it from certain artistic constraints, even if, in turn,

he himself would point the way toward a new academicism.

During this revolutionary period, David found the time to produce several paintings. The painting of *Lepelletier de Saint-Fargeau*, a member of the National Convention, who had voted for the King's execution, and then been assassinated by a Royalist on the eve of the King's death, has been lost. Only the painting of Marat has come down to us in its finished form (see colorplate 17). In this masterpiece, which has aptly been called a "Revolutionary Pietà," David expressed with extraordinary emotion, simplicity, and authority the admiration he felt for the assassinated "Friend of the People."

The Accomplice of the Terror

Perhaps his only persuasive witness in the trial posterity brought against him for his political activities during the Reign of Terror was, indeed, *The Death of Marat*.

President of the Club des Jacobins in June 1793, Secretary of the Convention in July, on September 14, 1793, he was appointed to the Committee of General Security. During the more than ten months following his appointment, he would sign—or rather, countersign with his colleagues—those arrest warrants which, in the majority of cases, would lead the arrested individuals to the scaffold. Much has been written in an attempt to justify his actions; afterwards, he tried to do this himself. But the facts remain.

David signed nearly three hundred arrest warrants for the apprehension of suspects and about fifty summonses calling the parties involved before the Revolutionary Tribunal. Among the victims, most of whom would be guillotined, were the names of individuals who had once been his patrons, such as Philippe Egalité, the former Duke d'Orléans, who had also, like David himself, voted for the execution of the King; the Marshal and the Duchess de Noailles, who had commissioned a painting from him; General Alexandre de Beauharnais, the husband of the future Empress Josephine; and Madame du Barry, among others.

It is only fair to recognize that, thanks no doubt to his intervention, not a single artist was sentenced to death, and that he sometimes intervened to assist the flight of suspects, such as General Seriziat, a relative of his brother-in-law. He also signed nearly a hundred or so orders to release prisoners. These do not compensate, however, for the number of people he helped send to the guillotine.

Undoubtedly, in all these instances, he was fulfilling his role as a member of the Committee of General Security. He attended no more than one-third of the sessions and signed less than one-tenth of the warrants issued. He later argued in his own defense that his functions prohibited him from taking any personal

36. *Study of the Head of Marat.* 1793. Pen and ink on white paper, pasted on brown paper, 10⅝ x 8¼". Musée National du Château de Versailles

37. *Marie Antoinette Brought to Execution.* 1793.
Pen and ink, 5⅞ x 3⅞″. Musée du Louvre, Paris
(Collection E. de Rothschild)

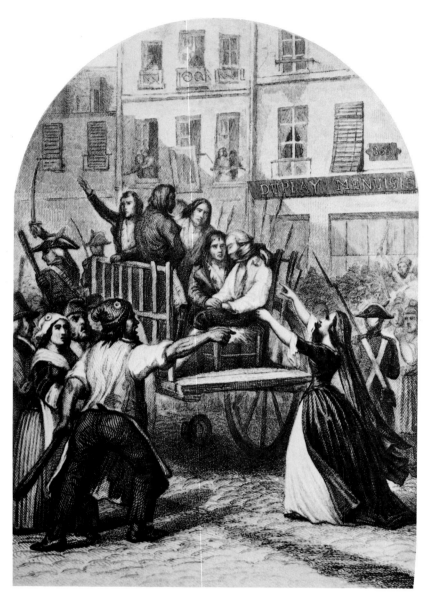

38. Marcke. *Robespierre and His Followers Being Brought to Execution.* Musée Carnavalet, Paris

measures. A striking example of his state of mind during this period, however, was the drawing he did of Marie-Antoinette on her way to the scaffold: the sketch is startlingly true to life, but there is not the slightest trace of emotion in its execution.

One might be tempted to conclude that, in his political activities during the Reign of Terror, David behaved generally like a fool and a scoundrel. Even his wife, who loved him, was unable to tolerate his conduct. A divorce decree was issued in March 1794; she retired with her two daughters to the estate of her father, Monsieur Pécoul, in Saint-Ouen, leaving the two boys in their father's care. Once Robespierre's fall put an end to the Terror, and the madness that had seemed to possess David—as it had many other patriots during that terrible year—there would be a reconciliation.

On the 8th Thermidor of the Year II (July 27, 1794), David in a last emotional outburst, declared to Robespierre: "My friend, if you drink the hemlock, I will drink with you." But he did not attend the session of the Convention that voted for Robespierre's overthrow; he sent a note saying he had been afflicted by a "sudden illness."

Ordeals and the Restoration of Calm
On the 15th Thermidor (August 2nd), the Convention ordered David's arrest. He was taken to the house of detention at the Hôtel des Fermes, rue de Grenelle. He was reproached for his ties with Robespierre and for his fanaticism during the Reign of Terror. His imprisonment seems not to have been too harsh, however; he found himself in the studio of one of his former students and was soon able to return to painting. His

wife came to see him as soon as she could, bringing their children and assuring the concierge of the prison, whom she had bribed: "He is the most honorable man I know: believe the woman who divorced him."

He was moved to the Luxembourg at the end of one month, and there he painted the *View from the Luxembourg* (see colorplate 19), the only landscape he has left us. It expresses, through its classicism and luminous softness, a nostalgic longing for peace. He also completed the first sketch for *The Sabine Women,* a painting not devoted to the glorification of martial or superhuman valor, as in the past, but to reconciliation and—were the painting not quite so grandiose—one might say to feminine good sense.

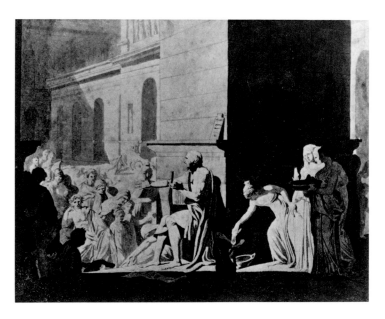

39. *Homer Reciting His Verses.* 1794. Black pencil, sanguine, pen and black ink, 10⅝ x 13⅝". Musée du Louvre, Paris (Cabinet des Dessins)

He still did not really understand why he had been arrested. The argument he most often used to justify his conduct during the Reign of Terror is psychologically very revealing. He wrote to the Committee of General Security: "If the false virtues of Robespierre misled my patriotism, the error that seduced me was less the effect of the personal feelings that bound me to him, than the result of the universal esteem in which I always saw him held." No less revealing is his letter at the same time to a friend: "I believed, in accepting the post of legislator—an honorable post but one very difficult to fulfill—that an upright heart would suffice, but I was lacking in the second quality, by which I mean insight." Nor should we forget Fabre d'Eglantine's response several months earlier, when David had asked him: "And I, do you believe that I could be corrupted?" "More

easily than another, by promising you the honors of the Pantheon during your lifetime."

A delegation of his students demanded that the Convention release him, and he was freed on December 28, 1794. Although he was reinstated as deputy to the Convention, he had made powerful enemies in artistic circles. There was a torrent of denunciations and calumnies directed against him. Sensing the growing danger, he took refuge in April 1795, at the home of his brother-in-law Seriziat, who had settled at Saint-Ouen. There, he began to paint his sister-in-law, *Madame Seriziat,* in May (see colorplate 20).

He was arrested again on May 29, and taken to the house of detention at the Collège des Quatre Nations. His brother-in-law Charles Seriziat intervened in his behalf. Pleading poor health, David requested that he be allowed to retire to his home. The Committee of General Security granted him a temporary release on August 3, and he returned to Saint-Ouen in the custody of a gendarme. His wife continued her unremitting efforts until she succeeded in obtaining his full release.

In September, he finished the portrait of his brother-in-law, *Monsieur Seriziat* (see colorplate 21). This painting with its freshness, simplicity, and remarkable perceptiveness, demonstrates that David

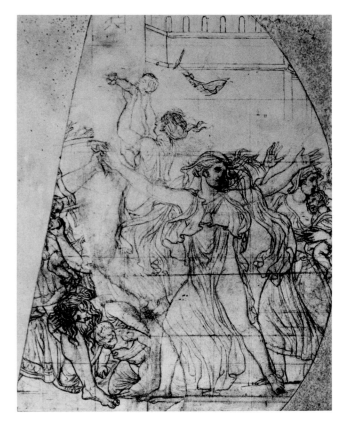

40. *Study for the Central Group in "The Sabine Women."* 1794–99. Black pencil, pen and black ink, 11⁵⁄₁₆ x 8⁹⁄₁₆". Musée des Beaux-Arts de Lille

41. *Jeanbon Saint-André.* 1795. Pen and black ink with brown wash, 7⅛" diameter. The Art Institute of Chicago (Joseph and Helen Regenstein Collection)

During all of 1795, David maintained a low profile. He painted several portraits, including those of *Jacobus Blauw* (see colorplate 22) and *Monsieur Meyer;* he returned to his studio at the Louvre.

He remarried his former wife in November 1796; the marriage contract showed that they were no longer very wealthy. They each owned an apartment house in Paris and had a modest amount of cash. From that point on, David was obliged to accept payment from his pupils, except for the younger ones, whereas he had previously been content to receive gifts in kind. As always, he took great pains with the artistic training of his pupils. He sought to develop their individual personalities and talents; he did not seek to impose his own ideas upon them. This authoritarian man, imbued with a sense of his artistic superiority, had a genuine respect for the freedom of others.

David returned to his grand plan for a painting of *The Sabine Women* (see colorplate 24). He wanted not only to present the theme in a new way, but to revise the form as well, by returning to what he believed to be the originating principles of art—that is,

had recovered his equilibrium. "I am leading a life which pleases me very much; I am in the midst of nature, engaged in work related to the countryside and to my art." He did not forget the Salon to which, in October, he sent both the portraits he had painted that year, those of Monsieur and Madame Seriziat. The public recovered its favorite painter.

Recovery and Cure: The Sabine Women

On October 26, 1795, the Convention approved a general amnesty for crimes related to the Revolution. David recovered his full freedom and returned to Paris. At the same time, the Convention enacted a law creating the Institut National des Sciences et des Arts, to be composed of the most eminent men in the sciences, literature, and the fine arts. It also reestablished the École de Rome. In November, the Directoire succeeded the Convention. One of its first acts was to name David to the painting faculty of the Institute on December 6th. Things began to move along at a rapid pace—a *very* rapid pace. David and his first colleagues were charged with selecting the other members of the Institute. It is worth noting that David chose Vien, his former teacher, although the two men had quarreled about the Academy. David was invited to participate in the juries, but he refused to sit on the Salon jury, in accordance with his ideas concerning the freedom to exhibit—ideas that he had publicly defended.

42. *Monsieur Meyer.* 1795. Oil on canvas, 45⅝ x 35". Musée du Louvre, Paris

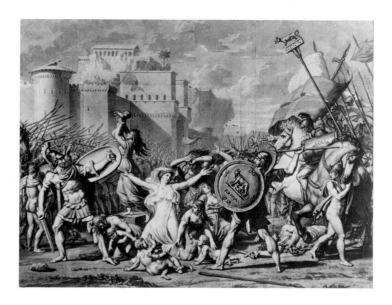

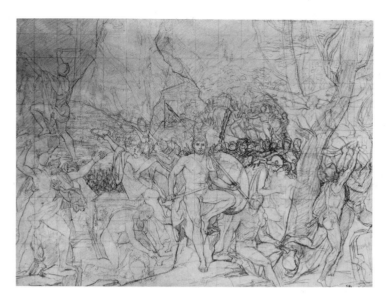

43. *The Sabine Women*. 1794–99. Black pencil, pen, and black ink with gouache relief, 18⅝ x 25″. Musée du Louvre, Paris (Cabinet des Dessins)

44. *Leonidas at the Battle of Thermopylae*. Undated. Black chalk, 16 x 21⅝″. The Metropolitan Museum of Art, New York (Rogers Fund, 1963)

to Greek art. In fact, it was an even greater degree of simplicity than in his past works that he wished to attain. Toward this end, he chose to paint his heroes nude, and he asked his most handsome and best proportioned students to take turns posing in the nude.

In 1799, when he had completed this painting, David organized a public exhibition of his works. At first, the idea was considered shocking, but the overwhelming response of the public drowned out the cries of the critics. The exhibition continued for five years, and nearly 50,000 people went to see it. The proceeds from the entrance fee, 1.8 francs per person, made it possible for David to buy a farm in Seine-et-Marne. Once more, David was a success. The nudity of his main personages in *The Sabine Women* caused a bit of a sensation, but the theme he had selected, as well as the magical quality of the light, and the beauty of the composition, carried the day.

There were those, however, who criticized David for his selection of a Roman subject as the theme for his exemplification of Greek art. And when Napoleon Bonaparte went to see the exhibit, he criticized the lack of action and the fixed poses of the warriors in *The Sabine Women*. David's rejoinder—after Napoleon had left—is said to have been that generals understand nothing about painting. Always concerned with improving himself as an artist, David then conceived a project for a painting that would be entirely Greek, both in style and in subject. Thus, in 1799, was born the concept of *Leonidas at Thermopylae*.

Once more, France was in danger. The threat this time came from without: the armies of the Allies were at her gates. A hero sacrificing himself at a distant outpost to give the rear guard time to organize its re-

sistance was obviously a theme with great contemporary relevance.

David was again captivated by dreams of glory. The excesses of the Revolution had faded—he now recovered the heroic exaltation of former times. In addition, he was thinking, for the last time, of completing *The Tennis Court Oath*.

Discovery of the Living Hero: Napoleon Bonaparte

It was at the end of 1797 that David met Bonaparte. This meeting would become the point of departure for a new phase in David's career, as well as in his work. Bonaparte, who had already sought to enlist David in the service of his glory, had the artist invited to dinner. Thoroughly charmed, David offered to paint Bonaparte's portrait. Bonaparte consented to pose for only a single sitting, and David was able to make just a sketch of his face. The sketch was, nonetheless, a passionate piece of work. David was already fascinated by Bonaparte and told his students, when describing the sitting to them: "What a fine head he has—pure, great, as beautiful as the Antique! Here is a man to whom altars would have been erected in Antiquity; yes, my friends, Bonaparte is my hero!" In April 1798 Bonaparte suggested that David accompany him on the expedition to Egypt, but David, thoroughly immersed in his painting of *The Sabine Women* at the time, declined this exotic experience.

Such a hero as this was far more real and alive than any personage from Antiquity. The glory of Bonaparte began to eclipse that of bygone ages.

David abandoned the painting of *Leonidas at Thermopylae*. He would return to it in 1802, and then

again in 1813, under tragic political circumstances similar to those surrounding its conception. By the end of 1813, France would no longer merely be faced with the threat of invasion. The beginning of 1814 would bring not only actual invasion but the collapse of the Empire as well.

But all of this was in the future. Now David painted several portraits that were very simply and boldly drawn, and rank with his best work: in particular, *Madame de Verninac,* Delacroix's sister (see colorplate 25), followed by *Madame Récamier* (see colorplate 26), a painting he never completed, but a subtle and penetrating portrait nevertheless. These women were all very attractive and stylish—the Revolution was definitely over. Almost without realizing it, David resumed his distinguished pre-Revolution role, that of the realistic portraitist of brilliant individuals and the determined painter of heroic scenes.

The coup d'etat of the 18th Brumaire (November 9, 1799) elicited David's comment—speaking volumes about the disillusionment of the former Republicans—concerning the incapacities of government by assembly: "Come, come; I always thought we were not virtuous enough to be Republicans." The day after the coup d'etat, Bonaparte had himself named First Consul, which had been the title conferred upon Brutus, First Consul of the Roman Republic (whom David had painted). Bonaparte had always presented himself as the defender of the Revolution, the man who would keep the Revolution alive. Now he was attempting to restore order and establish peace; he was the idol of France. How could David have been other than captivated, especially since Bonaparte flattered him, approached him about accepting the most powerful position at the École des Beaux-Arts, consulted with him about plans for the beautification of Paris, visited him, took long walks with him?

The First Consul signed the decree naming David the Government's painter in February 1800. David, however, refused to accept the position. It may be that he had hoped for more. Once again, Bonaparte asked David to paint his portrait. He gave him this laconic instruction: "I want to be painted calm, on a fiery horse," and assured David that he was not concerned about a likeness. "It is enough," he said, "that genius be there." David responded magnificently to this appeal in his painting *Bonaparte Crossing the Saint-Bernard,* which he began at the end of 1800 and completed in just a few months (see colorplate 27). Bonaparte, who came to see the painting in June, seemed satisfied, although slightly surprised by the disproportionate size of the model in relation to his soldiers. David exhibited the painting in September 1801, together with *The Sabine Women.* He was made Chevalier of the Legion of Honor in December 1803 as a reward for his work.

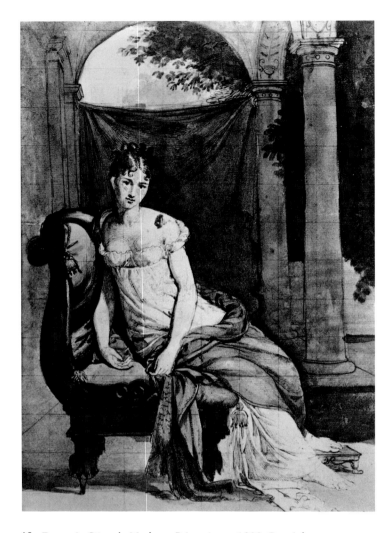

45. François Gérard. *Madame Récamier.* c. 1800. Pen, ink, and watercolor on paper, 12¼ x 9″. Musée Carnavalet, Paris

In the Service of the Emperor: the Coronation

David planned or began other portraits of Napoleon, some of which he completed. One of these, intended for the city of Genoa, was ultimately rejected by the Emperor. It was, however, upon the occasion of the Coronation that David received those important commissions that would make him the Emperor's painter.

He was invited to witness the ceremony, on December 2, 1804, from a private gallery where he was able to make notes concerning the major elements of the scene. Several days later, on December 18th, he was named First Painter to the Emperor. Napoleon asked David to paint several grand scenes: the Coronation in Notre-Dame, the Enthronement, the Distribution of the Eagle Standards, and the Reception of the Emperor and the Empress at the Hôtel de Ville, and he planned to exhibit them in a separate wing of the Louvre that would be named after David. Only the first and third of these paintings were ever completed, several years after the ceremony; the second and fourth exist only as preliminary drawings.

For the composition of *The Coronation of Napoleon and Josephine* (see colorplate 29), David proceeded as he had for *The Tennis Court Oath* (which he had definitively abandoned in 1801); he began by painting a gallery of portraits. The first portrait, completed in February 1805, was that of the Pope. It is ironic to note that the painter, an atheist, began with the Supreme Pontiff. Pius VII, however, was a simple and affable man, "a good man, a true evangelic," wrote David. Their mutual embarrassment was transformed into reciprocal esteem. An Emperor, a Pope—Fabre d'Eglantine had been right: David was susceptible to the lure of great men, and the Pantheon had come down to earth. His enthusiasm for heroes, however, also applied in this particular case to a "good

man" as he put it, to a saintly man, and this is somewhat touching.

Continuing to work on his gallery of portraits, David drew several of his main characters from life, beginning with the Empress Josephine. He did not draw the Emperor from life, however, remembering Napoleon's admonition as First Consul not to concern himself overly with achieving a likeness. Eventually, the painting which was to have shown the coronation of Napoleon actually focused on a later stage in the ceremony—the coronation of Josephine. This idea was borrowed from the painting by Rubens, already in the Louvre, depicting the coronation of Marie de Médicis by Henri IV, instead of the coronation of the King himself.

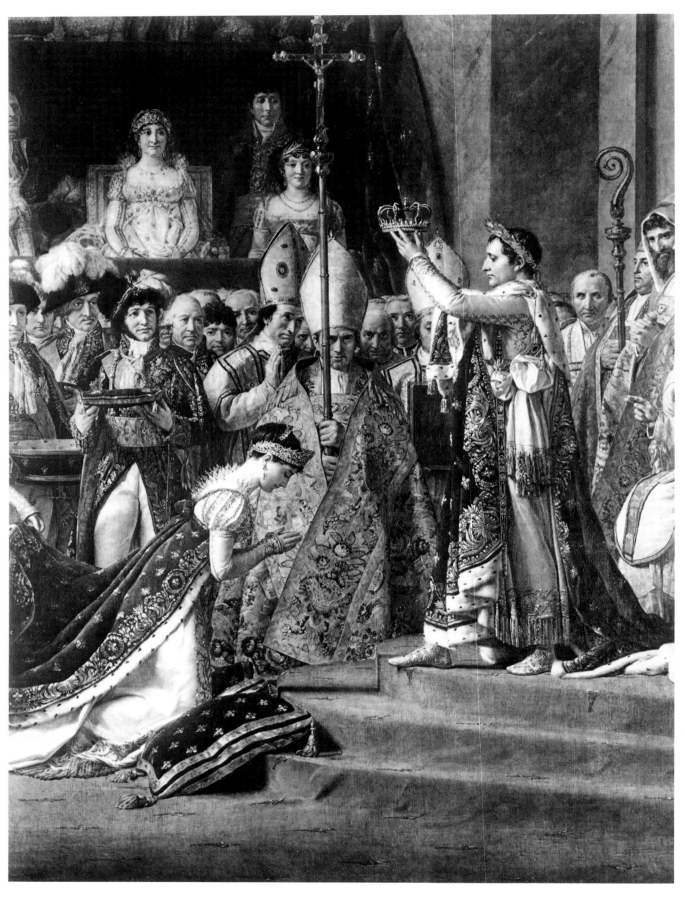

47. *Detail of "The Coronation of Napoleon and Josephine."*
c. 1805–07. Oil on canvas, 20′ x 30′6½″ (entire work). Musée
du Louvre, Paris

With this masterpiece—one of his most dazzling accomplishments—David succeeded in capturing the moment, in translating and rendering its grandeur, and in synthesizing a gallery of portraits and a solemn ceremony into a finely orchestrated apotheosis. The distinctive timbre of each individual instrument can be heard, while, at the same time, their diverse voices have been fused into a harmony of the highest order.

The work was completed at the end of 1807. The Emperor and Empress came to see it in January 1808, and Napoleon expressed his satisfaction. David tells us: "His Majesty, having praised my work—after having examined it for more than an hour, and examined it with the most scrupulous attention—deigned, on leaving, to raise his hat to me and pay tribute, in my person, to the high esteem he has for an art which thus helps to make an Empire illustrious." The painting was put on exhibition and enjoyed an immense success with the public. David did not hesitate to note: "It is a triumph the like of which has never been seen in the Gallic nation."

Demands and the Last Oath

David came to identify himself more and more with the imperial epic. His son Eugène enlisted in a regiment of dragoons, and when his daughter Emilie married Colonel Meunier it was the Emperor who gave his blessing to the marriage—both he and the Empress signing the marriage contract. A year later, David's other daughter, Pauline, married Lieutenant-Colonel

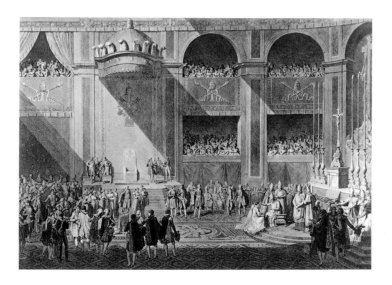

48. Delvaux. *The Anointing.* 1807. Engraving. Bibliothèque Nationale, Paris (Cabinet des Estampes)

Jeanin. David requested from Napoleon—and received—a sizeable advance against the fee that had been agreed upon for the *Coronation.* This emboldened him to lay claim to the position that had been held by the painter Le Brun under Louis XIV; he even drafted the articles of a bill that would have given him almost dictatorial authority over all matters related to the visual arts.

It is probable that David's request, and his con-

49. Malbeste. *The Distribution of the Eagle Standards.* 1807. Engraving. Bibliothèque Nationale, Paris (Cabinet des Estampes)

35

50. *Study of the Empress Josephine.* c. 1804. Black crayon, 7⅞ x 5⅞". Musée National du Château de Versailles

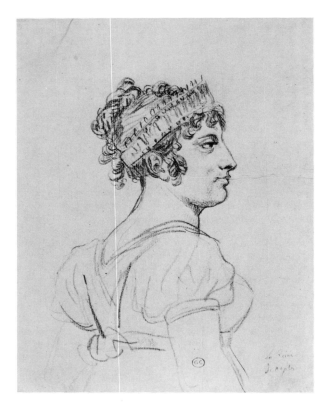

52. *Study of Caroline Bonaparte, Princess Murat, Queen of Naples.* c. 1805–07. Graphite with black chalk on ivory paper, 8⅝ x 6¾". The Art Institute of Chicago (Helen Regenstein Collection)

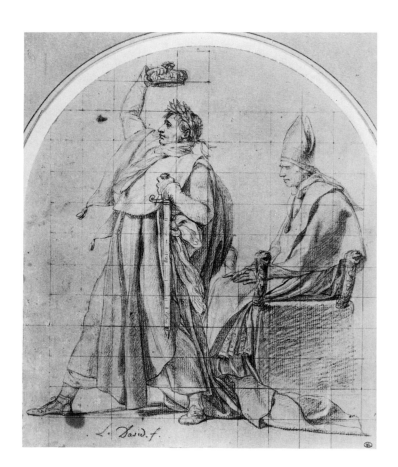

51. *Study of Napoleon Crowning Himself.* c. 1804. Black crayon, 11⅜ x 9⅞". Musée du Louvre, Paris (Cabinet des Dessins)

tinual demands for considerable sums for his paintings, offended the Emperor, who—while continuing to admire David as a painter and to feel a certain personal regard for him—became somewhat aloof. The Emperor agreed to additional advances of money, but for smaller amounts and, despite David's repeated requests, refused to accord him full satisfaction. The Grand Marshal of the Court, Duroc, wrote at the beginning of 1808 that David's demands were exaggerated, saying: "Let him work on his painting and he will have money."

David had already received 65,000 francs for the *Coronation;* he was asking for a total of 100,000 francs. Napoleon thought this a high price to pay for a work devoted just to the coronation ceremony. He presented David with the letters-patent of Chevalier of the Legion of Honor, a title which had been bestowed on him in 1803, but which was now made transferable; Napoleon also gave David a coat-of-arms. This, however, was as far as David would advance in the heraldic order. He would never receive another noble title—a sign, no doubt, of imperial disaffection.

The Enthronement and the Reception at the Hôtel de Ville were not painted "for political reasons," according to David. In actuality, times had changed, imperial legitimacy was supplanting the legitimacy of the people's elected representatives and of the official

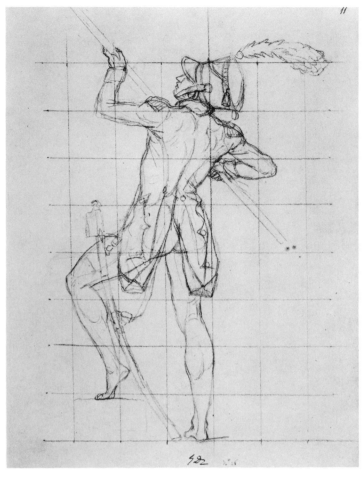

53. *Study for "The Distribution of the Eagle Standards."* c. 1805–07. Black chalk on ivory paper, 9½ x 7½". The Art Institute of Chicago (Helen Regenstein Collection)

54. *The Empress Josephine, Study for "The Distribution of the Eagle Standards."* c. 1805–07. Black chalk on ivory paper, 9½ x 7½". The Art Institute of Chicago (Helen Regenstein Collection)

bodies, and both these paintings had as their subject the legitimacy conferred by the people. David would complete only *The Distribution of the Eagle Standards* (see colorplate 30), painted between 1808 and 1810; moreover, he had to remove Josephine—whom Napoleon had divorced in the interim—from his canvas. This lyrical oath of the soldiers pledging their lives to serving their country and their Emperor and to making the eagles on their flags (that is, their standards) fly as they moved from victory to victory, concluded the series of large imperial commissions.

Decline of Imperial Favor and Aesthetic Eclipse
The end of this series also coincided with the zenith of the Empire. The Empire's trials were about to begin, as were those of David.

As First Painter to the Emperor he had not received a regular salary. He also found it difficult to collect the payments for his larger commissions. One should not be misled by the sums he demanded for his paintings: the expenses incurred in executing his grand canvases were enormous and his profit was relatively small.

In 1809 David showed an annual income of 9,000 francs—an amount which, in today's terms, would correspond to the salary of an upper-level executive in a medium-size business. He and his wife lived simply. David had never had a fortune and the Revolution had seriously reduced that of his wife, but the financial return from the exhibition of *The Sabine Women* had made it possible for him to buy a farm with an annual income of 6,000 francs.

In February 1810 he was finally given a salary of 12,000 francs as First Painter, "to cover emoluments as well as lodging," which considerably increased his income. He was to receive, however, no further favors from the Emperor.

More vexingly, David had not been awarded the Direction Suprême des Arts, a position which—for all practical purposes—he had held under the Convention until the fall of Robespierre. His election to various Institutes abroad, such as the Royal Institute of

37

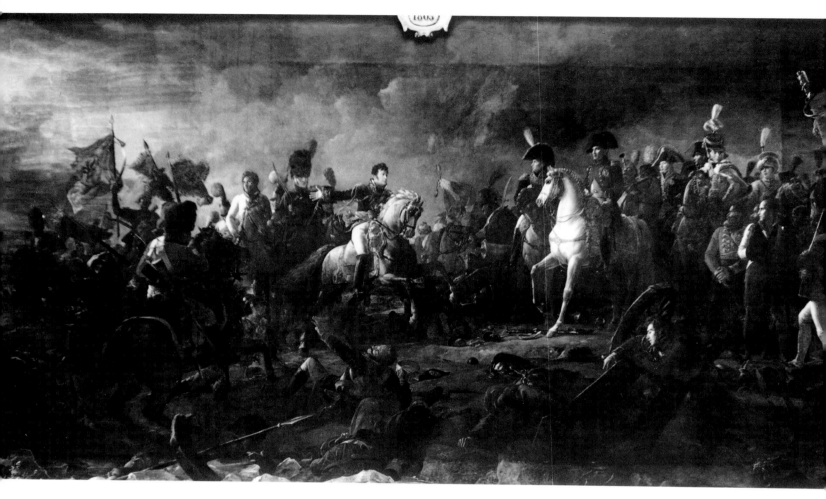

55. François Gérard. *The Battle of Austerlitz.* 1805. Oil on canvas, 16′8¾″ x 31′5⅛″. Musée National du Château de Versailles

Holland and the Academies in Munich, Florence, Rome, and Vienna, as an associate or foreign member, did not compensate for these other setbacks. He had suffered an even greater affront when Denon, Directeur Général des Musées, commissioning twelve paintings to celebrate the Emperor's victories, deliberately eliminated David from the selection.

David was beginning to quarrel with other artists. The man who had once fought the Academies was now seen as the Leader of a School. He had reformed French painting and introduced the public to new tastes. But his hegemony was feared and his ambition did him a disservice with his peers. There is no question that those artists who had access to Napoleon, or to Napoleon's closest aides, worked to intensify the Emperor's irritation with David.

Moreover, new tastes had begun to make themselves felt: the Greeks and Romans were somewhat less in favor; modern spectacles and paintings of battle scenes, with details provided by contemporary history, were gaining in interest. Above all, subjects taken from the history of France, or from mysterious legends, were becoming more popular—it was the dawn of Romanticism.

Renewed Interest in Individuals

David began to take more interest in his studio than he had in the past. He had a great many students, of different backgrounds, origins, and nationalities. Several of them were already famous and others would become famous in the future: Ingres, Fabre, Girodet, Gérard, Gros, Drölling, Isabey, Granet, and his namesake, David d'Angers who, unlike the others, would become a sculptor. David's students were his disciples. He trained them with as much care and respect for their individual personalities as ever. They returned his affection in full measure. David was truly a Master, in the classical sense of the word.

He had not ceased to paint for private clients and to play a certain role as a decorator and designer of furniture, but until the completion of the *Coronation* David saw himself as an artist in the Emperor's ser-

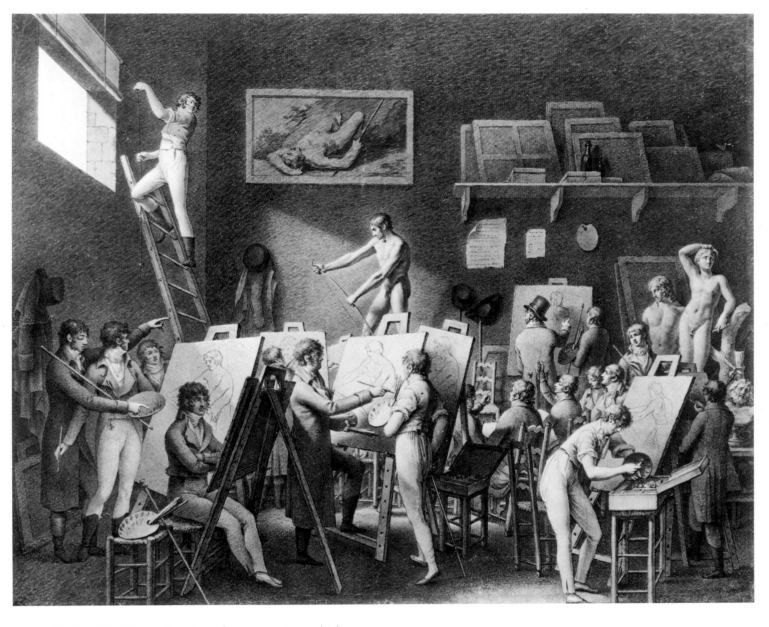

56. Jean-Henri Cless. *David's Studio*. c. 1810. Pen and ink with wash, 18⅛ x 22⅞". Musée Carnavalet, Paris

vice. In 1809 he began to take certain liberties with this notion of imperial service. He painted *Sappho and Phaon* in 1809 for a Russian aristocrat, Prince Youssoupoff. In the years that followed, he painted several other mythological subjects and many excellent portraits, including those of *Countess Daru* (see colorplate 31), *Count Français de Nantes* (see colorplate 32), Count Estève, his own daughters and sons-in-law, General Meunier, General Jeanin, and *Madame David*, his wife (see colorplate 35). He also undertook another self-portrait, as well as a painting of his old friends, *Monsieur and Madame Mongez* (see colorplate 34).

Sacrifice of Leonidas and the Fall of the Empire
Once again David returned, as he had during other periods of his life when shaken in his convictions and attachments, to plans for history paintings. He decided to begin work again on his painting of *Leonidas at Thermopylae*, which he had abandoned nine years earlier to devote himself entirely to the fortunes of the future Emperor.

In 1812 he painted a full-length portrait of *Napoleon in His Study* (see colorplate 33), but this was at the request of a British noble, Lord Douglas, who had approached David in 1810. When the Emperor saw the painting later, he paid David a somewhat cool compliment.

David did not complete *Leonidas at Thermopylae* (see colorplate 36), until 1814, after having added several personages to the original work. The real reason he returned to this canvas is that the subject

seemed to him (as it had in 1799) to have particular relevance to France's situation. Thus did Napoleon's uneasy admirer, whose son Eugène almost perished in 1813 during the German campaign, feel compelled to come to the defense of his country and of the Empire, which was being threatened on every side. In this painting—which of all David's works is the most Greek in its inspiration, both because of its subject and its utter simplicity—David applied himself to depicting the beauty and generosity of sacrifice.

The return of the Bourbons in 1814 disquieted David, but he thought he would be protected by the international character of his reputation. With the exception of Czar Alexander, the allied sovereigns had come to visit him in his studio. To Prince Youssoupoff, who had commissioned *Sappho and Phaon*, he wrote: "Your great Emperor has made himself adored and my happiness would have been complete if he had honored me with His August Presence." David thought it prudent not to send anything to the Salon and he contented himself with exhibiting *Leonidas* in his studio. This exhibit, of course, was tremendously successful with all those who came to view a work glorifying the ideas and moral qualities to which they subscribed. David wrote to one of his friends: "Everyone agrees that this is my best work. I have heard this so often that, despite my tendency to spurn praise, I am forced to believe it."

Napoleon returned from the Island of Elba on March 20, 1815. He wrote to his Minister of the Interior that he intended to reinstate David in his functions as First Painter, which had naturally ceased under the Bourbons. At the beginning of April he visited David's studio on the Place de la Sorbonne. This time, however, Napoleon did not reproach him for painting defeated heroes. He elevated David to the rank of Commander of the Legion of Honor. He gave one of David's sons a prefecture; to the other he gave the command of a squadron. David's sons-in-law were reinstated as generals.

Once again, moved and grateful, David embarked on a path that was imprudent and would prove harmful to his own best interests. In May he signed the *Acte additionnel* to the Constitutions of the Empire, which, in theory, would have made the Empire a semi-liberal regime. The following month, the Empire collapsed. On June 19th, however, the day after Waterloo, David applied for some back pay due on his salary as First Painter—but perhaps he had not yet received word of the defeat. Several days later he received the amount requested.

57. Jean-Auguste-Dominique Ingres. *Grande Odalisque*. 1814.
Oil on canvas, 35¼ x 63¾". Musée du Louvre, Paris

40

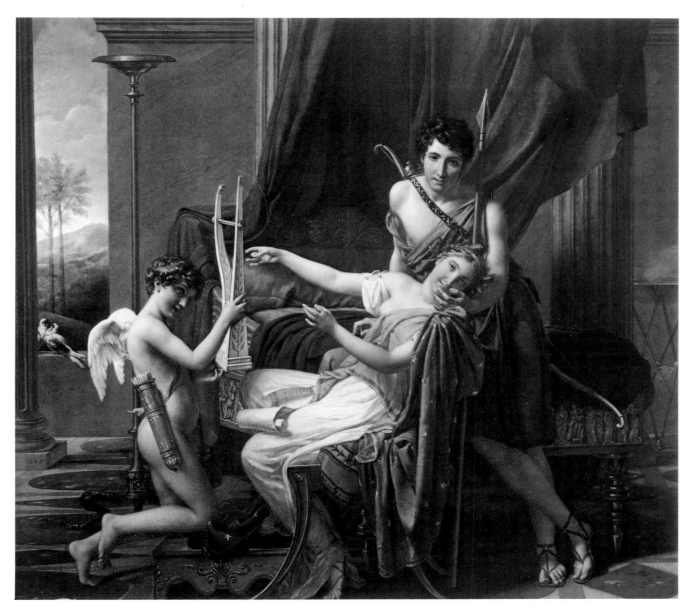

58. *Sappho and Phaon*. 1809. Oil on canvas, 87⅜ x 102⅜".
The Hermitage, Leningrad

Wandering and Exile

This time, however, David was seriously troubled. He applied for a passport for England, and another for Switzerland. He shipped *The Death of Socrates* and *The Distribution of the Eagle Standards*—which he was forced to cut into three separate pieces because of its size—to a safe place. He set off in the direction of Switzerland, stopped briefly in Besançon, made a tour of Lake Geneva, visited the Valley of Chamonix, and then, learning that he would not be banished, decided to return to Paris. He seemed to have been wandering, rather than fleeing. Back in Paris at the end of August, he began to work again: he painted the portrait of one of his friends, Alexandre Lenoir.

Up to this point he had not really been under attack, but the political atmosphere was fast deteriorat-

ing for him, as well as for others. On August 24th, the *Chambre introuvable* (the Chamber of the Incomparables) was elected; it contained a majority of ultra-royalist deputies, that is, those who were more royalist in their convictions than the King. Despite the wishes of the King and his Prime Minister, the Duke de Richelieu, on January 12, 1816 the Chamber enacted a law denying amnesty to the *régicides* who had signed the *Acte additionnel* to the Constitutions of the Empire. These *régicides* were to be banished forever and were given one month to leave France.

David greeted this news with dignity and courage. He was sixty-seven years old. He had served the Revolution and then the Emperor with enthusiasm. Remaining faithful to his political ideals, David rejected the favors of the King, who was willing to exempt

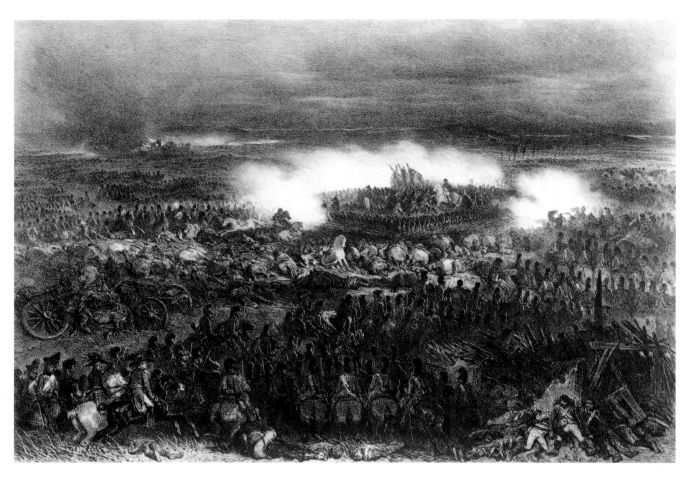

59. Raffet. *The Retreat of Napoleon at Waterloo, June 18, 1815.* 1829. Engraving. Bibliothèque Nationale, Paris (Cabinet des Estampes)

him from this law. In the twilight of his life, David, who could often have been accused of political inconsistency and adulation of power, made the courageous decision to reject compromise. He thereby gave the crowning touch to that revolutionary sincerity—somewhat eclipsed during the Empire—to which he had never ceased to bear witness in his art.

First he thought about going to Rome. Pius VII was consulted, but he yielded to the Allies, who barred the painter from living in Italy or Switzerland. David was then informed that the King of the Low Countries would be happy to welcome him.

Brussels and the Final Period

David arrived in Brussels on January 27th with his wife. He was pleased with his new home and did not display the slightest trace of bitterness. Yet he already found himself to be the butt of mean and petty actions. An attempt was made to take away the paintings that remained in his Paris studio, and he was under surveillance in Brussels. His friends and pupils sent a petition to the Minister of Police to obtain David's return to Paris; the names Gros, Gérard, Giro-

det, Isabey, and David d'Angers were among the many signatures. The petition fell on deaf ears. His name was removed from the Academy's registers and replaced by the name of one of his former adversaries, Guérin.

The King of Prussia proposed, on more than one occasion, that David settle in Berlin to work on "the establishment of a new Museum and the advancement of studies in all the branches of the arts and drawing." As a persuasive gesture, he sent his brother to try to sway David. But David refused: "I do not want to use my brush to recall the reverses and misfortunes of my country," he wrote to a friend. There is no reason to doubt his sincerity.

At the same time, he turned down a strange offer from the Duke of Wellington to paint the latter's portrait. "I have not waited seventy years to defile my brush. I would rather cut off my hand than paint an Englishman," he wrote to the person who had transmitted the offer. Moreover, he liked Brussels, where local artists and his former Belgian students gave frequent parties in his honor. He wrote to the Governor of Brussels that he intended to settle in that city per-

manently, and he then proposed entering the service of the King of the Low Countries.

From the King he even solicited the title and functions he had been offered in Berlin, that of "Director General of the arts and institutions related to the study of drawing and painting." His old dream of directing the arts had no doubt never totally deserted him, but he had become wiser—he did not ask for money; he merely observed that he would need "lodgings and some adjoining studios." Nothing came of it, however, and in the end David consoled himself very well with his situation.

He was increasingly content in Brussels; he wrote to Gros: "I have never been happier; my wife shares my happiness and it is thereby increased. . . . I work as if I were thirty years old; I love my art as I loved it at sixteen and I will die, my friend, holding my brush."

Joys and Profits of Artistic Activity
David now became fairly rich. He sold his paintings at high prices and received substantial royalties for the

60. *The Vicomtesse Vilain XIIII and Her Daughter.* 1816. Oil on canvas, 37⅜ x 29⅞". Private Collection

engravings made after them. His wife had a good head for business and their investments were profitable. In 1822 they had 140,000 francs in liquid assets, not counting the farm David had purchased with the proceeds from the exhibition of *The Sabine Women,* and an apartment house in Paris. Life in Brussels was simple and satisfying. David went to the theater, to cafés, socialized with other artists, drew, and above all, painted continually.

In 1816 he painted the portraits of *General Gérard* (see colorplate 37), of the *Count de Turenne* (see colorplate 38), of the Prince de Gâvre, and of the *Countess Vilain XIIII with her Daughter.* In 1817 he painted *Cupid and Psyche* (see colorplate 39), which he exhibited at the Royal Museum of Brussels for the benefit of the Établissements de bienfaisance (charitable institutions).

In this charming picture, youth and grace smile at us, as in his earlier paintings, in the personifications of these two young creatures whose nudity is both chaste and exuberant. The painting was a great success. David painted a pendant to it, *Telemachus and Eucharis,* treating the subject with equal youthful felicity. He exhibited it in Ghent in 1818 for the benefit of the unemployed workers in that city, and then in Brussels.

In 1817 he had also painted the portrait of Sieyès, another *régicide* exiled in Brussels. He agreed to paint the portrait of Madame de Staël, but the commission was given to Gérard instead.

Louis XVIII, far from desiring vengeance, was ready to give David permission to return to Paris at any time, but the King could not, or would not, initiate a general amnesty, which would have required the consent of the *Chambre introuvable,* and would have had profound political repercussions. The King of France's peace of mind was evidently of more concern to Louis XVIII than the fate of painting or painters. He did make certain gestures, however, that amounted to overtures. He restored David's son, Eugène, to his rank in the Legion of Honor. He purchased *The Sabine Women* and *Leonidas at Thermopylae* for the Royal Collections, or at the very least, he consented to the acquisition of the two paintings, which had been initiated by Forbin, the Directeur des Musées and a former pupil of David's.

By degrees, David became convinced of the sincerity of the King's offer. Forewarned, however, by the difficulties he had experienced with Napoleon, he negotiated cautiously. He received bids for his works from the King of the Low Countries and the King of Bavaria, but he rejected them, saving his paintings for France. The contract for the two paintings was finally concluded in November 1819: *The Sabine Women* and *Leonidas at Thermopylae* were bought by the Crown for 100,000 francs, in other words, for the same sum David had received for the paintings of the

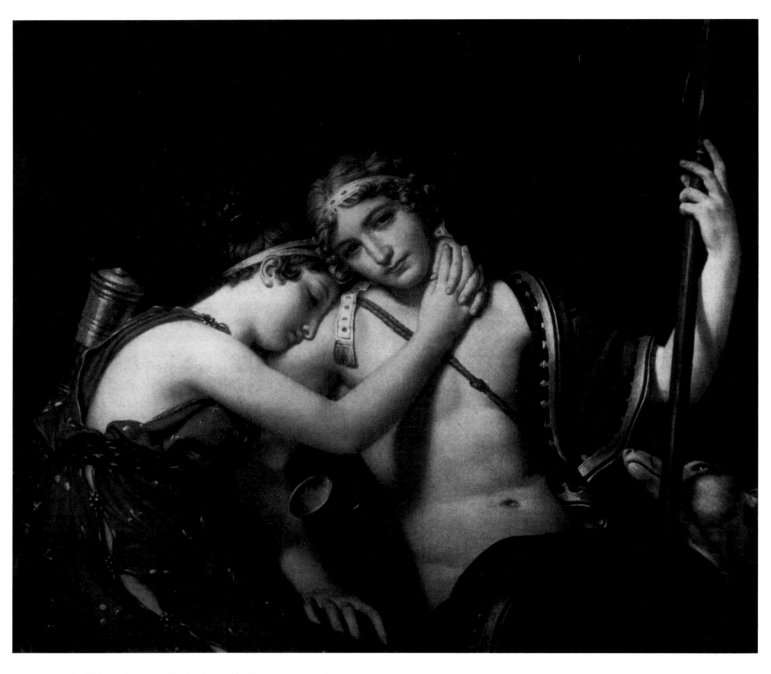

61. *Telemachus and Eucharis*. 1818. Oil on canvas, 35⅜ x
41⅜″. Private Collection

Coronation and the *Eagles*. Moreover, he reserved to himself the engraving rights, which were very lucrative at the time—in this particular case estimated to have been worth some 60,000 francs. The paintings themselves were moved to the Galerie du Luxembourg and were once again put on display for the public, whose response to both paintings was as enthusiastic as it had been when they were first exhibited.

David could have returned to Paris. The authorities consented, his friends insisted, his pupils entreated him. Instances of particular exiles receiving special favors were increasing. But David rejected anything that resembled a pardon. It would have come from the Bourbons and he saw himself guilty of nothing. He

wrote to his old friend, Mongez, who had been asked by Louis XVIII to use his influence to persuade David to agree to return to Paris: "I was exiled by a law. I shall return only by a law."

Last Works: Realism and Gallant Mythology

David now painted for pleasure as well as by profession. The portraits of Ramel de Nogaret, a former member of the Convention, and his wife, as well as those of Juliette de Villeneuve, of Joseph Bonaparte's daughters, and of Baron Alquier date from this period. He also painted another portrait of his wife, the good-hearted and devoted Charlotte whom he now adored, as well as portraits of his grandson, Charles Jeanin, of *The Actor Wolff,* and of Mademoiselle Philippont (a dancer and the mistress of the Crown Prince of the Low Countries).

In 1822, Stendhal wrote in an article on the painter: "His misfortunes do not seem to have defeated his strength of character which in the past enabled him to fight against and triumph over bad taste."

Despite his own activity as a portraitist, David advised Gros, his former pupil who had become, as it were, his representative in Paris, to work ardently and painstakingly on history paintings. For his part, David chose mythological subjects more in tune with his mature imagination, and less dangerous as pictorial themes.

In a way, he was returning to the aspirations of his youth, as if the subjects taken from the real or legendary histories of Rome and Greece could only have been painted during an exalted state such as he had known under the Republic and the Empire. The *Horatii* ushered in the Revolution; *Leonidas* brought the Empire to a close. Almost unconsciously, David reverted to the types of subjects formerly proposed by the Academy. In reality, he had rebelled not against the subjects themselves but, rather, against the treatment that had been suggested for them.

His style asserted itself and his return to mythology was accomplished through the affirmation of the mature painter's principles. In 1819 David painted his "third history painting in Brussels," *The Wrath of Achilles,* which followed as a sequel to *Cupid and Psyche* and *Telemachus and Eucharis.* Once again, David was pleased with his work and so was the public.

Final Coda: Mars and Venus

In 1822 David began to work on a fourth "history painting," which he completed the year before his death. It was *Mars Disarmed by Venus and the Three Graces* (see colorplate 40). That, at his age, the old Master could produce such a youthful, exquisite work was against all odds; even more surprising, the painting was an apotheosis of feminine grace and nudity. Dancers posed for the Graces; Venus and her female

62. *Zénaïde and Charlotte Bonaparte.* 1821. Oil on canvas, 50¾ x 39¼". Musée d'Art et d'Archéologie de Toulon

companions may be counted among the most charming and successful examples of figure painting, even if the inspiration may seem somewhat academic. However, another influence, at first perhaps unexpected, can be felt in the painting—that of David's former pupil Ingres, whose *Jupiter and Thetis* shows some striking similarities to David's canvas.

The work had a measured success. Thiers, then a young journalist who had discovered Delacroix, wrote a cloying piece praising the work that sounded like a funeral oration. It was David's last important work; but, most important, it was the final embodiment of the enduring freshness of David's art. He himself had said: "This is the last picture I want to paint, but I want to surpass myself in it. I will put the date of my seventy-five years on it and afterwards I will never again pick up my brush."

David's Illness and Death

In February 1824, on his way home from the theater, David was knocked down by a carriage. His violent

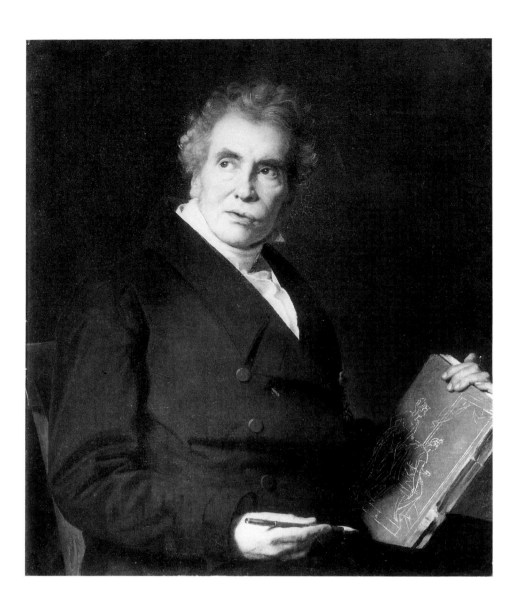

63. Jerome Martin Langlois.
Jacques-Louis David. 1825. Oil on
canvas, 31⅞ x 29⅝". Musée du
Louvre, Paris

fall resulted in internal injuries: an edema developed that would finally undermine his robust constitution. There was swelling, and he suffered from shortness of breath. Then his wife suffered a stroke in August and was taken back to Paris by their children. He was now alone. His wife and he were convalescing separately. They wrote to each other constantly, but he still refused to return to Paris, where his continued exile triggered a fresh outburst of emotion. It was remembered that the new King, Charles X, in the days when he was still Count d'Artois, had commissioned *Cupid and Psyche* from David. Madame Récamier and Madame de Genlis tried to intervene on David's behalf, but to no avail.

His children came to see him; his health seemed to improve and he wrote to his wife during the summer of 1825: "We will fix up our apartment which will be charming and worthy of the fuss made over both of us in society." Then he suffered a relapse. He had virtually ceased to paint. In November 1825 David declared to his friends: "I feel my imagination to be as vivid and as fresh as it was in the early years of

my youth, I compose with the same facility all the subjects which come to mind: but when I pick up my pencils to sketch them on the canvas, my hand refuses."

The following month, he caught a chill while leaving the Théâtre de la Monnaie, where he had just seen *Tartuffe*. He scarcely recognized two of his children who had come to sit by his bed. In a last lucid moment, he advised the engraver of *Leonidas*: "Be careful principally to avoid what I will call 'small execution.'...Do you know that there was no one but David who could have painted Leonidas?"

He died at his home in Brussels on December 29, 1825. He was seventy-seven years old. One of his relatives recounted his last moments as follows: "He preserved in the last days of his life the fullest consciousness and the greatest courage. He spoke of his approaching end with calm and resignation; however, he would fall from time to time into a deep torpor....He died dreaming of the art he made illustrious, thinking about it, speaking about it incessantly. One might say that the spirit of painting accompanied him to the threshold of the tomb."

COLORPLATES

ANTIOCHUS AND STRATONICE

Oil on canvas, 47¼ × 53⅛"
Paris, 1774
Unsigned
École des Beaux-Arts, Paris

At long last, success. This painting won David the Academy's first prize in 1774. The subject this time was also taken from ancient history. Erasistratus had been a Greek doctor and anatomist, the first man known to have dissected the human body. He was undoubtedly one of the fathers of modern medicine. Legend has it that he cured Antiochus, the son of Seleucus, King of Syria. This prince was afflicted with a malady that was causing him to waste away, and appeared to be incurable. Only Erasistratus was able to uncover the cause: Antiochus was dying of love for his young stepmother, Stratonice. Erasistratus persuaded the old king to give his young wife to his son, who then fully recovered.

It is interesting to compare this picture to *The Death of Seneca,* painted by David only one year earlier, to see how far he had advanced in so short a time.

There are only nine figures in this painting, whereas there had been fourteen in *The Death of Seneca.* The composition here is not marred by the extravagant contrasts in the earlier painting; it is linear, rather than angular. The space between the two main groups of characters is uncluttered and the groups are distinct from one another. On the left, Erasistratus is seated while Antiochus lies in bed; on the right, Stratonice is standing and Seleucus is leaning forward. In between, we have the elegant lines of Antiochus and his sickbed. The arrangement of the confidants and servants is discreet and appropriate to the occasion. The atmosphere is calm and noble—perhaps even a trifle too much so.

The magnificent ornamentation, the architecture worthy of an imperial palace, the majesty of the different personages—the composition as a whole has the air of a great spectacle, although one would be hard-pressed to identify the genre to which it belongs. It is not tragedy; it is not comedy; it is not opera, nor is it ballet. It is not a real illness or a real cure, but it is, all the same, a magnificent representation.

In this canvas, the painting—although still kept within the limits established by the Academy—is beginning to reflect a freer approach; David is beginning to find his way. Skillful and polished, this painting already displays the brilliance of a coloring that is starting to come to life. The colors David would always favor—white, blue, yellow, red, flesh and gold tones, gray and brown—are arranged with grace and suppleness as they softly ascend toward the red of Erasistratus's robe, the softer tone of the king's toga, and the indigo blue of the large drapery hanging from the ceiling. The drawing is firm but gentle: the body of Antiochus is superbly fresh, Erasistratus's head is vigorously rendered and Stratonice's face has a very pleasing delicacy. The lighting, however, is still arbitrary, and the architecture quite heavy and unbalanced.

Most vitally, this painting still lacks vigor and compactness. These qualities would not appear until later, after David had assimilated the true lessons of the Antiquity that here is still draped, decorated, and arranged in the affected manner of his age.

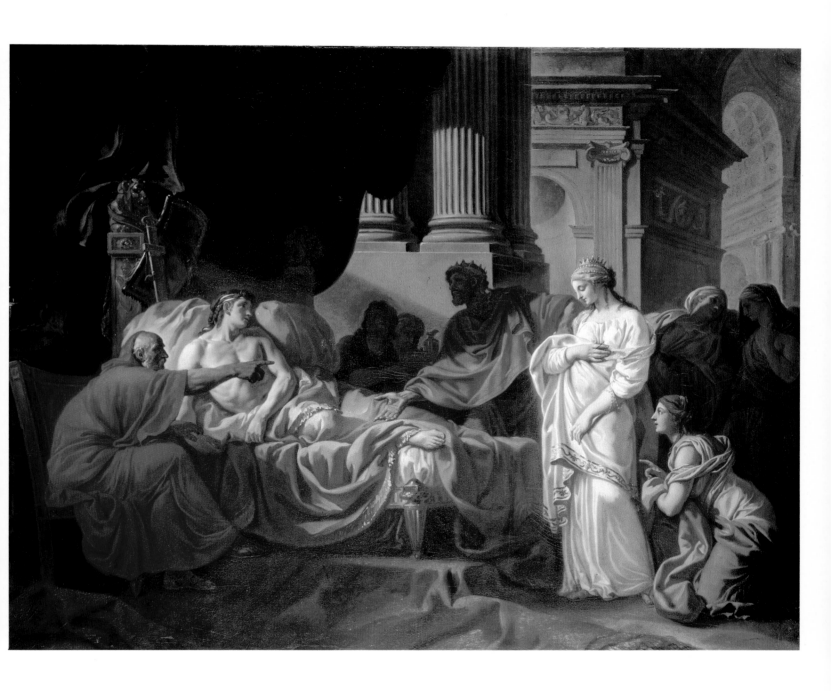

THE FUNERAL OF PATROCLUS

Oil on canvas, 37 × 85⅞"
Rome, 1778–79
Signed: J. L. David f. roma 1779
National Gallery of Ireland, Dublin

Shortly after David's arrival in Rome, the boarding students at the Académie de France were once again required to send an annual submission to the Academy so that their progress could be assessed.

Greece was beginning to be in vogue. For his first submission in 1776, David had chosen a Homeric subject, the combat of Diomedes, one of the leading heroes of the Trojan War. In 1777, he began to work on his submission for the following year, which would be another Homeric subject, the Funeral of Patroclus.

Patroclus was a brother-in-arms of Achilles. Wounded before the walls of Troy, Patroclus was killed by Hector. To avenge his friend, Achilles then killed Hector. Finally, Achilles gave Patroclus a solemn funeral described in detail in a long passage in the *Iliad*.

From Homer's account, David borrowed the site and the characters—the Trojan plain, the Greek vessels anchored by the shore, the tents in Agamemnon's camp, the disorderly procession of chariots and warriors on the left of the painting, the bearers of offerings on the right.

In the center of the painting, on a stone platform covered by a ceremonial rug, stands the light-splashed bier, like an altar at the foot of the funeral pyre. The shaft of light pierces the center of the picture to join, at an angle, with the oblique parallel lines of the composition. Achilles with his plumed helmet leans over the body of his friend, Patroclus; on the right, Hector's nude body is tied to a chariot drawn by rearing horses. On the left, a priest slays a Trojan, while servants hoist onto the pyre the body of another Trojan, already slain.

This is a transitional work. We can feel that David is still seeking his own style. He has put together a baroque configuration with nervous, agitated forms, but he has introduced into the scene the simplicity of the shaft of light that directs our eyes to the pyre, as well as an axial tension that gives the whole painting a sort of rearing movement.

Of Homer's narrative, David has preserved the spirit of grandeur, rather than the spirit of vengeance. He seeks this grandeur in the perfection of the attitudes and the stark simplicity of the nudes. With the impetuosity of youth, he finds it in the lyricism of a sketch that owes its success to the exceptionally iridescent light, to the magically flickering strokes of color, to the poetic nostalgia of an atmosphere that seems to embrace the duration of an entire day as well as all of memory itself, from the dawning light on the left to the dusky shadows on the right.

David exhibited his sketch in Rome in 1778; he then touched it up and signed it in 1779. He exhibited it in Paris at the Salon of 1781. In its report, the Academy noted that this sketch gave promise of "a prolific genius." "We think," said the judges, "that he would need to temper it and to tighten it in some way to give it more energy." David did not waste any time following this advice, only expressing regret that his painted sketch still showed "certain French traces" instead of giving full rein to his taste for the Antique.

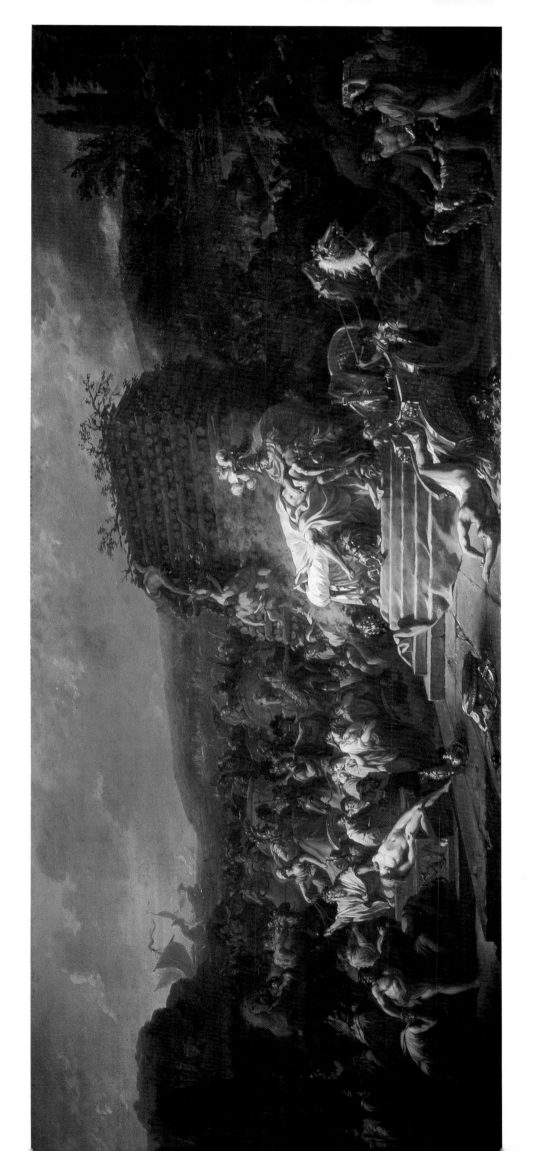

SAINT ROCH

Oil on canvas, 8'6³/₈" × 6'4³/₄"
Rome, 1780
Signed: L. David faciebat Romae. 1780.
Musée des Beaux-Arts, Marseille

Saint Roch was one of David's few religious paintings, together with a *Christ on the Cross* painted in 1782 for the Maréchale de Noailles, that was recently recovered in the Cathedral of Mâcon. Most important, it was David's first major painting.

Saint Roch, who was born and who died in Montpellier at the beginning of the fourteenth century, devoted himself to the care of the sick, especially those stricken by the plague. He was depicted in paintings as a pilgrim carrying a staff and accompanied by a dog.

The plague had totally devastated Marseilles in 1720 and the City Health Office, fearing a resurgence, wished to implore the aid of Saint Roch. Thus, in the autumn of 1779, this office had asked the Académie de France in Rome for a painting, to be done by one of its students, showing Saint Roch interceding on behalf of the plague-stricken.

Vien selected David, who eagerly set to work on this commission, which offered him some relief from the febrile state triggered by his new passion for the Antique. However, inspiration was somewhat lacking and he had to call upon all the resources of his pictorial background, as well as his particular skills as a portraitist.

First of all, there are two admirable faces in this painting that are moving because of the piety and suffering they show—the face of the kneeling saint and that of the plague victim lying at his feet. Their attitudes, however, were taken from works of several predecessors, and there are echoes of Poussin, and the Bolognese School of the seventeenth century, as well as of Raphael and Michelangelo in this painting.

Moreover, the upward thrust of the composition creates a feeling of movement that calls to mind Caravaggio's geometric and dynamic structures. The supple horizontal lines pull away from each other, floating upward in this atmosphere of grief. The short diagonals of the arms and legs of the figures form a crisscross pattern that also pulls the composition upward. The figure of Saint Roch seems to be extended along a forceful diagonal line and, together with the Madonna and Child sitting on their boulder, forms the highest point of this ascent of grief and prayer toward grace and hope; the last step is formed by the saint's forearms, raised in a gesture of supplication, almost meeting the protective downward tilt of the Virgin's arm.

Through the interplay of smoky colors brightened by white touches on the disordered jumble of plague victims' bodies, the more intense, although still somber, tones of the saint's costume, and the strong tones of his face and arms, the colors also seem to ascend, as they move upward toward the bright, clear tones of the Virgin and Child, around whom a tender copper light glows like a nimbus.

This painting was much admired in Rome. David was compared to Michelangelo. Vien sent word to Paris that his student had painted a picture worthy of the great masters: "The expression on the face of one of the stricken is so deeply felt that it is difficult to bear his gaze," he wrote to d'Angiviller.

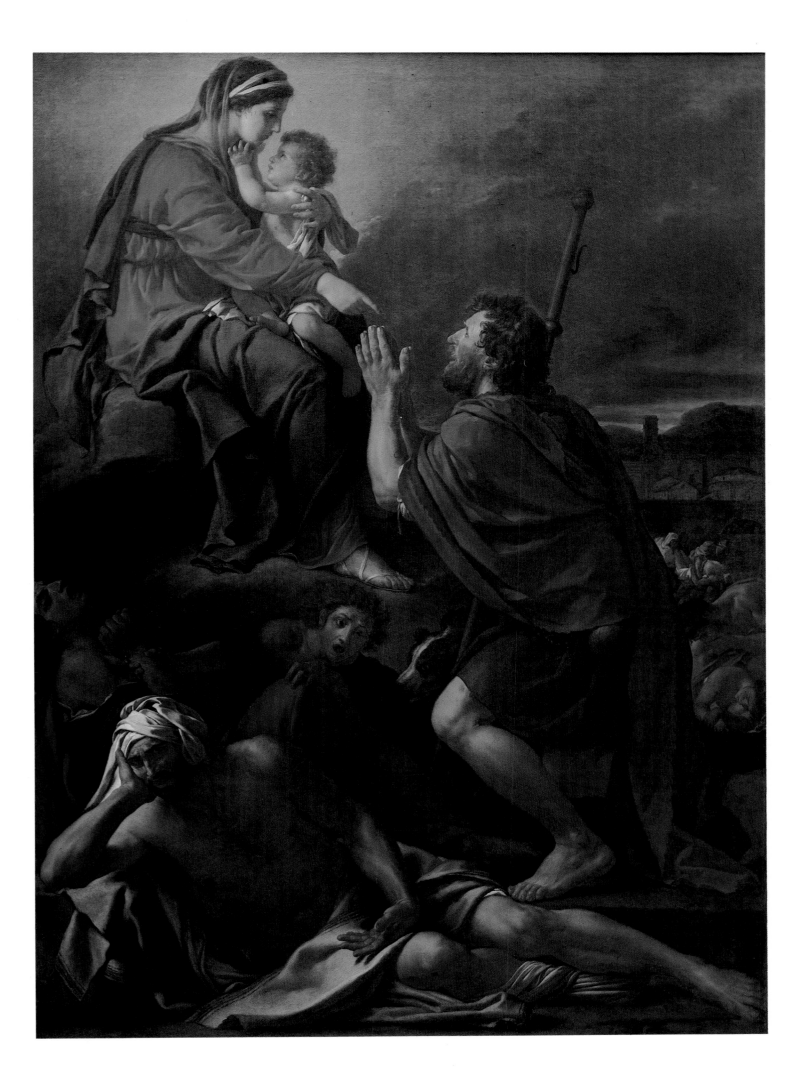

COUNT POTOCKI

Oil on canvas, 9'11⅝" × 7'1⅞"
Rome/Paris, 1780–81
Signed: L. David 1781
Muzeum Narodowc, Warsaw

Count Stanislas Potocki (1757–1821) was the perfect example of an aristocrat typical of the Age of Enlightenment. The rich heir of one of Poland's most illustrious families, an art lover, and an admirer of Winckelmann, whose works he translated into Polish, he traveled through Italy to broaden his education, develop his tastes, and prepare himself for the role of statesman. This was a role he was in fact to play under Napoleon, as Minister and President of the Senate in the new Polish kingdom established by the Emperor.

This painting, sketched in Rome during the early part of 1780, and completed upon David's return to Paris that same year, is an excellent illustration of the artist's versatile and sensitive temperament. David had always been drawn to the art of portraiture; he had already painted nearly all of the members of his own family. Now, for the first time, he was undertaking a work that was simultaneously realistic and heroic, as if seeking to open the way for a new genre between history painting—considered a superior genre—and portrait painting. This new genre would be the history portrait.

David had discovered the works of Antiquity and studied the masters. He had begun to refine his tastes: he now rejected that which was soft, overly graceful, picturesque, or artificial, and began to extol "nature idealized"—clean colors, sharp outlines, and noble compositions.

This painting, the work of a young painter whose subject is another young man in the full bloom of youth, is bursting with life. The tones are silky and velvety, the contrasts fresh, the yellows and blues vivid, the interplay of colors brilliant. The model seems larger than life, as does the entire composition—a sort of magnificent prelude to the journey through life upon which the hero is about to embark.

The compositional contrast between stark simplicity and stateliness is embodied in the abstract setting where the titanic proportions of the wall and columns evoke a certain sense of classical grandeur. At the same time, the presence of certain minor details, such as the wisps of straw, suggests the existence of a real manege.

In this portrait, the figure on horseback is rendered as a dominant motif, sufficient unto itself. Count Potocki is portrayed in informal dress, looking proud, gay, and exhilarated. The colors reflect the artist's energy and excitement: buckskin yellow, royal blue, a magnificent white, all brought together in a lighthearted and harmonious arrangement. David delights in adding boldly drawn details—little bows tied in the horse's tail and braided into its mane.

Certain details are meticulously painted, others added with a rapid stroke of the brush. Precision and freshness characterize the rider's face and clothing; his mount has been imbued with all the exuberance of youth. Bright tones, clean colors, and muted shades, like the wind, brass, and strings of an orchestra, sing to each other.

There is an electric quality in the painter's style, far removed from the frozen effigies that equestrian portraits so often seem to be. The high spirits of the horse and the authority of his rider stamp this painting as the work of a true virtuoso.

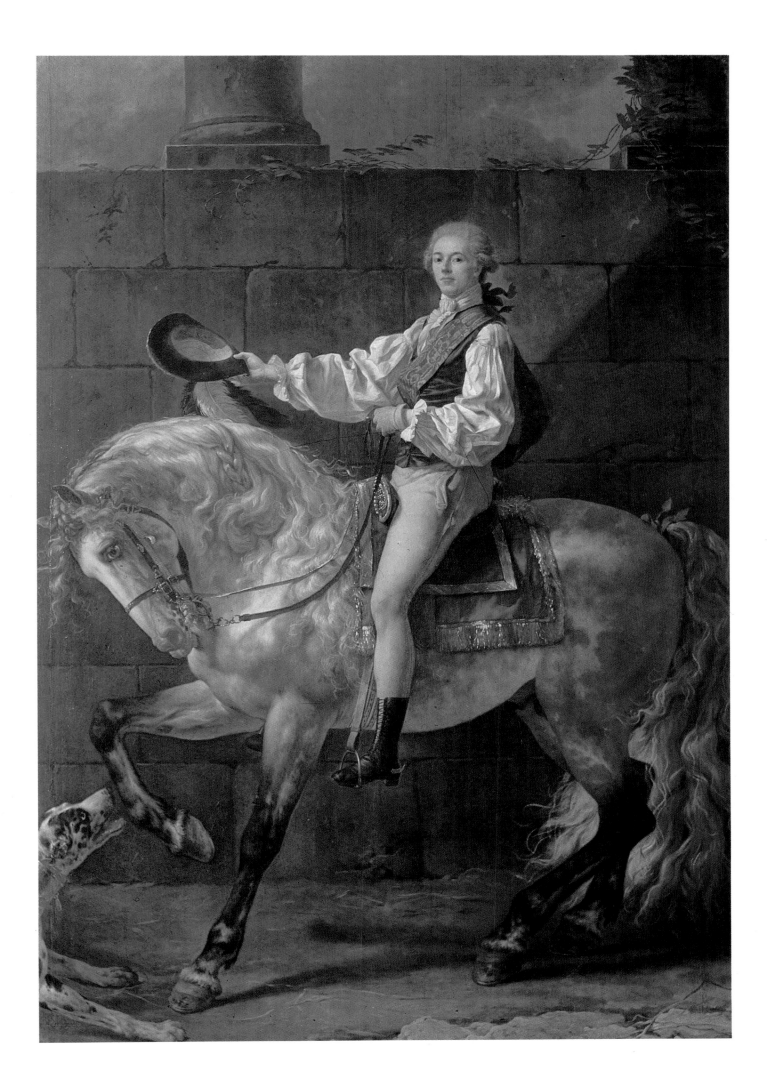

BELISARIUS

Oil on canvas, 9'5⅜" × 10'2⅞"
Paris, 1781
Signed: L. David faciebat anno 1781. Lutetiae
Musée des Beaux-Arts, Lille

David had just returned to Paris after his sojourn in Rome. He solicited the honor of being admitted to the Academy and participating in its annual exhibition with a history painting. The subject he chose belonged more to the sentimental genre of which his age was so fond than to the heroic genre. In this respect, both *Belisarius* and *Saint Roch* can be considered transitional works in David's career.

Belisarius, a general under Justinian, was one of the greatest military commanders of his time and the spearhead of Byzantium's attempts to rebuild the Roman Empire. His very successes, however, made him many enemies. Incriminated in a plot against Justinian, his eyes were put out on the Emperor's orders in 561 A.D. According to the historian Procopius, Belisarius, stripped of all his possessions, was reduced to begging in the streets of Byzantium.

In this painting, Belisarius is begging for alms at the foot of a monument redolent of military triumph. The structure opens out onto a classical landscape dotted with tiny figures and shrubs, which forms a painting within the painting—evoking Poussin's landscapes of the Roman countryside, but in a more geometric and architectural way.

This is a strong and sober work, centered around four expressive figures. Reticence and emotion emanate from the almost closed arc formed by these personages. The woman is restraining her emotion; the faces of the child and the old man are admirably disposed in a contrapuntal and harmonious relationship. Slightly tilted, one toward the right, the other toward the left, they seem to form two slopes, one in the light and the other in shadow. Their tresses are flowing and the old man's beard brushes against the child's curls. Beyond them, dumbstruck as he recognizes his former general in this beggar, a soldier throws up his arms. He stands there as erect as the colonnade, a ghost from the past.

The faces, which are very noble—those of the woman, the child, and the old man are particularly beautiful—personify different spiritual aspects of grandeur. The woman embodies delicacy, solicitude, and pity. The face of Belisarius exposes his suffering, which has been exacerbated by humiliation. Hennequin, David's young pupil, posed for the child's face, which is a cry of youth and entreaty.

The somewhat muted colors originate, for the most part, in a natural harmony with the sorrowful solemnity of the scene. Following Vien's advice, David erased the woman's red cloak and made it more subdued. A powerful shaft of light pierces the painting, pushing that which evokes the past or is a painful reminder of it into shadow. The bright white of the child's clothing and the somber tone of the woman's cloak are highlighted in homage to the purity of these two figures, while the face of Belisarius seems to be enshrouded by a gray nimbus, and the soldier seems frozen in a shadowy vigil.

It was on the basis of this painting that David was unanimously "approved" by the Academy in 1781. *Belisarius* was an immediate success, although some criticized its somberness. Diderot wrote: "This young man shows the grand manner in the way he has carried out his work; he has soul, his heads have expression without affectation, his attitudes are noble and natural, he draws, he knows how to cast a drapery and paint beautiful folds. His color is beautiful without being brilliant."

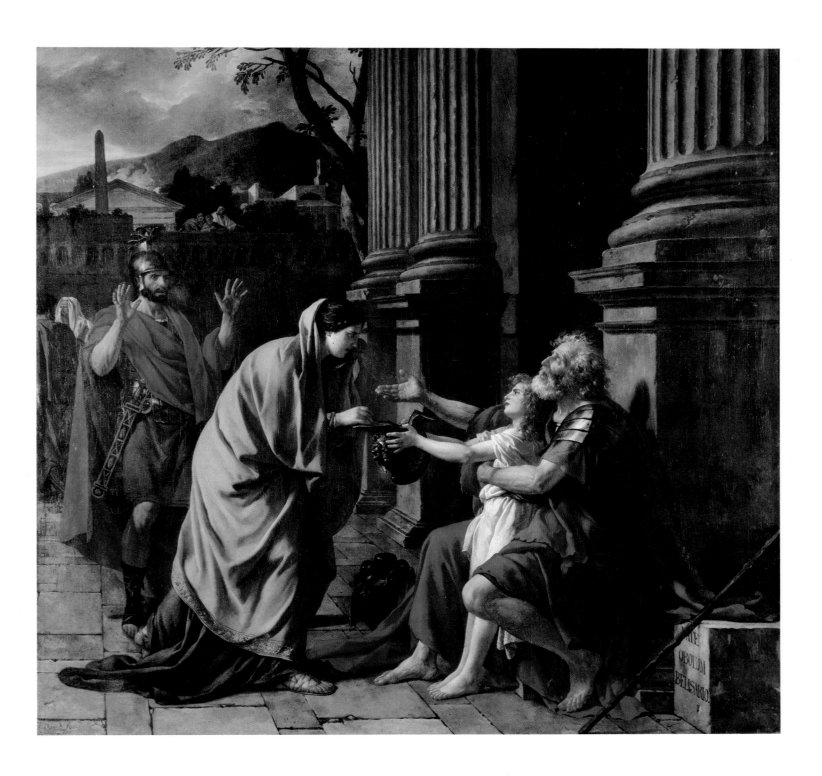

ALPHONSE LEROY

Oil on canvas, 28⅜ × 35⅞"
Paris, 1783
Unsigned
Musée Fabre, Montpellier, France

This portrait was shown by David at the 1783 Salon together with his painting of *Andromache Mourning Hector*. It escaped the particular attention of his contemporaries, who preferred historical compositions or portraits of famous people.

Alphonse Leroy was a well-known physician, an *accoucheur* whom David must have met when his first child was born in February 1783. The two men soon became friends.

This portrait poses several riddles. The left hand seems to be missing. It is difficult to imagine an *accoucheur* with only one hand. Should we suspect that a less skillful pupil had been unable to paint the hand, tucking it instead into the sleeve of the model's dressing gown? (It has been said that David entrusted the painting of fabrics and hands to one of his pupils, Jean-François Garneray.) Although the painting is unsigned, the fact that David entered it in the Salon shows the value he placed upon it. Whatever minor parts of the picture may have been undertaken by a pupil, under David's supervision, all of the essential elements were painted by David, and the general effect of this vigorous painting is discernibly in accordance with his intention.

The vital center of this painting reverberates in the Doctor's gaze—serious, questioning. Alphonse Leroy is at work, in his dressing gown. His arm rests on a treatise by Hippocrates; we have come upon him suddenly, startled him in the act of writing. David reveals his subject to us as always in his portraits: effacing himself, he allows Dr. Leroy to briefly and vividly assert his own personality. The composition is open and confident. The colors are warm and limited to a simple palette of blues, reds, and copper tones, with bright touches of white. The character of the doctor is portrayed with understanding and authority.

A practicing physician, Alphonse Leroy was also a scholar who would eventually wear himself out with work. He is writing by lamplight. His air of pensive application, which has something sorrowful about it, is admirably rendered: professional conscientiousness, intellectual curiosity, and scientific probity can be read in his face. When this portrait was painted, Dr. Leroy was almost fifty, living for his profession and his research. He gazes at us with the look of someone upon whom hard work—but not time—has left its mark. This doctor might belong to any period in history; he is a decent, dedicated man with a serious and determined mien that has something in common with David's own expression, as shown in certain self-portraits.

This may also explain the friendship that bound the two men, and David's decision to enter in the Salon the portrait of a man unknown to the general public, but who—in David's estimation—represented an admirable subject because he shared the painter's own lofty standards and virtues.

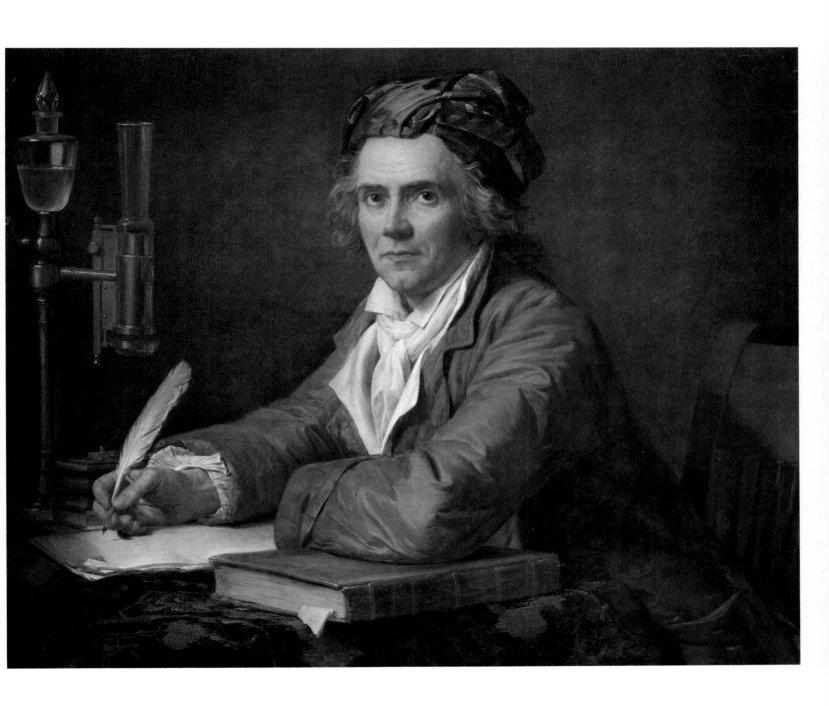

ANDROMACHE MOURNING HECTOR

Oil on canvas, 88⅝ × 80"
Paris, 1783
Signed: L. David 1783
Musée du Louvre, Paris
(on loan from École des Beaux-Arts)

This painting was executed in the interim separating *Belisarius* and *The Oath of the Horatii.* Andromache's history up to the death of her husband may be stated in just a few words: she was a faithful wife. Popular imagination had made her a symbol of wifely and maternal affection. Hector, the son of Priam, King of Troy, was able to defend Trojan independence for ten years before his defeat at the hands of Achilles, the Greek hero whose friend, Patroclus, Hector had killed. As a captive, Andromache had to fiercely defend her son by Hector. At the edge of the royal bed upon which the body of Hector lies, the worried faces of mother and son seem to be asking what fate has in store for them.

The general impression we receive is that David, moved by his discovery of the Antique, was torn by a painful, anguished notion of his own inadequacy as measured against the dazzling ideal that held him in its spell. But it is questionable whether the path David chose here was the best one. The composition, inspired in part by an ancient bas-relief of which he had seen a reproduction in a contemporary work, is glacial. The painting itself is basically divided into two vertical segments. The massive bed with its rectangular posts occupies the entire width of the canvas; the equally massive shafts of the columns stand erect on a rigid support to which a heavy drapery is carefully attached. Hector's torso is slightly elevated in relation to the bed; Andromache's body supports that of her child. The gigantic brazier, taken from a Piranesi engraving, rests on a trapezoidal pedestal. The furnishings, the helmet, and the sword were drawn from antique models.

The rumpled bed covering, the blanket thrown over the body, Andromache's voluminous gown and veil, as well as the child's oversized robe, all represent an attempt to inject something natural and lifelike into the painting, which is too coldly schematic. The Greek inscriptions on the brazier's pedestal look like a schoolboy's exercises. The general effect produced is that of a labored composition, despite the apparent simplicity.

There also seems to be a lack of space in this painting—the bed is pressed against the wall; the top part of the picture is heavy. David handled the transitions without subtlety. The colors are coppery and slightly muddy. Andromache's attitude is simultaneously theatrical and flat. Hector's torso is an example of noble and tragic beauty, but his face is too impersonal. These figures are, in fact, like classical statues whose bodies are more moving than their faces. Only the child is really touching. One point that deserves to be noted, however, is how superbly the draperies are done.

The Academy admired this painting, which seemed to comply with its standards, but criticisms were voiced about the work's monotonous coloring, its affected sensibility, and its coldness. Today, its flaws seem to outweigh its merits.

In *Andromache Mourning Hector,* David tried to endow a simple theme with too much meaning and thus fell into the trap of false solemnity, of false piety. A distant echo of the agitation brought on by his new artistic passions, this painting should be viewed as an exercise—that is, another step on David's path to self-discovery.

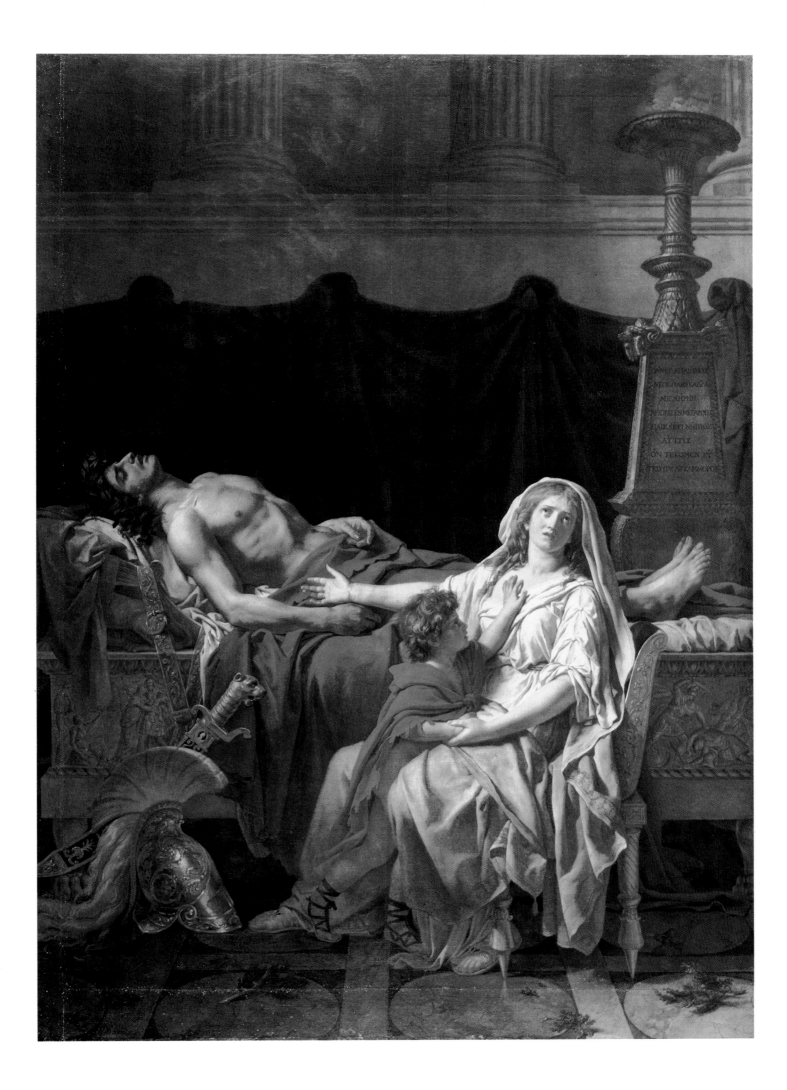

THE OATH OF THE HORATII

Oil on canvas, 10'9⅞" × 13'11¼"
Rome, 1784
Signed: L. David faciebat Romae Anno MDCCLXXXIV
Musée du Louvre, Paris

This painting occupies an extremely important place in the body of David's work and in the history of French painting. The story was taken from Titus-Livy. We are in the period of the wars between Rome and Alba, in 669 B.C. It has been decided that the dispute between the two cities must be settled by an unusual form of combat to be fought by two groups of three champions each. The two groups are the three Horatii brothers and the three Curiatii brothers. The drama lay in the fact that one of the sisters of the Curiatii, Sabina, is married to one of the Horatii, while one of the sisters of the Horatii, Camilla, is betrothed to one of the Curiatii. Despite the ties between the two families, the Horatii's father exhorts his sons to fight the Curiatii and they obey, despite the lamentations of the women.

David succeeded in ennobling these passions and transforming these virtues into something sublime. Thus had Corneille and Poussin also done. Moreover, David himself stated: "If I owe my subject to Corneille, I owe my painting to Poussin."

However, unlike Corneille, David finally decided to treat the beginning, rather than the denouement of the action, seeing that initial moment as being charged with greater intensity and imbued with more grandeur. And, it was he who chose the idea of the oath (it is not mentioned in the historical accounts), transforming the event into a solemn act that bound the wills of different individuals in a single, creative gesture. He was not the first painter to do so, but certainly the first to do it in such a stirring manner.

If he was thus paying homage to the spirit of Poussin, from whose *Rape of the Sabine Women* he also borrowed the figure of the lictor for his drawing of the youngest Horatius, his conception was nonetheless much more sober and innovative. Instead of following a tight order, David disposed the figures in a spacious and rhythmical series. They stand out against something that resembles not so much an antique-style frieze as a three-dimensional proscenium, forcefully asserting their autonomy.

In addition, the viewer's eye is spontaneously able to grasp only two superimposed orders—that of the figures and that of the decor. The first is striking because it is organized into three different groups, each with a different purpose. To the appeal of the elder Horatius in the center, the reply on the left is the spontaneous vigor of the oath, upheld loudly and with a show of strength, while on the right it is a tearful anguish, movement turned in upon itself, compressed into emotion. The distance between the figures accentuates this contrast. To the heroic determination of the men the canvas opposes the devastated grief of the women and the troubled innocence of the children.

The decor is reduced to a more abstract order, that of architectural space—massive columns, equally massive arches, opening out onto a majestic shadow. The three archways loosely correspond to the three groups.

The contemplative atmosphere is softened by shades of green, brown, pink, and red, all very discreet. Instead of opening his painting out onto a landscape or an expanse of sky, David closes it off to the outside, bathes it in shadow. As a result, the light in this setting takes on a brick-toned reflection, which encircles his figures with a mysterious halo.

Through David's rigorous and efficient arrangement, the superior harmony of the colors, and the spiritual density of the figures, this sacrifice, transfigured by the oath, becomes the founding act of a new aesthetic and moral order.

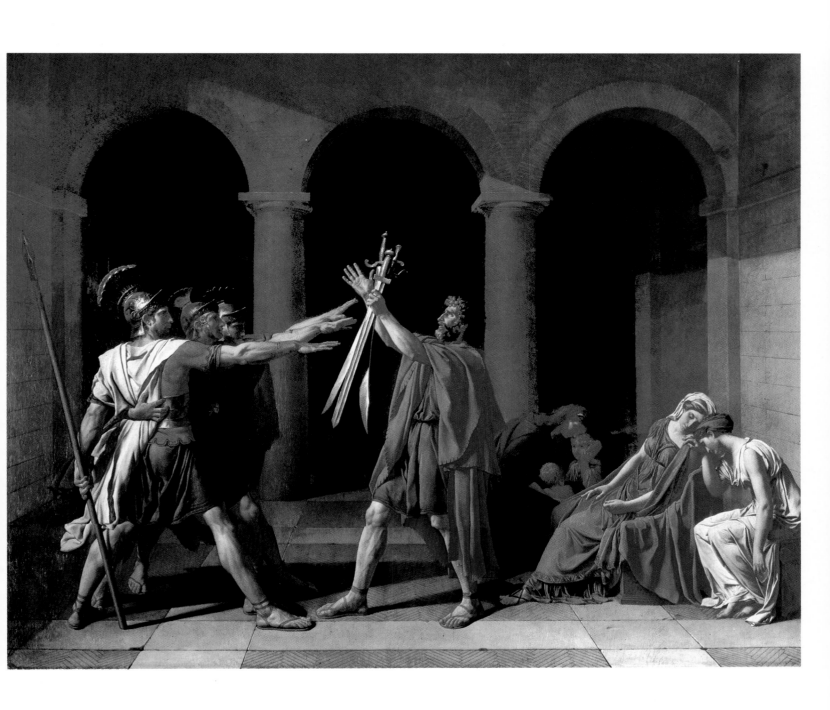

THE DEATH OF SOCRATES

Oil on canvas, 51⅛ × 77⅛"
Paris, 1787
Signed: L.D.—MDCCLXXXVII
The Metropolitan Museum of Art, New York
(Wolfe Fund, 1931, Catherine Lorillard Wolfe)

Plato tells us that Socrates, his master, had been condemned to drink poison, hemlock, for having criticized the tyranny of Critias, the oppressor of Athens. Never even considering the possibility of fleeing—as one of his disciples, Crito, suggested—Socrates accepted his fate and wished to convey to all his disciples a serene acceptance of death as one final, supreme lesson.

The moral beauty of this story inspired David. For the details of the scene, he consulted a scholar, Father Adry. Above all, he wanted to simplify the story and reduce the number of disciples and other observers mentioned in Plato's account. Thus, he eliminated the philosopher's wife, Xanthippe, and he altered the ages and comportment of the disciples. He made Plato, who had been a young man at the time, a solemn old man, seated at the foot of the bed, lost in thought. Apollodorus, who—according to Plato—had been sent away by Socrates because of his overwrought behavior, becomes the individual leaning against the wall, prostrate with subdued grief. Crito sits by his master's side, his attitude denoting affectionate respect. Other disciples express, through their restrained gestures, sadness and pity. The tribunal's vassal seems to be both moved by and ashamed of his appointed task—to hand Socrates the cup containing the hemlock.

In the middle of this sorrowful gathering, Socrates, sitting up, one arm raised to punctuate his lesson, the other carelessly extended to accept the lethal cup, continues to expound with all his vigor, which remains constant. Legend has it that it was the poet André Chénier who gave David the idea for this gesture. In any case, the pose is typical, the courage natural. Only the head can be said to be truly idealized, if it is compared to the misshapen representation we have of Socrates in a classical bust.

David has treated his picture in a deliberately new way. He had been sensitive to some of the criticisms that had arisen amidst the applause for the *Horatii:* a compartmentalized composition, poor spacing of the figures, a garish contrast of colors. He himself wondered if he had not gone too far pictorially with the *Horatii* in the direction of starkness and geometricity.

Here his composition is more supple and, also, more in keeping with the disorder of grief. Most important, his palette has a shimmering quality. Several different tones of red form a mounting crescendo. From Crito's robe on the right to the cloaks of the men climbing the stairs in the background, the highest note is sounded by the tunic worn by the man bearing the drink of oblivion. The painter reserved two very soft shades of blue-tinged white and gray for the togas of Socrates and Plato, to underscore their serenity. The yellow panel of the robe on the right counterbalances the flesh tones.

David maintained the principle of the architectural background, which is solid and neutral with its stone-tiled walls and floor, but he opened the wall up via a vast archway through which we see weeping disciples leaving by a staircase and two lattice-work windows in the background, giving the canvas a feeling of depth.

This painting was widely admired. The English painter, Sir Joshua Reynolds, went so far as to declare that it was "the greatest effort in art since the Sistine Chapel and Raphael's chambers in the Vatican."

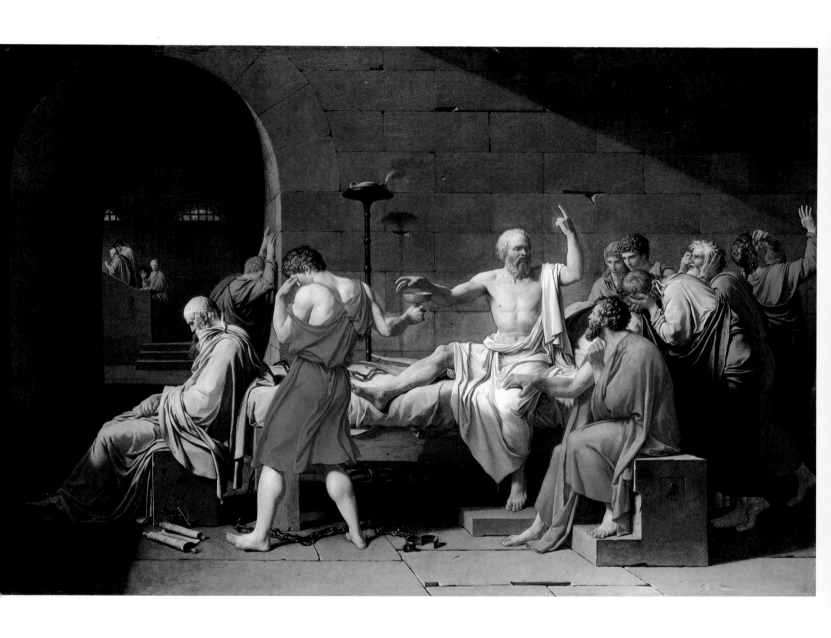

MONSIEUR LAVOISIER AND HIS WIFE

Oil on canvas, 8'8¼" × 7'4⅛"
Paris, 1788
Signed: L. David, Parisiis, Anno 1788
The Metropolitan Museum of Art, New York
(Purchase, Mr. and Mrs. Charles Wrightsman Gift, 1977)

Antoine-Laurent Lavoisier (1743–1794) was an eminent scientist. Elected to the Académie des Sciences at the age of twenty-five, he became the first great French chemist. In 1783, he was the first person to succeed in determining the composition of water and in synthesizing the compound from its elements. This discovery made him famous. He was also an extremely wealthy man. A Fermier-Général (tax collector for the Crown), he belonged to that class of financiers whose wealth would eventually arouse envy and precipitate its downfall. He was also a remarkable administrator. In recognition of his very diverse talents, he was elected alternate deputy to the States-General in 1789.

His wife, Marie-Anne Paulze (1758–1836), was the daughter of a Fermier-Général. She took drawing lessons from David, and was an intelligent, cultured woman with a passion for chemistry that matched her husband's.

In this double portrait David has painted a happy couple—two intelligent, sensitive people who are united by their tenderness for each other. Aside from his portraits of the members of his own family, David, ever the realist, did not paint many common people. Most of his models came from the aristocracy and the haute-bourgeoisie. For this painting, David was paid an astronomical sum at the time: 7,000 pounds, or nearly double the amount he received as the royal commission for the *Horatii*.

He preferred the sublime to the unpretentious; the Lavoisiers, however, had both qualities. David expresses his respect and affection for them through the air of superior simplicity with which he has endowed them. What David is depicting in this portrait is charming virtue, natural talent, intimacy between two exceptional individuals. This is the core of the painting.

The balance, however, is admirable in its delicacy and harmony: the composition is enhanced by the dominant colors—red, black, blue, and white. Madame Lavoisier is wearing a full white dress whose folds form a reversed corolla. David has made the dress a soft, luminous mass that corresponds to the softness of her features and her gaze. Her husband's black suit, far from being somber, takes on a kind of luster from the whites and reds around it. The warmth of the large red velvet table covering reinforces the subdued simplicity of the scene. The blond curls of Madame Lavoisier's wig cascade down her back. Her aquamarine sash, tied like a ribbon on a gift box, and her husband's bright cuffs and jabot are sparkling grace notes against the pure tones of their garments.

The laboratory instruments share this quietly shimmering quality. The distillation flask on the right has the transparency and brilliance of the finest glass, while the test tubes on the table have the flat, dense look of thick glass; each instrument has its own distinct texture and reflections play off their surfaces with a marvelous lightness. They are in the picture to bear witness to the Lavoisiers' experiments and their sole object is to serve as symbols and emblems. They are, above all, still life masterpieces. On the left, the portfolio on the chair is a reminder of Madame Lavoisier's interest in art.

The overall movement of the painting, restrained and delicate, is skillfully contained in a triangle bisected by Lavoisier's extended leg. This is not merely family tenderness—it is also amusing chemistry. It is a felicitous and quietly radiant display of David's talent at its best.

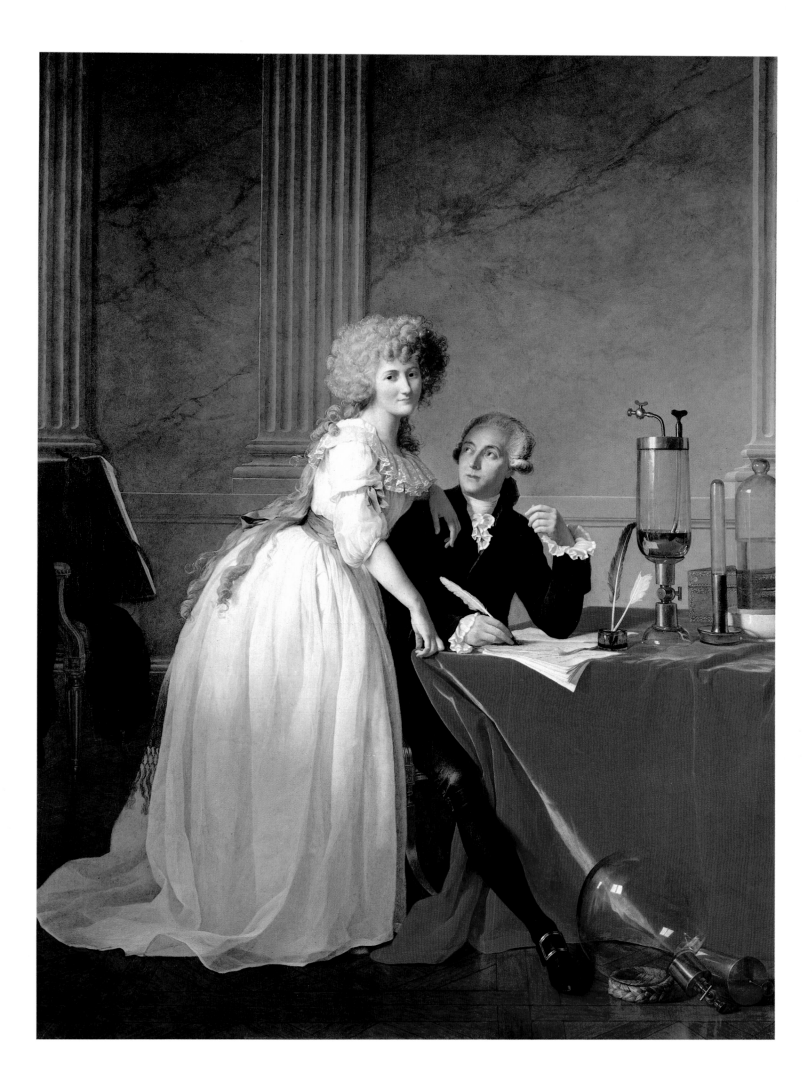

PARIS AND HELEN

Oil on canvas, 57½ × 71¼"
Paris, 1788
Signed: L. David faciebat Parisiis anno MDCCLXXXVIII
Musée du Louvre, Paris

The subject of this painting is taken from the *Iliad*. Paris, the son of Priam, King of Troy, was famous for his physical comeliness. He abducted Helen, the beautiful wife of Menelaus, King of Sparta, and took her to Troy. To appease the wrath of Menelaus, who had united all of the Greeks into a league to do battle with Troy, he had to agree to fight him for Helen in man-to-man combat. He was defeated, but retained his conquest anyway.

David had an elegiac conception of love, and most important, he was seeking to advance his art, to simplify it, to make it sublime. This commission for a *scène galante* from the Count d'Artois provided him with the opportunity to carry on his aesthetic and moral quest.

He plunged into his memories of Rome, looking for equivalents for his Greek characters and theme. He used furniture that had been made for him by the famous *ébéniste* (cabinetmaker) Jacob, which would later reappear in the painting of *Brutus* and the portrait of *Madame Récamier*. He devised a drapery for the conventional room-divider behind the bed. His reconstruction was thoroughly fanciful, but it was abstract rather than dismaying. The pair of lovers was his primary concern. In total opposition to his predecessors, he clothed his female subject, albeit in something gauzy and transparent, and undressed his male hero. For David, however, the male nude was not sensual, or even especially masculine; his representation of nudity—to borrow a term from the vocabulary of the corrida—is as a sort of "garb of light" that fully expresses a vision of plastic beauty and permits David to unveil a deeper spiritual value, for which nakedness serves merely as a translucent covering. This is the idea expressed by the ancient Greeks of "a beautiful soul in a beautiful body."

Paris is young; he is beautiful rather than handsome, in a masculine, athletic way. It is Helen who offers herself, who is soft and desirable. To her is reserved the wild abandon of love and the senses. Paris seems to be more interested in playing the lyre for Helen than in possessing her. He is charming and he has an elegiac quality, but he conveys feeling more than temperament. Why is he portrayed nude if not because his nudity is an aesthetic and moral idea?

Helen's face and body are exquisite in their grace and beauty, and the bodies of the lovers have an undulating, supple quality. The triangular composition forms a sort of ornate capital letter that could be the "A" in "Amour." The general impression is charming, even if the absence of any violent emotion gives the scene a certain precious quality. The lovers' gazes have a delicious tenderness. The tonal contrasts are extremely well-wrought. The colors, softer than in his earlier paintings, point to the influence of Rubens, whose paintings David had seen during the course of his travels through Flanders. The decor is elaborate and discreet enough to allow the light and colors to flow as Helen leans on her lover's body in a tender atmosphere reminiscent of *galante* mythology.

This is a delicate painting whose aesthetic intentions and intellectual meaning are ultimately eclipsed by the couple whose love is about to express itself in an embrace.

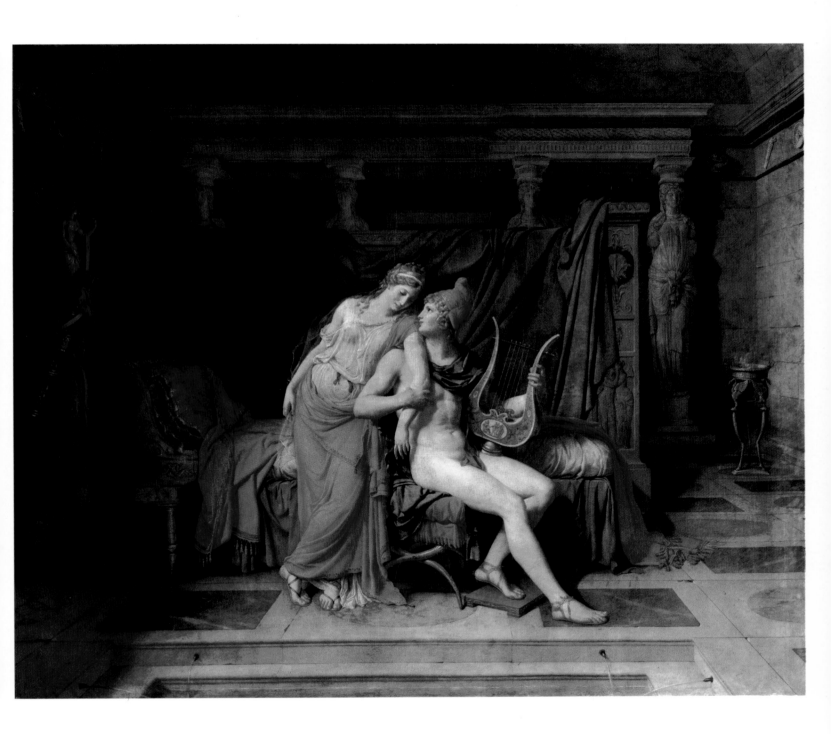

BRUTUS

Oil on canvas, 10'7⅛" × 13'10⅛"
Paris, 1789
Signed: L. David faciebat Parisiis anno 1789
Musée du Louvre, Paris

The subject of this painting was taken from the history of the early days of the Roman Republic, in the 6th century B.C. It is thus not about Marcus Brutus, Caesar's assassin, but his distant ancestor, Lucius Brutus, First Consul. The painting's full descriptive title adequately describes the scene: "Brutus returned to his home, after having condemned his two sons to death for joining in a conspiracy against Roman freedom; the lictors bring back their bodies so that he may give them burial." The sons of Brutus had plotted for the return of the monarchy from which he himself had freed the Romans.

Once again, David, in response to a commission for another painting for the King, chose a heroic theme from the most distant reaches of the past. He strove for archaeological accuracy in the decor. He again used the furniture designed by Jacob. He strove to imitate certain archaeological details in the statue of *Roma* and the head of Brutus, which was drawn from the Capitoline bust.

It can also be seen that David played with light and the direction of the different movements to compose a theme in three parts, each with its own tempo and accents. The funeral procession seems to spring from the source of light and then quietly fade into shadow. The mysterious statue of *Roma* places Brutus against the light, thus diminishing the horror of the scene. The group of women, on the other hand, trembles under the strongest light in the painting. The majesty of the Doric columns and the regular rhythms of the stone tiles punctuate the harsh discontinuities of the three scenes disposed around the central column in the shape of a star. There is a deliberately jarring, as well as swirling, feeling in this concatenation of contrasts.

The interplay of lines draws all of its subtlety from these jagged rhythms. Thus the chair, with its elongated back and gentle curves, standing strangely isolated in the middle of the scene, offers the link which—at first glance—might seem to be missing between the body of Brutus turned in on itself as he is absorbed in his austere meditation, and the bodies of the frightened women clinging to each other. Thus, the funeral litter borne by the lictors impresses itself upon our attention as a moral horizon. Each group is characterized by the interplay of its own distinct lines—hard lines for the dead, nervous lines for Brutus, and undulating lines for the women.

Color is not treated in this canvas as the means of composing a melodic line, but as a way of accentuating focused meanings. The gray mantle and wine-colored shirt of Brutus have a metallic harshness. The palette of colors used in the women's clothing and the table covering contrasts the disordered grief of the whites, oranges, and intense red of the central group to the severe blue on the extreme right; further on the left, two different shades of blue and the orange and yellow tones express, in a deliberately cacophonous palette of colors, the impassiveness of the lictors.

We can sense, however, that David has carried his moral and pictorial quest to its farthest limit in this painting. Completed the year the Revolution began, exhibited at the Salon of the summer of 1789, the painting was valued by David's contemporaries less for its aesthetic beauty than for its political content. David contrasted the strict morality of the Roman Republic's first defender, sacrificing his sons for his country, to the moral flabbiness of Louis XVI, who had allowed his brothers to emigrate.

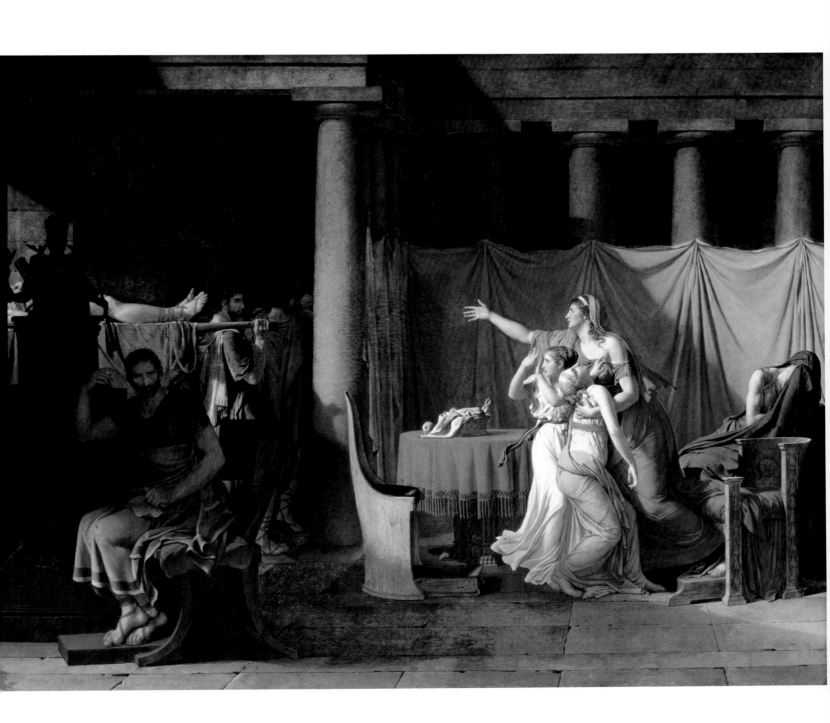

THE MARQUISE D'ORVILLIERS

Oil on canvas, 51⅝ × 38⅝"
Paris, 1790
Signed: L. David 1790
Musée du Louvre, Paris

This painting virtually closes the series of aristocratic portraits, or, at the very least, those commissioned from David by the great lords of the Ancien Régime.

The Marquise d'Orvilliers and her sister, the Countess de Sorcy-Thélusson, whom David also painted in 1790, were the daughters of the Genevan banker Rilliet, called to Paris by Necker to assist in the management of financial affairs. Jeanne-Robertine Rilliet was only eighteen years old when this portrait was painted and had just been married. Her husband, a very wealthy man, had only recently been ennobled, since his family name, until then, had been Tourteau.

This young woman was not a great beauty, nor was her sister. Her attractiveness lies chiefly in a certain youthful freshness, even if her plumpness is quite evident. There is seemingly nothing about her that would attract particular attention—and yet this is an admirable portrait.

First of all, it is admirable for its simplicity; David has stripped away any superfluous details. This is not only because the period was characterized by a simpler style of dress, or less complicated coiffures. The simplicity of 1790 was still limited to the way people dressed; it did not extend to a more generalized austerity. It is David himself who introduced his own brand of simplicity and even starkness into the picture. If this portrait is compared to others he painted earlier, for example, those of *Count Potocki, Alphonse Leroy,* and the *Lavoisiers,* we note that here David has consciously banished all accessories from his canvas. The background is bare; the Louis XVI chair is of a very simple pattern. Only the dress, despite its simplicity, retains in its fullness something of the profuseness of earlier styles.

The Marquise d'Orvilliers is dressed, coiffed, and seated as in everyday life, but David has discarded everything that might come between him and his model.

She seems to be lost in a daydream, passively allowing her portrait to be painted. The features of her round face are not unusual and life itself seems lost in somnolence—a life free of curiosity and complexes.

David was undaunted. He took his model as she presented herself to him and applied himself, with honesty and attentiveness, to rendering that in her which suggested a kind of natural torpor, a life lived almost in a trance.

He also studied the Marquise d'Orvilliers's pose. Close scrutiny of the painting reveals that he reworked the folds of the scarf and that he raised the left arm and added a bit of lace to it, which is not repeated on the right arm. The curve of the arms and of the bust, the way the dress and scarf fall, form a play of lines in harmony with the rounded, fleshy face. Nothing in this painting challenges the model's serenity, her settled stillness, nothing except, perhaps, this air of complacent simpleness which could have been the painter's criticism, whether unconscious or deliberate, of this all-too-docile soul.

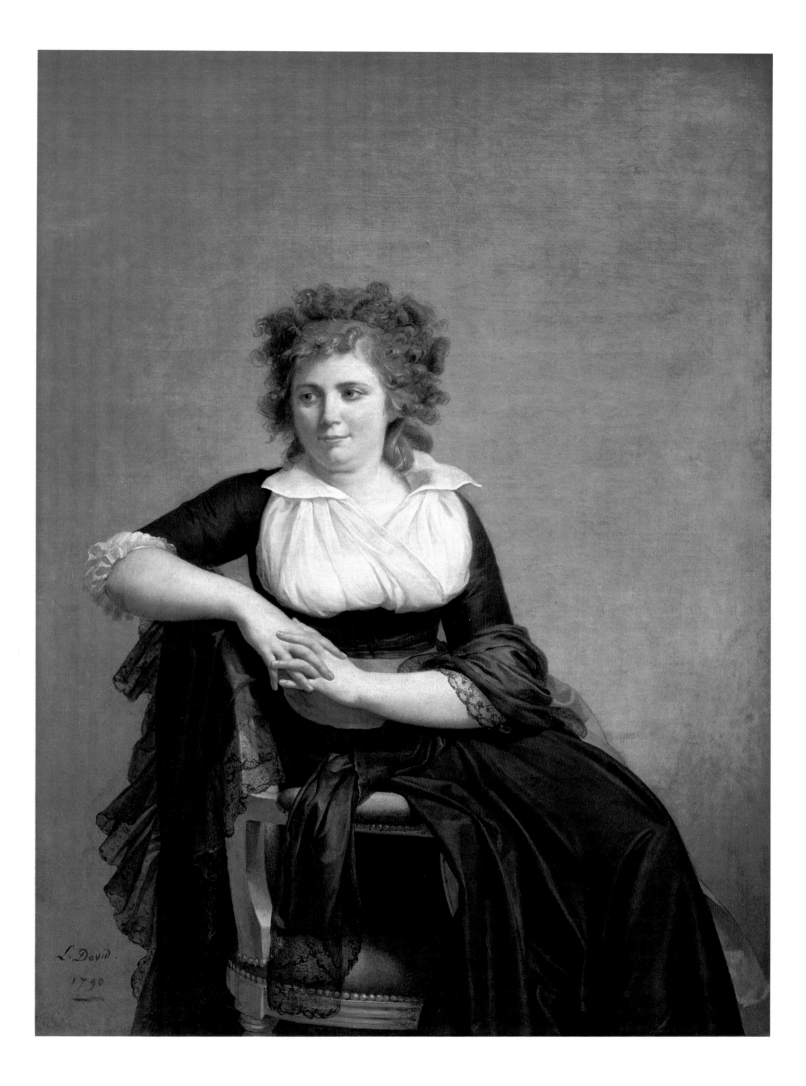

THE TENNIS COURT OATH

Pen washed with bistre with highlights of white
on paper, 26 × 41⅜"
Paris, 1791
Unsigned
Musée National du Château, Versailles

It was on June 20, 1789, at Versailles, that the members of the Third Estate, joined by members of the Clergy, met in the hall of the Jeu de Paume. It was there that, with only one exception, they all took an oath pledging "never to be separated and to meet wherever circumstances so require, until the Constitution of the Kingdom is established firmly on solid foundations."

The King soon capitulated. On June 27, he ordered the Nobility and the Clergy to join the Third Estate. The States-General ceased to exist and, on July 9, the body of deputies became the Constituent Assembly. The Revolution had begun.

As early as the following year, a society was organized to commemorate the event; the idea was soon taken up by the Club des Jacobins which, on October 28, 1790, invited "the creator of *Brutus* and the *Horatii*, this patriotic Frenchman whose genius foreshadowed the Revolution," to execute the painting.

David, who had discovered (after the fact) the prophetic nature of his genius, accepted the commission, although he requested a schedule that would permit him an extended period of time to work on the painting. This was a totally new kind of project for him—it was a notable departure for a painter of portraits or small groups to embark upon such a vast undertaking; this drawing was the preliminary sketch for his composition.

The Assembly is seen from an imaginary vantage point located in the front part of the hall, slightly above the heads of the deputies at the level of its President, Bailly, who had climbed up on a table to read the proclamation in which the Assembly declared its independence. The wave of pledges converges toward Bailly. At the foot of the table, three members of the Clergy, who have just joined the Third Estate, embrace each other, lending a note of religious gravity to the secular oath of the deputies of the Third Estate. Slightly to the right, one character is seen pressing his hands to his bosom, which is heaving with emotion: it is Robespierre, who already symbolized, in David's eyes, revolutionary purity and passion. On the extreme left, representatives of the people and the National Guard crowd through the narrow entrance-way in order to express popular support and enthusiasm.

This gallery of personages, most of which are portraits, constitutes a powerful frieze borne on a wave of excitement; the extraordinary diversity of attitudes is impressive. Some of them may seem theatrical, but the majority are natural and convey the spontaneity and unanimity of the oath.

The rest of the drawing is given over to the unadorned emptiness of the hall, except for the two galleries overflowing with the curious, who seem to be inviting us to participate with them in the event. David has added an almost supernatural, albeit historical, detail: a strong gust of wind has lifted a curtain to afford us a glimpse of the prophetic bolt of lightning that would strike Versailles.

David had conceived the representation of an idea. The drawing, with its linear purity and the spareness of its execution, lent itself entirely to this conception. It is striking to note that David exhibited this drawing at the 1791 Salon, thus showing that he did not judge it unworthy of his earlier paintings.

Planning to paint "1,000 to 1,100 figures in the most energetic attitudes," David actually only dashed a handful of figures onto a large canvas, a substantial portion of which remained blank. He gave up on the project once and for all in 1801.

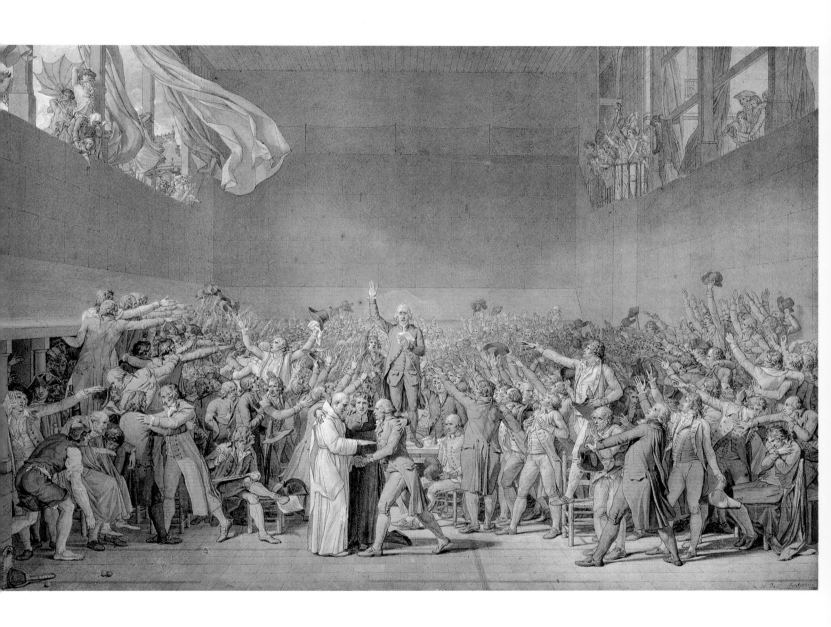

MADAME PASTORET

Oil on canvas, 52⅜ × 39⅜"
Paris, c. 1792
Unsigned
The Art Institute of Chicago
(Clyde M. Carr Fund and Major Acquisitions Fund)

Until at least 1785, David's studio had been open to both young men and women. Legend has it that Adélaïde Piscatory (1765–1843) had been David's pupil, but that her apprenticeship with him was brief. On July 14, 1789, she married Claude Pastoret (1756–1840); they had a child in 1791, Amédée-David (1791–1857). This painting, which was never finished, is undated. It was probably painted at the end of 1791 or the beginning of 1792.

Adélaïde and her husband both came from very well-known families in Marseilles. On the eve of the Revolution, Claude Pastoret had been head of the delegation that asked the Constituent Assembly to make the Église Saint-Germain a Pantheon devoted to great men. He was elected Representative of Paris to the Legislative Assembly and became its first President.

This is the portrait of a woman whose background was the liberal haute bourgeoisie. She was part of that first generation of supporters of the Revolution that came from the upper classes. She was very taken with the fine arts, social reform, and new trends. She raised her child in accordance with the novel ideas some of her contemporaries were beginning to adopt in reaction to the child-rearing practices of the past.

David painted her sitting by the cradle of her child, whose head can be seen, in the act of watching over him and sewing his swaddling clothes. She is very simply dressed in a tea-gown tied at the waist, which shows off her ample bosom. She is sitting in a very modest chair, as modest as the cradle itself. Her hair is not powdered.

Her gaze is intense, almost brusque. This is how she must have been—intelligent, unaffected, without false modesty, and with definite ideas concerning people and things. She is natural and witty rather than beautiful; she has a long nose and a small mouth, together with the beginning of a double chin.

The color is as fresh as the drawing and both are matched to the model's character. Her attire is a trifle disordered, which does not preclude there being something warm and harmonious in the overall effect that suggests ease, spirit, and an impulsive gesture.

The painting was never completed, probably because the paths of the painter and his model diverged. David embarked on a political career as Deputy to the Convention in September 1792. The arrest of Louis XVI put an end to the career of Claude Pastoret, who emigrated shortly afterward.

His wife, who was imprisoned during the Terror, became involved in charitable works and in 1800 established the first schools for infants, the forerunners of today's nursery schools. Under the Empire and the Restoration, she had a salon that was very highly regarded. Her husband was made a Count by Napoleon. Under the Restoration he became the Marquis de Pastoret and a Peer of France. President of the Chamber of Peers, member of the Académie Française, he was also Minister of State and Chancellor of France under Charles X. Times had changed once again. The portrait of the Marquise de Pastoret was sold for only 400 francs at the auction of David's works after his death. The Pastorets' son (the baby in the cradle here) became Councillor of State under the Restoration. Loyal to the Count de Chambord during the July Monarchy, he supported the Second Empire and eventually served as a Senator.

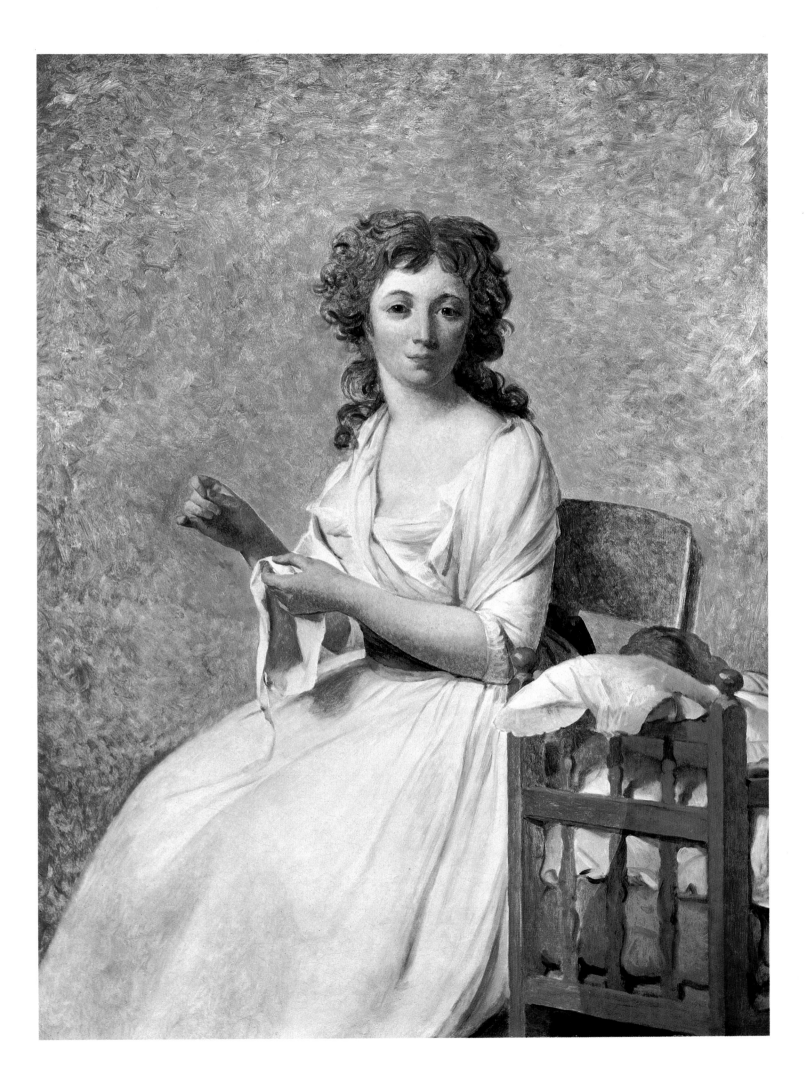

THE TENNIS COURT OATH

Oil on canvas, 13′1″ × 21′¹³/₅″
Paris, 1791–92
Unsigned
Musée National du Château, Versailles

David had already finalized the composition he intended to execute on canvas: it was the drawing he had completed in May 1791 and exhibited at the Salon in September of that year.

The large canvas kept at the Versailles Museum is all that remains of the original canvas which, unsold after David's death, had been cut down, almost in half, to its present dimensions. Only two groups are represented here—the Clergy, which is simply drawn and which, because of the reduced size of the canvas, is now on the left, and, on the right, the group consisting of a handful of deputies from the Third Estate, whose heads have been painted in.

The four deputies, from right to left, are Barnave, Mirabeau, Gérard Senior, and Dubois-Crancé; the fifth character, who is only drawn in, is Robespierre.

Barnave (1761–1793), the deputy from Vizille, a brilliant lawyer, young, sensitive, enthusiastic, and elegant in both heart and mind, was one of the leading figures of the Constituent Assembly. Moved by the misfortunes of the Royal Family after its flight to Varennes, he placed himself at the King's service, was arrested after August 10, 1792, and guillotined in November 1793.

Mirabeau (1749–1791), the deputy from Aix, was a popular orator famous for his love affairs and adventures who became passionately involved in the Revolutionary cause. He was the author of the famous retort to the Marquis de Dreux-Breze on June 23, 1789, when the latter had been charged by the King to dissolve the Assembly: "Go tell the King that we are here by the will of the people and that we will leave only by the force of bayonets." After exercising a leading influence in the Constituent Assembly, he moved closer to the Court and, a believer in constitutional monarchy, sought to advise the King while remaining in favor with the people. Worn out by exhaustion and a life of debauchery, he died on April 2, 1791, his popularity intact. With his enormous head, his face pitted by smallpox, his ugliness was considered to be both "grandiose and flashing."

Gérard (1737–1815), the deputy from Rennes, a well-to-do peasant who insisted on attending the sessions in his Breton costume, briefly became a legendary figure embodying allegiance "to the principles of 1789"—he then returned to obscurity in his native Brittany.

Dubois-Crancé (1747–1814), the deputy from Vitry-le-François, a professional military man, was the same gentleman who had proposed the selection of David to commemorate the Oath on canvas. A member of the Convention and a *montagnard*, he was one of the group responsible for the overthrow of Robespierre, and the first to propose universal conscription. As Minister of War in 1799, he opposed Bonaparte's coup d'etat, after which he retired into obscurity.

The four heads painted by David are superb. Although they reproduce the features of the four corresponding heads in the drawing, they have the superiority not only of a more detailed study, but of life itself. The head of Robespierre on the left, in contrast, is not very different from the almost impersonal outline apparent in the drawing. It is merely a somewhat more developed study.

These four portraits, at least one of which—Mirabeau's—is idealized, are a dazzling demonstration of how David moved from the heroic idea, as expressed in his great drawings, to its embodiment in living beings.

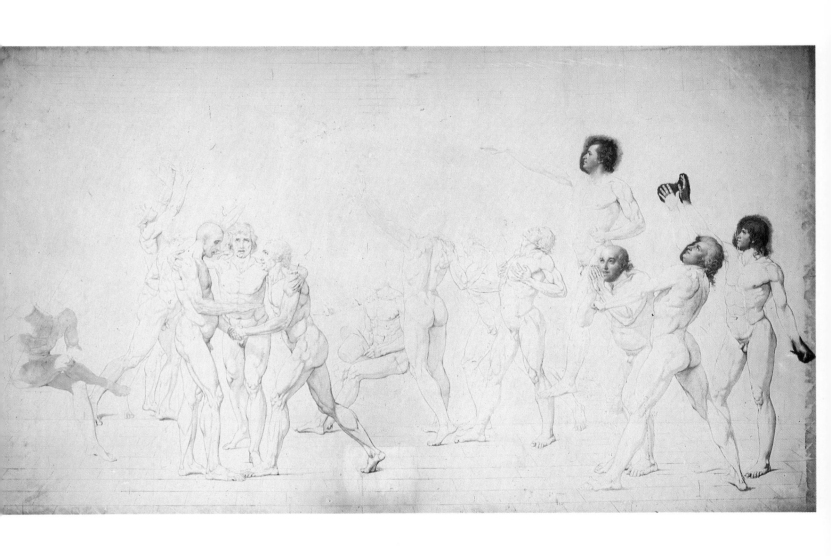

THE DEATH OF MARAT

Oil on canvas, 63¾ × 49⅛″
Paris, 1793
Signed: À MARAT, DAVID. L'AN DEUX
Musées Royaux des Beaux-Arts, Brussels

France was in danger and the Revolution was in peril. The Committee of Public Safety had just been created. The Reign of Terror had begun. It was the "terrible year."

Marat, Robespierre's friend, deputy to the Convention, and editor-in-chief of *L'Ami du Peuple,* was a fiery orator; he was also a violent man, quick to take offense. Some saw him as an intransigent patriot; for others he was merely a hateful demagogue. On July 13, 1793, a young Royalist from Caen, Charlotte Corday, managed, by a clever subterfuge, to gain entry into his apartment. When Marat agreed to receive her, she stabbed him in his bathtub, where he was wont to sit hour after hour treating the disfiguring skin disease from which he suffered.

David, who had been Marat's colleague in the Convention, saw in him a model of antique "virtue." The day after the murder, David was invited by the Convention to make arrangements for the funeral ceremony, and to paint Marat's portrait. He accepted with enthusiasm, but the decomposed state of the body made a true-to-life representation of the victim impossible. This circumstance, coupled with David's own emotional state, resulted in the creation of this idealized image.

Marat is dying: his eyelids droop, his head weighs heavily on his shoulder, his right arm slides to the ground. His body, as painted by David, is that of a healthy man, still young. The scene inevitably calls to mind a rendering of the "Descent from the Cross." The face is marked by suffering, but is also gentle and suffused by a growing peacefulness as the pangs of death loosen their grip.

David has surrounded Marat with a number of details borrowed from his subject's world—the green covering, white sheet, and wooden packing case—and he has also added a few others, including the knife and Charlotte Corday's petition, attempting to suggest through these objects both the victim's simplicity and grandeur, and the perfidy of the assassin. The petition ("My great unhappiness gives me a right to your kindness"), the assignat Marat was preparing for some poor unfortunate ("you will give this assignat to that mother of five children whose husband died in the defense of his country"), the makeshift writing-table and the mended sheet are the means by which David discreetly bears witness to his admiration and indignation.

The face, the body, and the objects are suffused with a clear light, which is softer as it falls on the victim's features and harsher as it illuminates the assassin's petition. David leaves the rest of his model in shadow. In this sober and subtle interplay of elements can be seen, in perfect harmony with the drawing, the blend of compassion and outrage David felt at the sight of the victim.

The painting was immediately the object of extravagant praise, then, returned by the Convention to David in 1795, it was rescued from obscurity only after his death. Misunderstood by the Romantics, who saw in it only a cold classicism, it was restored to a place of honor by Baudelaire, who wrote: "This is the bread of the strong and the triumph of spiritualism; as cruel as nature, this painting is redolent of the Ideal. What then was that ugliness which Holy Death so quickly erased with the tips of her wings? Marat can henceforth defy Apollo, Death has kissed him with her loving lips and he rests in the tranquillity of his metamorphosis. There is, in this work, something at once tender and poignant; in the cold air of this room, on these cold walls, around this cold and funereal bathtub, a soul flutters...."

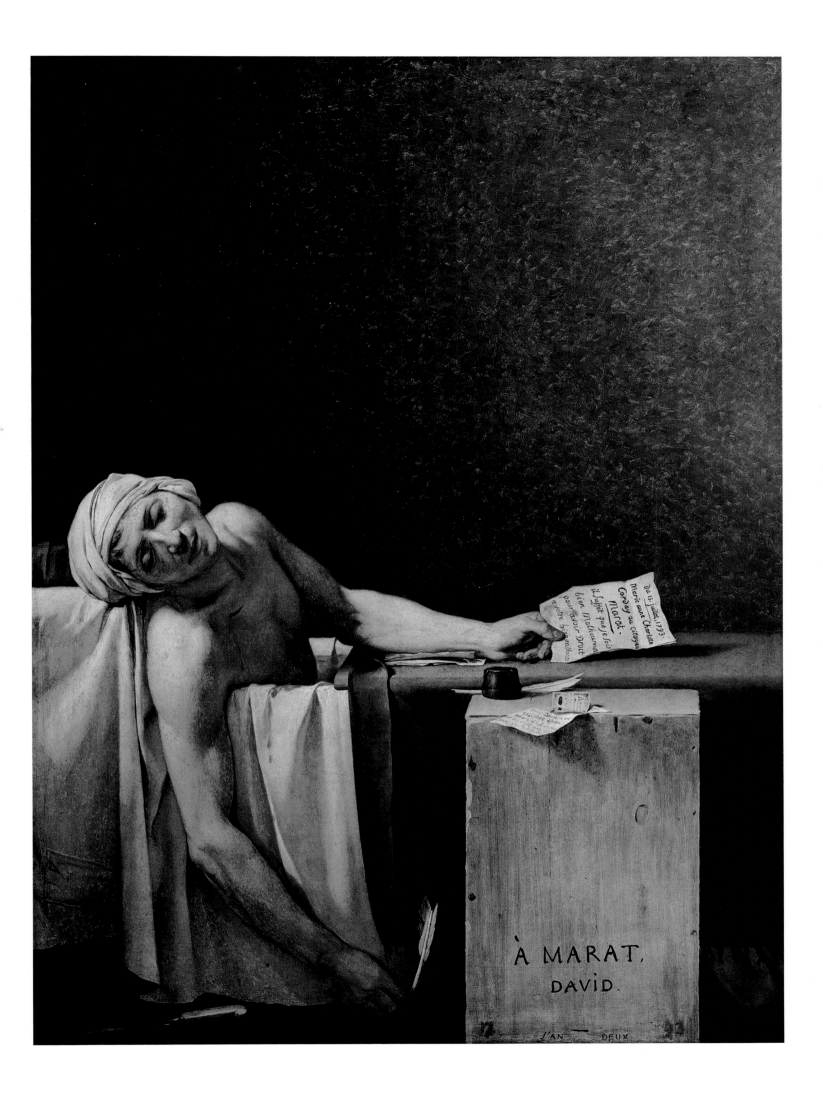

SELF-PORTRAIT

Oil on canvas, 31⅞ × 25¼"
Paris, 1794
Unsigned
Musée du Louvre, Paris

David painted his first self-portrait in 1784, in which he looks like a figure by Frago-nard. He painted quite a different self-portrait in 1790–91—one characterized by a very disquieting gaze. In his last self-portrait, painted in 1813, he is wearing a frock-coat with the Ribbon of the Legion of Honor pinned to his buttonhole. This picture, which he painted in prison after the fall of Robespierre, expressed—perhaps more fully than the others—David's power and truthfulness, his determination, lucidity, and self-respect.

Arrested just after Thermidor, August 2, 1794, David was taken to the House of Detention at the Hôtel des Fermes, rue de Grenelle. His cell was, in fact, a small studio belonging to one of his pupils who was then serving in the Army. The condi-tions of his imprisonment were lenient. His wife, from whom he had been divorced since March, took their children to see him. One of his pupils brought him drawing and painting materials as well as a mirror. It was in front of this mirror that he ex-ecuted this self-portrait in August 1794. After all that had happened, he wanted to see himself clearly.

His grandson, Jules David, who has given posterity valuable information about the painter, described David as follows: "He was a man of large stature, with well-proportioned limbs developed by physical exercise, especially fencing, in which he had acquired a certain strength, giving him a very distinguished appearance. He had chestnut hair, luxuriant and curly, a high forehead, and eyes of an extraordinary brightness."

David's genuine attractiveness was unfortunately marred by a facial deformity. As a result of a wound suffered in his youth during a fencing match, a tumor had begun to develop in his right cheek and, over the years, it caused the cheek to swell more and more. At the time this portrait was painted, the tumor was still benign, but it bothered the painter, whose elocution was already marked (as had been his fa-ther's) by the exaggerated way in which he rolled his "r's." In his self-portrait, David tried to mask the size of his cheek, although he did not altogether diminish it. This is the only detail about himself that he touched up.

On the moral plane, also, we can read the painter's character in his own rendi-tion: willful, reserved, passionate, and agitated. We need only to look at him to un-derstand why he threw himself into the Revolution with such fervor; above all, we understand—and this may be the most interesting psychological aspect of the work—how David was simultaneously a portraitist and a history painter. His scruti-nizing gaze flashes with both acumen and eagerness. He had the gift of seeing more intensely than other people; he has an inquisitive air about him. He tried to make his rendering more forceful—his fingers tightly clasped around the brush and palette are an involuntary admission. Finally, an almost fierce passion can be seen in his gaze, the passion to penetrate reality, to discover its meaning and purpose. The portraitist wanted to grasp the core of human nature, the history painter wanted to give it an ideal form.

This work is in the tradition of the great portrait that concentrates upon the face and hands while embroidering only a few of the setting's features. In a very modern style and with a very lucid treatment, David rediscovered the manner of Rembrandt and of Titian. It was not by chance that he thus joined the greatest painters in this serious and profound self-examination.

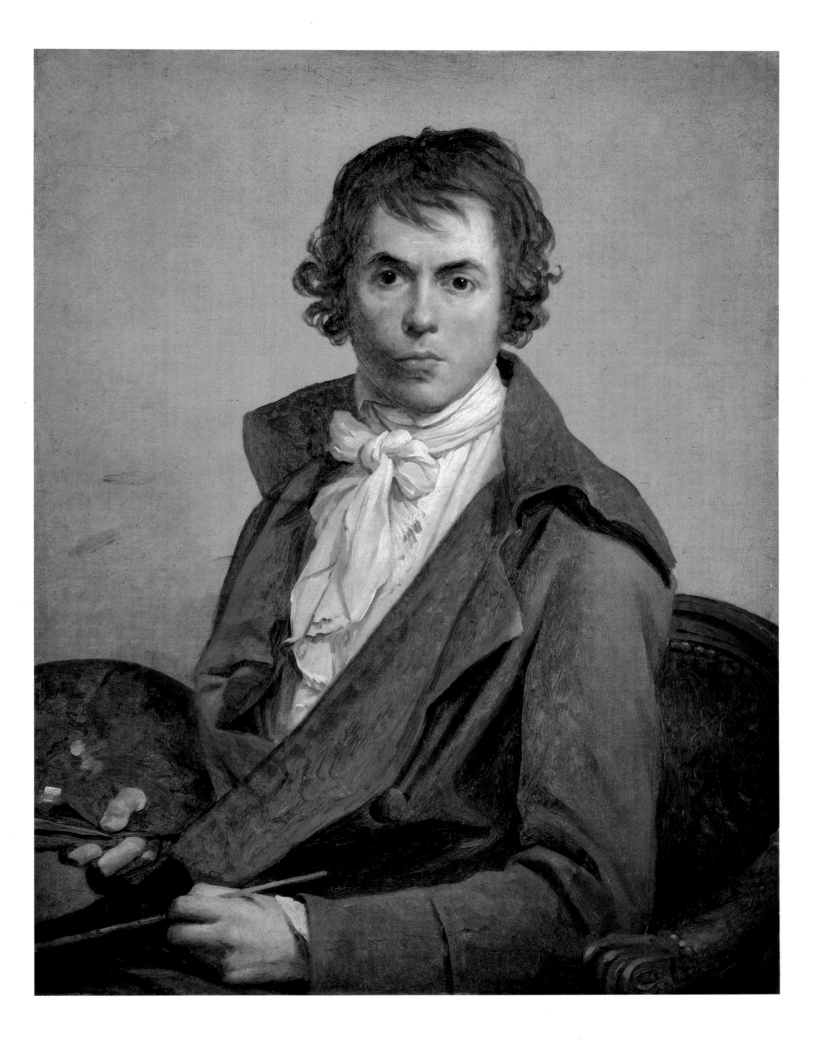

VIEW FROM THE LUXEMBOURG

Oil on canvas, 21⅝ × 25⅝"
Paris, 1794
Unsigned
Musée du Louvre, Paris

This is the only landscape David ever painted, or, at any rate, the only landscape he drew from nature and which was intended to stand on its own. He painted it during his detention in the Luxembourg Palace in the autumn of 1794. The painting represents part of the garden surrounding the Palace, in the state of neglect into which it had fallen during the Revolution.

David's portrait of nature is true-to-life and affectionate. We sense he has not added a single leaf or branch. The trees are absolutely still and there is not the slightest breeze. It is a sunny day at the beginning of October, when nature takes on a warm glow. Before the beauty of the day and the splendors of autumn, the painter begins to dream of a mild and calm tranquillity.

He cannot be other, however, than a scrupulous observer and a good painter. His brushstroke has the quivering quality of a leaf and the flickering quality of light. The large beech trees seem to be covered with a sun-dappled moss of golden reflections. His rendering of nuances and masses is admirable; he avoided limiting himself to the tedious detail or to reducing the whole to a muddled opacity. Each tree stands out clearly enough, as David traced with a large sure stroke the upward lines of its trunk and the spread of its branches. His trees have the individuality and life of human beings observed, one by one, in a crowd.

The houses on the rue de Vaugirard on the right, Mont Valérien in the background, and the paths between the trees provide him with the opportunity to paint large expanses of light, but it is to the fence and the area enclosed within it that he reserves the best of his palette. Luminous intervals punctuate the rows of stakes and props. All the elements in this static choreography are apparently interchangeable. Nonetheless, David has succeeded in bringing this repetitive series to life by imperceptible modulations of form and by subtle tonal variations. The fence marks off an almost empty space, a vague, fallow sort of field, in which four tiny figures seem to be busy doing something with their sticks. We have here a bit of pure color for David to model as he pleased.

We now have a better understanding of why this landscape charmed David to the point where he felt impelled to paint it; not only because it offered him the escape of which all prisoners dream, but also because this landscape was already articulated along regular, clear-cut planes, staking off open spaces and geometrical structures. Thus, this painting can take its place in the opus of a painter whose inspiration relied on both imagination and reason.

The painting style itself, however, is completely new. There is a pastoral simplicity in this work that was rare in eighteenth-century painting—no light effects, no special arrangement of the decor, just honesty and feeling, obvious delight in objects and color, enchantment with the natural light of the sun's rays.

This style prefigures Corot. The quivering mossy treatment of the foliage announces the Impressionists. The two most important portions of the painting, the fence and its enclosure, belong to the great painting of all ages and evoke Velásquez as well as Goya and Manet, three painters who also produced few landscapes and who, like David, aimed for substance rather than effect in those they did paint.

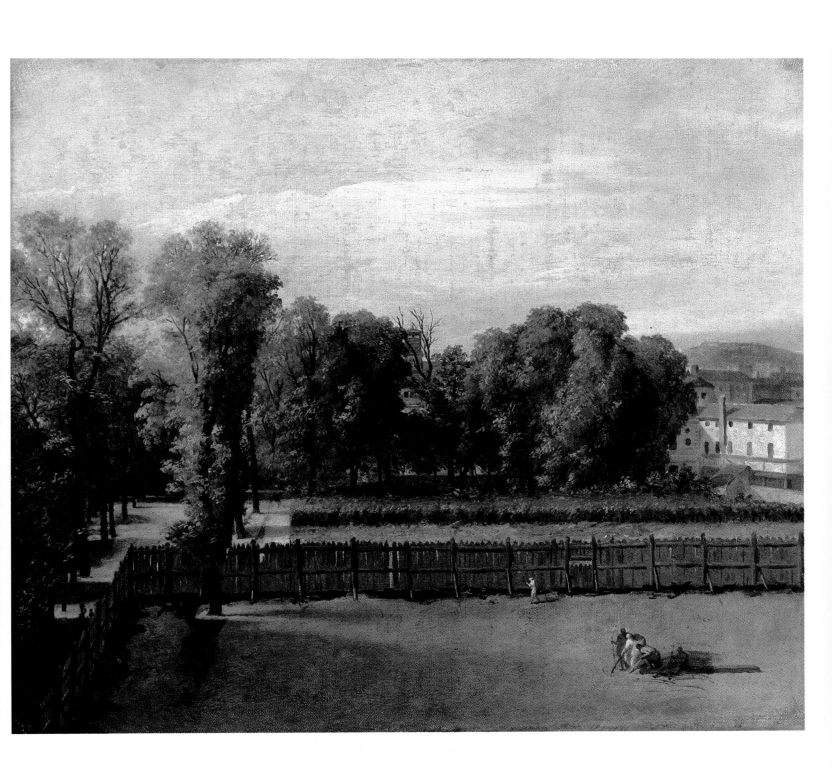

MADAME SERIZIAT

Oil on canvas, 51⅝ × 37⅞"
Saint-Ouen, 1795
Unsigned
Musée du Louvre, Paris

Scarcely one year had passed since the fall of Robespierre. The Thermidorian reaction had been intense and profound; David himself had been arrested and imprisoned. After his release at the end of 1794, he had become seriously ill, and in April 1795, he requested leave to retire to the home of his favorite sister-in-law in Saint-Ouen, for a period of recovery. Emilie Pécoul, his wife's sister, had married a magistrate, Charles Seriziat. After the death of her father in the autumn of 1794, she and her husband had moved to the family estate at Saint-Ouen.

The weather was fine, his family warm and welcoming, and the surroundings pleasant. France was catching her breath, and David's equilibrium was being restored. He himself said that he had found an infallible cure: work.

Since he was very fond of his sister-in-law, he painted her portrait, with her charming child, first. The work must have been started in May and completed in August 1795, the painter's stay at Saint-Ouen having been interrupted between these two dates by his arrest again on May 29th, followed by his release at the beginning of August.

Madame Seriziat is dressed very simply, but also very elegantly, in the height of that fresh and gay fashion which flowered spontaneously once the Revolutionary turmoil had come to an end, just as the wild flowers in her hand had burst into bloom after the winter.

She is perched on a table covered with an unpretentious pink cloth. She turns her very gentle, unaffected gaze upon us, but her look is also, at the same time, somewhat veiled. Flashes of gaiety and melancholy can be seen in her eyes, there is a hint of pink rising in her cheeks, and she has the delicate, timid grace of a very young woman. The small boy observes us with that air common to children, a blend of timidity and curiosity, as he half-hides beside his mother who is affectionately holding his hand.

Madame Seriziat has just come back from a lovely walk; she is happy, the spring day is bright, the month of May gives promise of a pleasant summer ahead. She has a beautiful child, a husband who adores her, and a brother-in-law who is affectionate and so talented that she blushes a little at the thought of being his model.

She is very flattered that he finds her so charming; she half-admits it to him. With her child, she wonders how she should pose and how she should look so that he can paint them as he wishes. This is the cause of her slightly nervous, startled look.

There are only three basic tones: white, green, and pink. The pink harmonizes especially well with the green in the background.

The stripped-away quality apparent here is neither artificial nor dry; it is simplicity itself that is being portrayed. The drawing in this canvas, put in with a light touch, serves only to set out the folds of the clothing and tie bows into the ribbons. A successful blend of freshness, lightness, and softness, this is as wonderful an arrangement as Nature's own, symbolized by the flowers.

Madame Seriziat's face has so much charm and beauty that we are moved, but she offers herself to our view in such a feminine and natural way that our primary feeling is one of tenderness. This is the effect David was striving for, as he shows us his delightful sister-in-law, and makes us respond to her as he did—very spontaneously and affectionately.

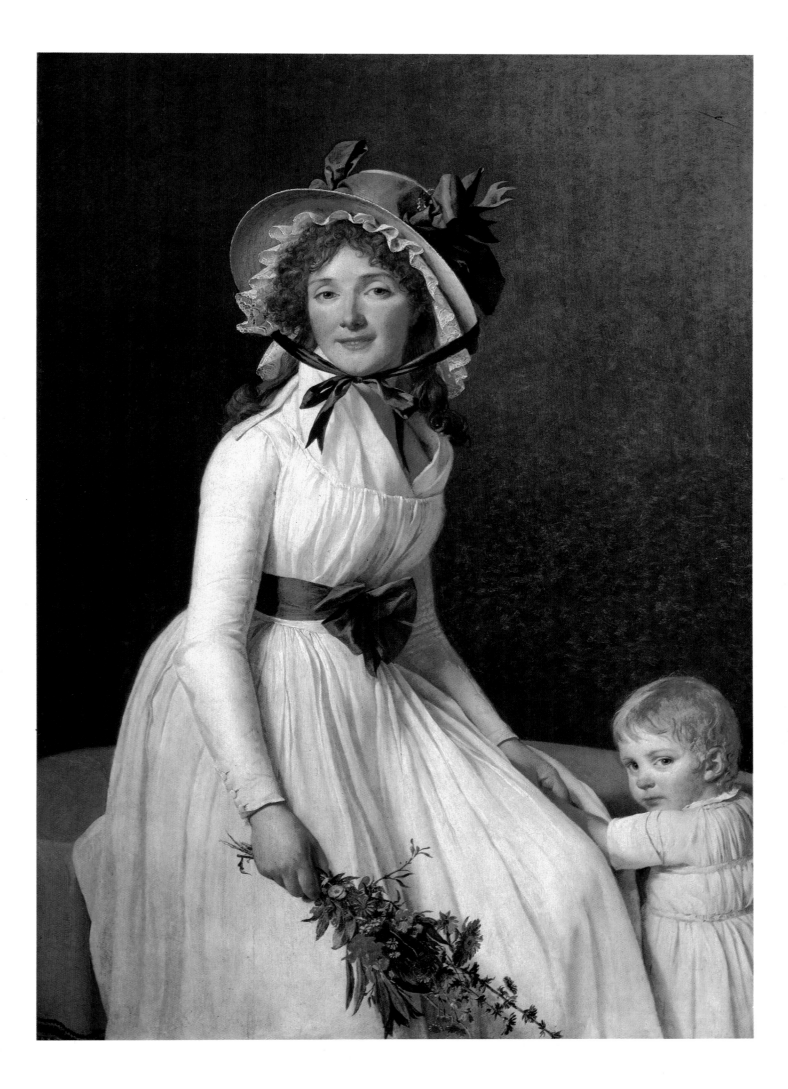

MONSIEUR SERIZIAT

Oil on canvas, 51⅝ × 37⅞"
Saint-Ouen, 1795
Unsigned
Musée du Louvre, Paris

When David was arrested for the second time at the end of May 1795 for his activities during the Terror, his brother-in-law, Charles Seriziat, intervened on his behalf. David's wife, who had been reunited with him, assured him that he could count Seriziat "among his most devoted friends."

Released in August, David found the same peaceful family atmosphere he had enjoyed in the spring. At the end of September, he wrote: "I am not wasting a minute and I am ready to finish the second portrait. My sister-in-law's portrait completed, I am working on one of her husband, who will also never cease to be dear to me. . . . I am leading a life which pleases me very much; I am in the midst of Nature, engaged in work related to the countryside and my art."

The painting was finished at the end of September or the beginning of October. It was a work successfully accomplished on the first try, springing spontaneously from David's talent and his affection for Charles Seriziat.

Monsieur Seriziat's portrait, more elaborate than that of his wife, is much more than a brilliant psychological study. The face, which seems to scrutinize the spectator, is so alive and the bearing of the figure is so natural, that we have the impression the painter and his model reversed their roles. We have just touched upon one of the secrets of David's art as a portraitist. He gave himself wholeheartedly to his model. He captured his models, but for the purpose of allowing them to eclipse him and change places with him momentarily. It is Monsieur Seriziat who is looking at us, through David's art which offers him to us.

We can observe the face at length without turning away from this gaze in which we see gentleness, simplicity, and a curiosity that is at times incisive, and almost ironic, or, if we respond to it in a spirit of complicity, simply amused and playful. It is a moment suspended in time, as if the face were submitting itself briefly to our scrutiny to reclaim itself the very next instant, as if the figure is resting for an instant, intending to rise again the very next moment. It is all of this compressed into a single second.

At first glance, the skill of David's presentation may elude us; we may simply feel that which we experience in real life when we are struck by someone: the impact of the encounter, an appeal.

David did not choose the colors of his brother-in-law's outfit—they were the fashionable shades of the day—but the painter has set them out in a definite order and arranged them in a certain manner. He gives us the impression of having invented and composed the colors himself. The yellow and white tones of the clothing emphasize the youthfulness of the face; the stronger tones form a supple frame around the model that enhances his grace. It must be September—on the right David places some imaginary plants bathed in mist and dew. He allows some light from the setting sun to trickle down on the left and then, with broad strokes, he brushes in the oblique sky, streaked with blue.

Monsieur Seriziat, seated casually on his cloak, leans forward slightly toward the spectator; the sky also has a slight tilt, and meets the figure at an angle. In the end we are charmed by so much urbanity—it may all seem a bit staged, but the result is felicitous and expressed with wonderful boldness.

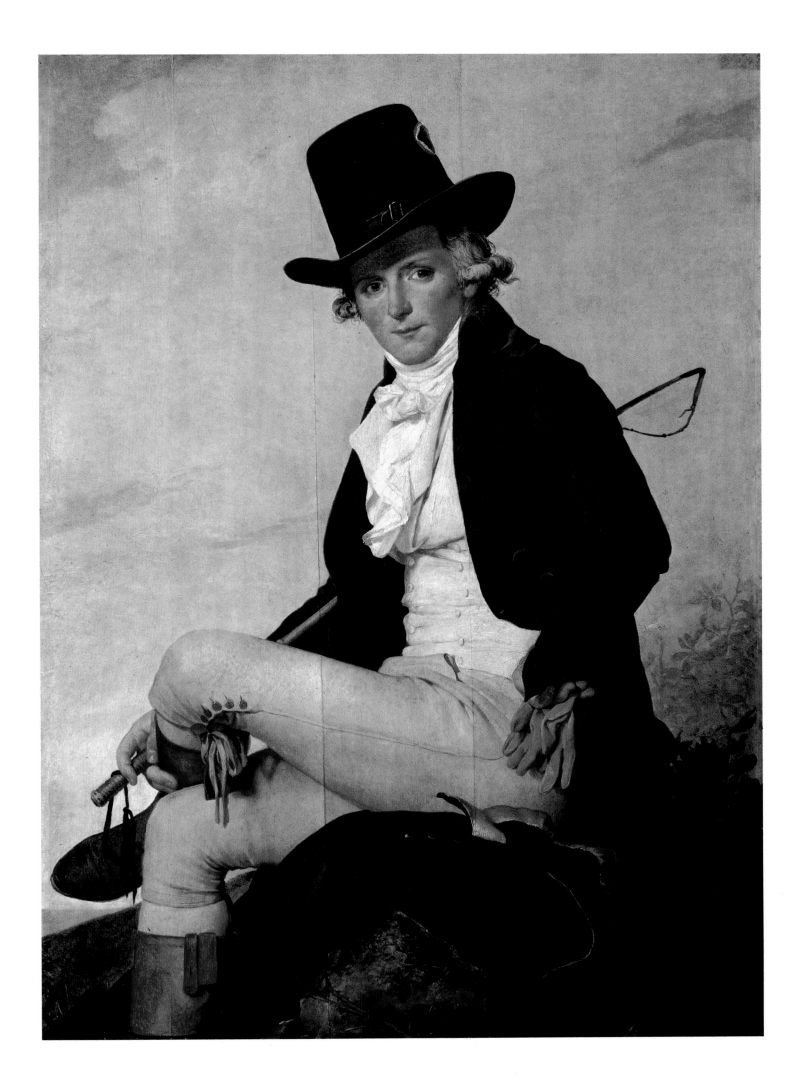

JACOBUS BLAUW

Oil on canvas, 35⅞ × 28⅜"
Paris, 1795
Signed: L. David P.
The National Gallery, London

Jacobus Blauw (1752–1829) was born in Gouda and studied at the University of Leyden. After a legal career in the Antilles, he returned to Holland in 1784 and was elected deputy to the States-General of the Low Countries. An influential member of the Dutch patriotic and liberal party, he took part in protest movements and greeted the advent of the French Revolution with enthusiasm. He participated in the creation of the Batavian Republic proclaimed in 1795 after the French invasion of the preceding winter, as well as in the conclusion of the treaty between France and Holland in May 1795. Blauw was then his government's envoy, together with one of his compatriots, Gasparus Meyer, whose portrait David also painted; both men were given the powers of Ministers Plenipotentiary in Paris.

David and Blauw became close friends, and in this portrait (which had been completed by the end of November 1795), David returned to the style of picture he had painted on the eve and during the early days of the Revolution: a stripped decor, eloquent forms, open colors, and a harmonious blend of all the elements. The ground is a simple scumbling that deliberately allows us to see the roughly applied brushstrokes and is smooth only around the face. A very ordinary chair and a wooden table covered with a green cloth are the only props. The back of the chair flares out like the frock coat. The horizontal lines of the work table make the model look firmly ensconced in his seat; his cushion is a short cape into whose folds David has slipped his signature. The suit itself is a very simple frock coat of a coarse fabric with brass buttons, moire waistcoat, and muslin collar.

David has introduced here (as in his portrait of the Lavoisiers) a small still life composition. Jacobus Blauw, whose name appears in capital letters at the top of the sheet of paper on which he is writing with his quill pen, is adding a note to a report with his right hand while his left hand clasps a tortoise-shell and gold snuffbox. A red and white checkered handkerchief, folded over, rests near his hand. The same handkerchief and a similar snuffbox reappeared twenty years later in the portrait of Sieyès, painted in 1816 in Brussels. On the one hand, this still life is linked to the model's personality—it is a reminder of his official functions—on the other, it is also linked to the composition itself: it is the quiet counterpoint to the objects in the painting.

The essence of the portrait is obviously the face, so genuine in its expression, which resembles reflection more than astonishment, and the hands, which are also so alive as they carry on their two disparate activities, one conscious, the other mechanical. The beauty of this picture lies in the treatment—which is as vigorous as it is warm—of the model, as well as the powerful simplicity of the construction and the splendid and subtle arrangement of the palette David selected for this canvas. Two tones dominate, the dark blue-green of the frock coat and the fresh tones of the face. This double brilliance is enhanced by the tonal variations: mauve and brown in the waistcoat and cape, green in the table covering, a bright red and a dull red in the chair and the handkerchief, all set against the green and brown tones of the ground, which matches the color of the model's eyes and serves as a delicate frame for the pink flesh tones.

This is a portrait in which youth and maturity, friendship and talent have come together with outstanding success.

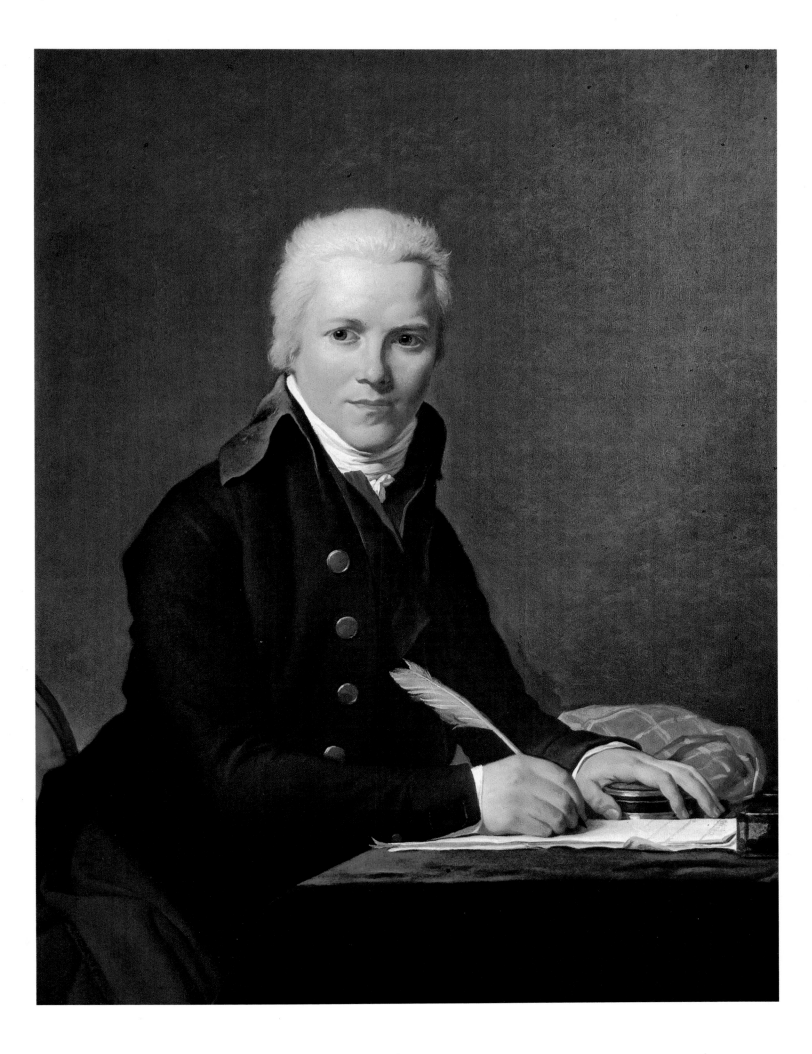

BONAPARTE

Oil on canvas, 31⅞ × 25⅝"
Paris, 1798
Unsigned
Musée du Louvre, Paris

This was David's first portrait of Napoleon, who was still only General Bonaparte at the time it was painted. Even in its unfinished state, it is the most moving, probably because it is the youngest and most spontaneous, of the portraits David did of Napoleon.

Disappointed and saddened by his experiences during the Revolution, David was instinctively seeking another hero, just as France was seeking a leader. Bonaparte was still a Republican general; he had pledged his revolutionary zeal under the Convention and the Directoire. He was an officer, and politically left-wing. He had been named Commander-in-Chief of the Army by Barras in March 1796.

Bonaparte sped from victory to victory, from Lodi to Castiglione and from Castiglione to Rivoli. He conquered the Milanese and Venetian Republics, the Duchy of Modena, the northern papal states; he created the Cisalpine and Ligurian Republics. In October 1797 he forced Austria to accept the Treaty of Campo Formio, which gave France the Milanese territory and the Low Countries. Bonaparte returned to Paris that autumn and stayed for several months; he assessed the measure of his immense popularity, the weakness of the Directoire, and the yearning of the French people for a stable, authoritarian regime. In an effort to turn this yearning to his own advantage, he sought the support of famous men.

Bonaparte arranged to meet David by having him invited to a dinner that Bonaparte himself was attending. He cajoled the painter, who, both flattered and dazzled, agreed then and there to paint a portrait of him. Bonaparte wanted to be represented at the site of one of his victories, at Rivoli, at the foot of the Alps, on horseback, at the head of his staff officers, holding the Treaty of Campo Formio in his hand. He wanted an allegorical painting celebrating him as both conqueror and peacemaker. David, who was then working on *The Sabine Women,* whose theme was one of reconciliation, waxed enthusiastic about the idea of bringing together in a new canvas the virtues of war and peace embodied in a living hero.

The sitting lasted only a few hours. Bonaparte was alone with David, then he left and did not return. David would not see him again until after his return from the Egyptian expedition. This brief encounter made a very strong impression on the painter. But how could he paint a canvas commemorating a victory at which he was not present, and a Treaty with whose text he was unfamiliar? How was he to represent a group of staff officers he had never seen? David wanted to wait until all these elements could be brought together, but by that time Bonaparte had other concerns. David was thus limited to tracing in the contours of his model and brushing in his face. He no doubt represented him as he had seen Bonaparte in his studio, standing, one fist on his hip, the other on his chest.

Bonaparte is young, less than thirty; he is already a conqueror and already famous, but it is toward the future that David turns his gaze, as if he can foresee his hero's glory. This is not a portrait of the present moment; it is the portrait of a flashing instant that crosses the path of destiny. Mixed with golden and ashy tones, the three-color palette of the canvas has the freshness and dash of a feverish youth.

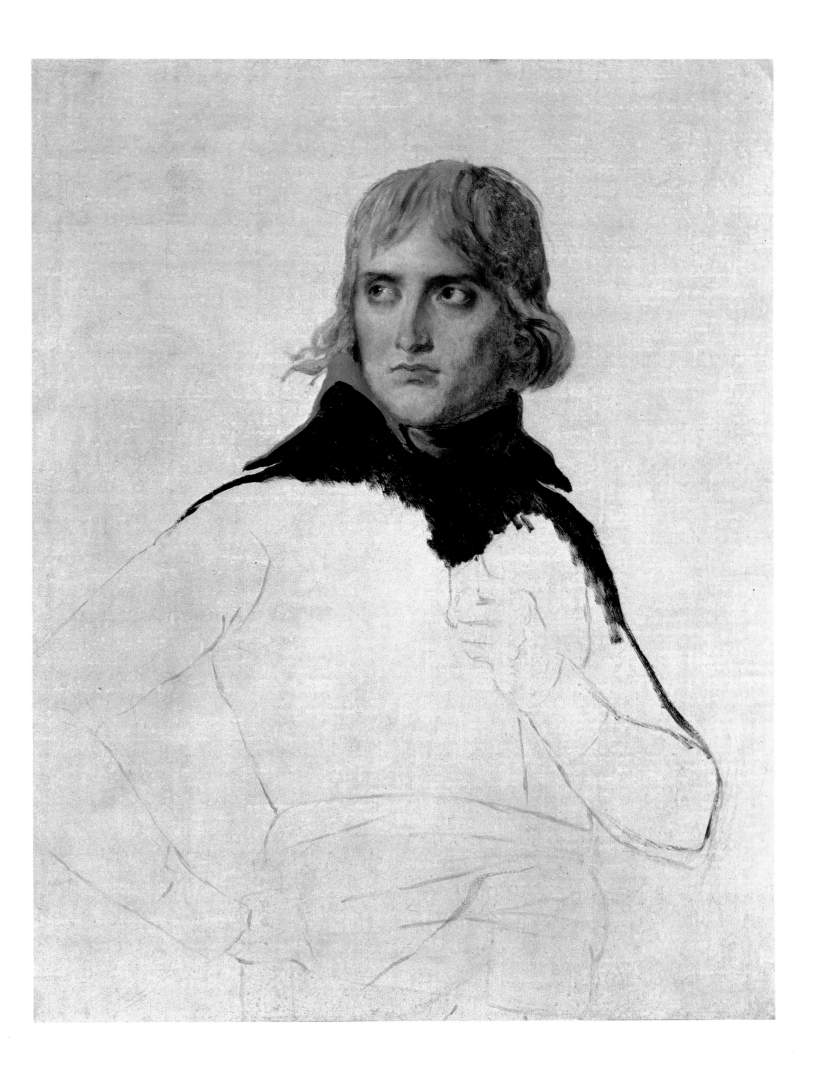

THE SABINE WOMEN

Oil on canvas, 12'8" × 17'3/4"
Paris, 1796–99
Signed: David faciebat anno 1799
Musée du Louvre, Paris

We are in the early days of Roman history. The Romans have abducted the daughters of their neighbors, the Sabines. To avenge this abduction, the Sabines attacked Rome, although not immediately, since Hersilia, the daughter of Tatius, the leader of the Sabines, had been married to Romulus, the Roman leader, and then had two children by him in the interim. Here we see Hersilia between her father and husband as she adjures the warriors on both sides not to take wives away from their husbands or mothers away from their children. The other Sabine Women join in her exhortations.

After many preliminary compositional sketches, which occupied him for some time, David chose to set out in a totally new direction, marking a turning point in his artistic development. He himself explained that, finally, he had wanted "to go back to the source" and "return art to the principles followed by the Greeks." It might surprise us that, in view of his intention to paint a picture that was "more Greek than the earlier ones," David chose a Roman subject. But the term "Greek Art" should be understood here in the ideal meaning of the term.

As in his previous history paintings, David strove simultaneously for truth and grandeur. His figures are at one and the same time human beings and heroes. He borrowed his attitudes from classical bas-reliefs and his figures from contemporary models..

The most striking thing about this painting is that the warriors are nude. David was inspired by the idea that the Greeks had represented their gods, athletes, and heroes in the nude. David was not seeking, as had Michelangelo, for example, to glorify masculine beauty, but rather to endow his heroes with a superior quality that, ultimately, was more moral than physical. With the exception of Romulus, these nude bodies are not particularly muscular. David wanted to refine, to strip away anything that was unnecessary, to reduce everything to a supreme, heroic simplicity.

The element that we probably find most seductive about this painting today is the way in which David has projected and controlled the tumultuous movement of all the figures, which he then brings to an abrupt halt. Hersilia and the other Sabine Women really seem to be bursting onto the scene, which they dominate. In contrast, the armies are only suggested, rather than represented, by a forest of lances, pikes, and standards; the leader of the cavalry puts his sword back in its sheath, the horses rear in a static, quivering motion; the two warriors who are about to clash are frozen in their attitudes, their furious precipitation arrested as they seem rooted to the spot.

David has also tamed his colors. Of his earlier palette, he has retained only some of the vivid reds on the shoulder of Tatius, Romulus's helmet, and the robe of the woman behind Hersilia; elsewhere, the reds are shaded with brick-toned hues. Some yellows, not as bright as in earlier paintings, a bit of green on the old woman's robe, and a bit of blue near Tatius's foot recall the tones David had once preferred. In contrast, the nude bodies, the walls of Rome, the standards and the pikes, the horse's hide, and Hersilia's tunic make up a spectrum of clear bronzed tones under a slightly tinted sky.

He has totally abandoned any attempt at chiaroscuro or shadow effects. The light is everywhere. He wants to show the light as a triumphant but gentle mediatrix, like the Sabine Women.

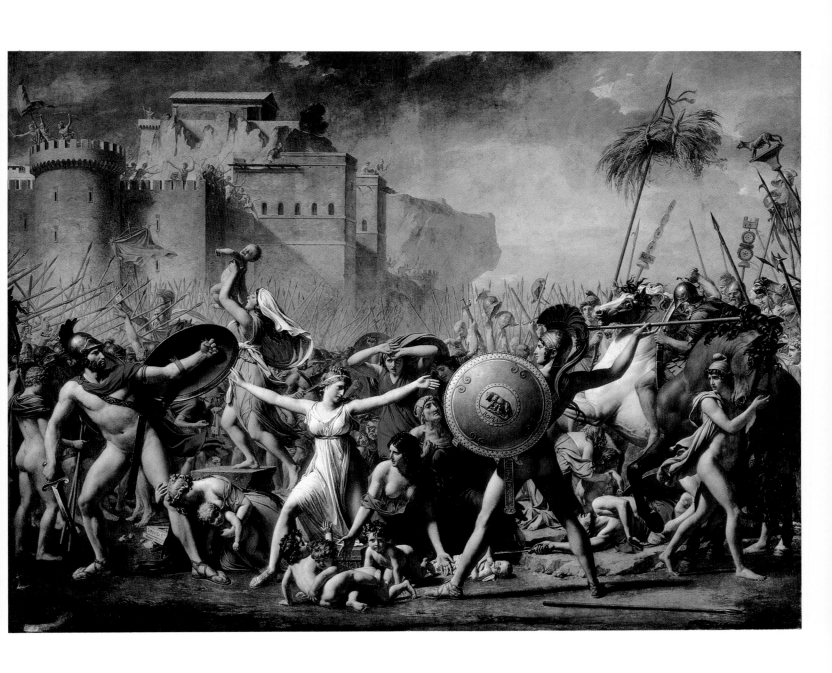

MADAME DE VERNINAC

Oil on canvas, 57⅛ × 47¼"
Paris, 1799
Signed: David. f. bat. Anno Septimo. R.G.
Musée du Louvre, Paris

This "beautiful and calm Juno," as she has been called, was the sister of Eugène Dela-croix, the painter who would become the leader of the Romantic School and strike the first decisive blows at the Classical School founded by David. But Eugène Dela-croix was not even two years old when this portrait was painted. (We might add that he was probably Talleyrand's son and thus only the half-brother of Madame de Verninac.)

Henriette de Verninac was not yet twenty when David painted her portrait. In 1798 she had married a thirty-five-year-old diplomat, Raymond de Verninac, who had already served as Minister in Sweden and Ambassador to Constantinople. When this portrait of his wife was painted, he had just been appointed Prefect of the Rhône.

Thus, in terms of her family background, Henriette de Verninac was from the same social milieu as David. We see her here in the full bloom of youth. She would later "brighten with her beauty" the prefecture of Lyons, where she settled. In fact, David did not leave Paris, so it must have been there that he painted Madame de Verninac, before her husband's departure for Lyons.

It is a kind of family portrait and even, one might add, a class portrait that David, the ever-truthful painter, has painted of this young woman who would later prove to be quite fierce in defending her position and whatever remained of her fortune.

Madame de Verninac gave birth to a son, Charles, in 1800, who was the favorite nephew and friend of Eugène Delacroix, only two years his elder. Delacroix would keep this portrait of his sister for his entire life, and paint her himself on her death-bed. Thus, David's art would occupy a material place in Delacroix's life, although the latter kept the portrait more in memory of his nephew than out of affection for his sister or admiration for the painting itself.

David did not disguise the young woman's peacefulness, the opulence of her flesh, her complacency, and this is where his merit lies. Henriette de Verninac was probably already pregnant when David painted her; perhaps this may explain the slight heaviness apparent in the face and body, which the drapery serves to emphasize rather than mask. Whether or not one favors "this style of beauty," the portrait is pleasing in its simplicity, its tranquillity, and its sculptural qualities.

The decor is reduced to a minimum. Madame de Verninac is sitting on a mahog-any Directoire chair with some simple bronze ornamentation. She is set off against a smooth background that does not reverberate to the slightest degree. She is dressed in a gown *à l'antique,* then very much in fashion, and to whose popularity David's con-tribution had been considerable. The folds of the gown are ample and soft. A cham-pagne-toned silk scarf crosses over her bosom and falls languidly into her lap.

There is something monumental about the face. It really is an incarnation of Juno we have before us, the goddess of voluptuousness, while Madame Récamier would be an embodiment of Venus. Furthermore, Madame de Verninac's gaze is without any mystery; the unblinking eyes add almost nothing—they have the limpid quality of still water. The mouth is sensual and the features fleshy. A few locks of hair brushed in with quick strokes seem to have emerged from one of Goya's canvases and provide the only movement, albeit of an orderly and symmetrical nature, animat-ing this face.

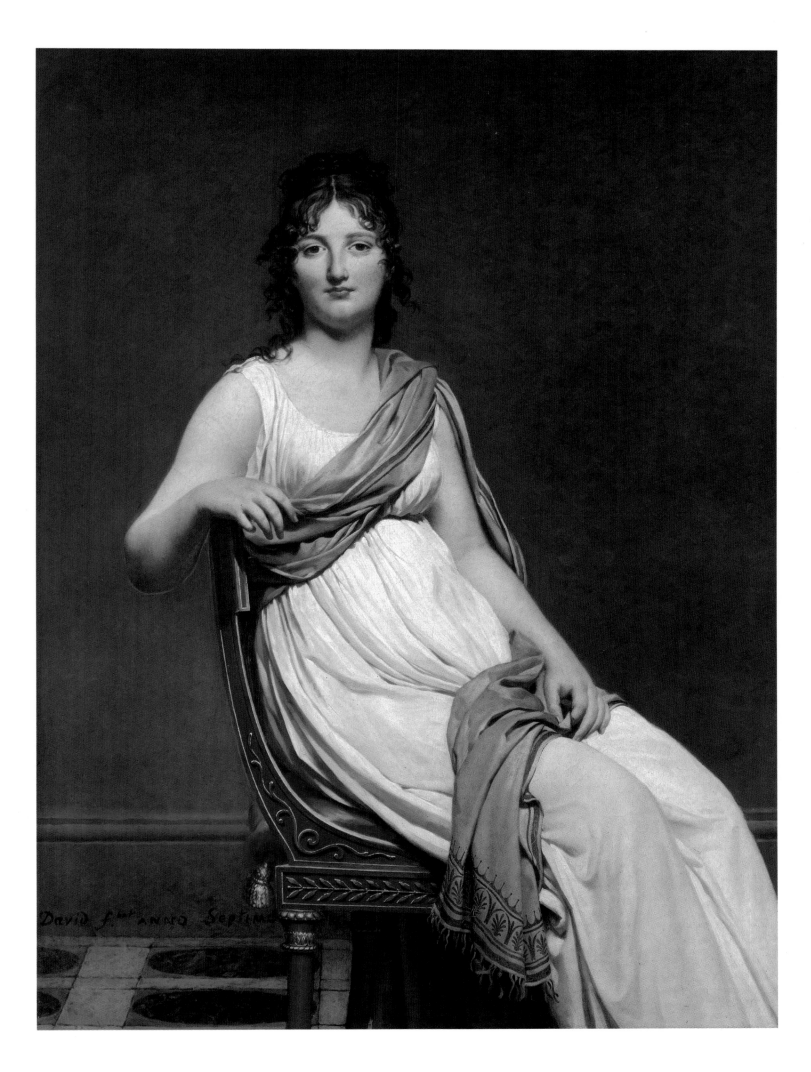

MADAME RÉCAMIER

Oil on canvas, 68½ × 96⅛"
Paris, 1800
Unsigned
Musée du Louvre, Paris

While he was beginning to work on the composition of *Leonidas* and his enthusiasm for Napoleon was growing, David devoted this painting of freshness and youth to charm and beauty.

Juliette Récamier had the attributes to enthrall a painter such as David. She was exactly twenty-three years old and was married to an immensely wealthy banker from Lyons who had settled in Paris. With her beauty, which was both adolescent and prepossessing, she had to the highest degree the gift of seducing others without giving of herself. Throughout her entire life she would enjoy dazzling social success, and the number of famous men who were subjugated by her charms without receiving anything in return—except, possibly, Chateaubriand—was countless.

Her seductiveness is already apparent. Juliette is exquisite; she is in fashion in a Paris recovering from its wounds, and which has ceased to be a wearisome stage for revolutionary rhetoric and civil grandeur—it is once more returning to the pleasures of living. Amidst the survivors of the Ancien Régime and the ambitious men of the new upper classes, she appears like a new breed of flower.

For her part, Madame Récamier is flattered that, young as she is, her portrait is being painted by the most illustrious portraitist of her generation and, no doubt, she is delighted to have at her feet one of those terrifying Revolutionaries she had heard so much about—without actually having known any. She went to his studio in secret for her sittings. This explains the totally stripped background, the divan made by Jacob for David before the Revolution, and the lamp, which had already appeared in *The Death of Socrates;* accessories which, furthermore, conformed thoroughly to the tastes of the day. If David entrusted to Ingres (his pupil at the time) the execution of some of the accessories, he reserved the actual portrait for himself.

Madame Récamier did not like submitting to the discipline of holding the pose David had chosen for her; additionally, she had also commissioned another portrait of herself from Gérard, a pupil of David's. David finally became irritated and wrote to her: "Madame, ladies have their caprices, so do artists. Allow me to indulge mine. I will keep your portrait in its present state." But the painting seems to be fully finished. It is difficult to see what might have been added that would have been important, much less essential.

The decor is even more neutral than in David's other portraits. The vertical blends into the horizontal and the tones are in harmony, rather than in contrast. David tried to represent his model in that spirit of simplicity which attracted him to Greek art, and which inspired the fashions of the time. Juliette's long floating gown barely outlines her body and its folds fall softly to the foot of the stool. Her throat is bare, as are her arms and feet. From one end of the painting to the other, the forms balance each other and harmoniously fill in the broad expanse of empty space. The entire composition, in its refined simplicity, is a discreet tribute to youth, grace, and to the ideal power of beauty.

As André Maurois wrote about David's painting: "His Madame Récamier, unfinished, is admirable for the grace of the pose, but also for the complexity of her expression. This grave, somewhat sad, questioning look, the imperceptible hardness of her gaze, this seriousness in frivolity and the firm set of her mouth, all this helps us, more than volumes of description, to solve the enigma that was Juliette."

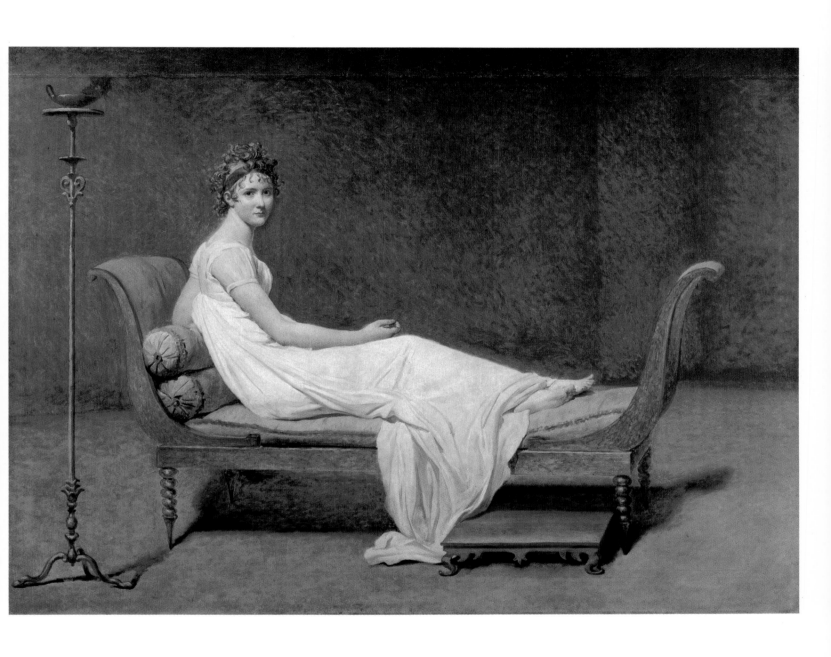

BONAPARTE CROSSING THE SAINT-BERNARD

Oil on canvas, 8'10⅝" × 7'7¼"
Paris, 1800–01
Signed: L. David, L'an IX
Musée National du Château de Malmaison, Rueil-Malmaison

This painting is prodigious in the literal sense of the word. It upsets the laws of equilibrium and probability. It carries us high up above the mountains into the realm of the demigods. David himself was carried away by a new, consuming passion: Napoleon Bonaparte. He had pursued the dream of bringing together the real and the ideal, and finally his dream had materialized.

Bonaparte, who was now First Consul, had finally taken up again the idea of having his portrait painted after his victory at Marengo, in June 1800, which had opened up all of Northern Italy to him. The subject is merely a pretext. Bonaparte had in fact crossed the Alps at the Saint-Bernard pass in May 1800 on the way to his second Italian campaign, although on a mule, rather than on horseback. David himself had crossed the Alps on his way to Italy, but he obviously viewed the landscape only as a setting for his hero and not as a subject in itself.

He thus invents here an extraordinary landscape filled with huge rocky cliffs and clouds with jagged edges like the mountains. The diagonal lines of the cliffs and the clouds charge toward and cross over each other like swords clashing. The site is lofty and unreal, with rugged lines and soft tones, as might be appropriate to a hero's heavenly abode. This landscape has a singular pictorial beauty insofar as it is dominated by a single tone: gray.

Our attention is focused on the horse and its rider. David painted the horse rearing. The scene swirls, as a raging storm whips the horse's tail and mane. Bonaparte's cloak is blown out by the wind in a burst of lyricism, endowing the violence with a romantic grandeur. But the horseman remains impassive, exerting his dominance over the scene. It is not only the wind that energizes the scene, crackling with electricity—it is glory itself, and glory is, in its turn, vanquished by the Conqueror's gaze. Quivering and submissive, it is held tightly within the geometric order of the painting. David possesses the art of simultaneously unleashing and reining in, of capturing the impetus of a movement and transfixing its impact.

The horse and uniform are Bonaparte's. The First Consul had insisted on an exact likeness of his favorite horse, but not of himself—his main concern was that the presence of genius be apparent. The uniform is the one he wore at Marengo, which the painter obtained from the First Consul's valet de chambre. On the other hand, the idealization of Bonaparte's countenance is passionately rendered. The impetuous eyes looking at the painter are those of a master and a hero. For us, the eyes are meant to blaze like bolts of lightning that pierce through the storm and subdue the maelstrom.

At Bonaparte's feet we see a stream of tiny soldiers, half-hidden in the craggy mountain pass, as they hoist the mount of a cannon up the slope of the Saint-Bernard. In the background on the right, a small flag behind the parade of bayonets reminds us that these figures are soldiers in Bonaparte's Army. David gave them no more importance in his canvas than the painters of the Middle Ages gave to the crowds that appear in their great religious paintings: they are merely the mute and obscure servants of their leader's greatness. On the rocks at the bottom of the painting, on the left, can be read the names of two of Bonaparte's most illustrious predecessors who also crossed the Alps—Hannibal and Charlemagne.

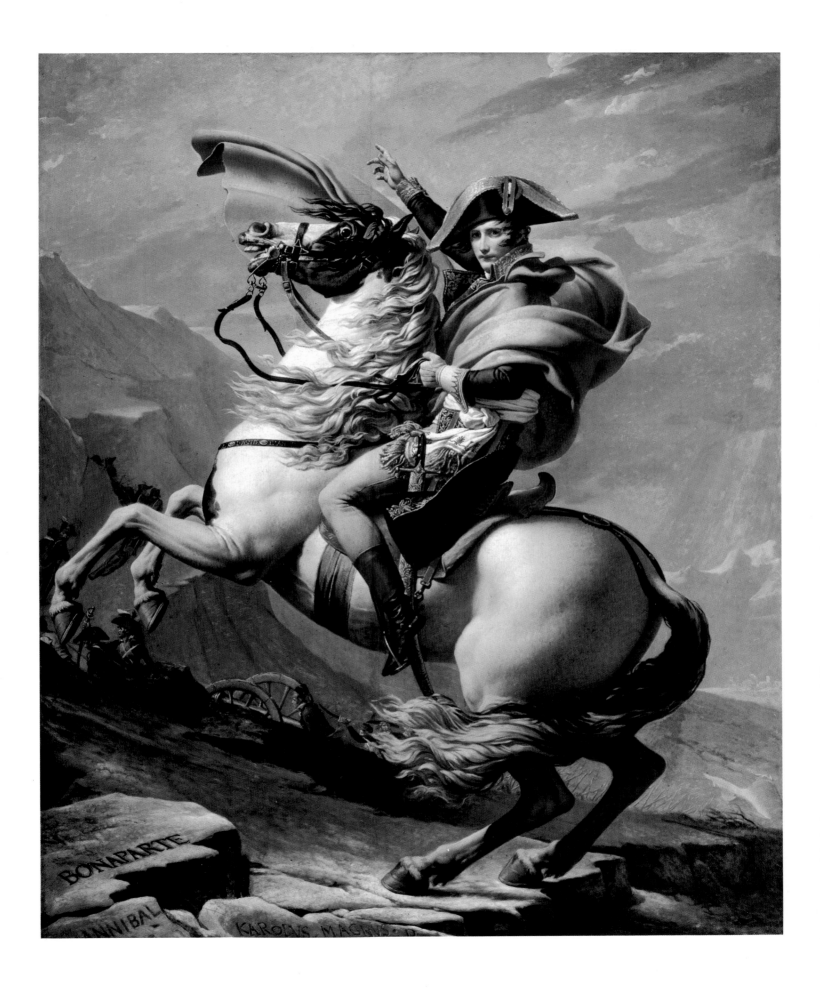

POPE PIUS VII

Oil on panel, 33⅞ × 28"
Paris, 1805
Signed: Lud. David, Parisiis, 1805
Musée du Louvre, Paris

Commissioned to paint *The Coronation of Napoleon and Josephine,* David wanted to begin by painting his major characters from life. He started with the Pope, who would shortly be returning to Rome.

Pius VII, elected in 1800, thought that the reestablishment of the Catholic Church in France was well worth a Coronation Mass and the company of a few miscreants. The Pope hesitated, however, to have himself painted by David. He was said to have been concerned about finding himself alone with a man "who had killed his King and who would make short work of a poor papier-mâché Pope."

The first meeting between the two men took place at the end of December 1804, and the ice was quickly broken. His heart and spirit overflowing with emotion, David brushed out a sketch of the Pope reflecting his model's simplicity. He drew inspiration from Raphael and Velásquez, who had painted Jules II and Innocent X seated in the same majestic and serene manner. The background is somber and neutral, as usual. The Pope is garbed in what could be called his "official uniform"—a cassock, a mozzetta of red velvet trimmed with ermine (the Pope was unaccustomed to the chill of a Paris winter), and a stole of red and gold brocade. In his right hand the Pope is holding a piece of paper upon which can be read the words: *Pio VII bonarum artium patrono,* in homage to his supposed love of the arts, or rather, to his kindness toward David.

The focus of the painting is the beauty of the face—humble, grave, and alert at the same time. The Pope was sixty-three years old. A former Benedictine monk, he was a man of a studious and reflective bent; mild-tempered, inclined toward conciliation and forgiveness, he was subsequently to resist Napoleon, who had him deposed in 1809 and who confiscated his states. Restored to power upon the fall of the Empire, he interceded with the European Courts to plead for the release of Napoleon, who was being held captive on Saint Helena, and he welcomed Napoleon's family to Rome. If he refused to allow David to settle in Rome in 1816, it was to satisfy the Allies; and probably also because of his concern about provoking some sort of incident with the arrival of a man whose quarrels with the Académie de France in Rome had indirectly been the cause of anti-French riots that had caused bloodshed in the streets of the Eternal City in 1792.

Such was the Pontiff David painted in February 1805. He faithfully rendered, with respect and even affection, the Pope's very Italian face: black hair and eyes, olive skin. With great delicacy, he also conveyed the man's humility, his fine scruples, as well as his inner strength, his willingness to go to great lengths to bring about a state of reconciliation while refusing to compromise his basic principles, his firmness (which was of a spiritual rather than a physical order), and his habit of intellectual study, if not of prayer.

David did not paint a religious portrait. He penetrated to the man's soul, but he barely touched upon any metaphysical aspects. This is what makes the portrait so modern and so human. David shows us, in his subject's gaze, a sort of spiritual uneasiness, a charitable nature that was both ardent and lucid, as well as an attitude toward the Napoleonic adventure that was at once indulgent and alarmed. David was not mistaken when he said that he had met "a true evangelic," and this is what he painted.

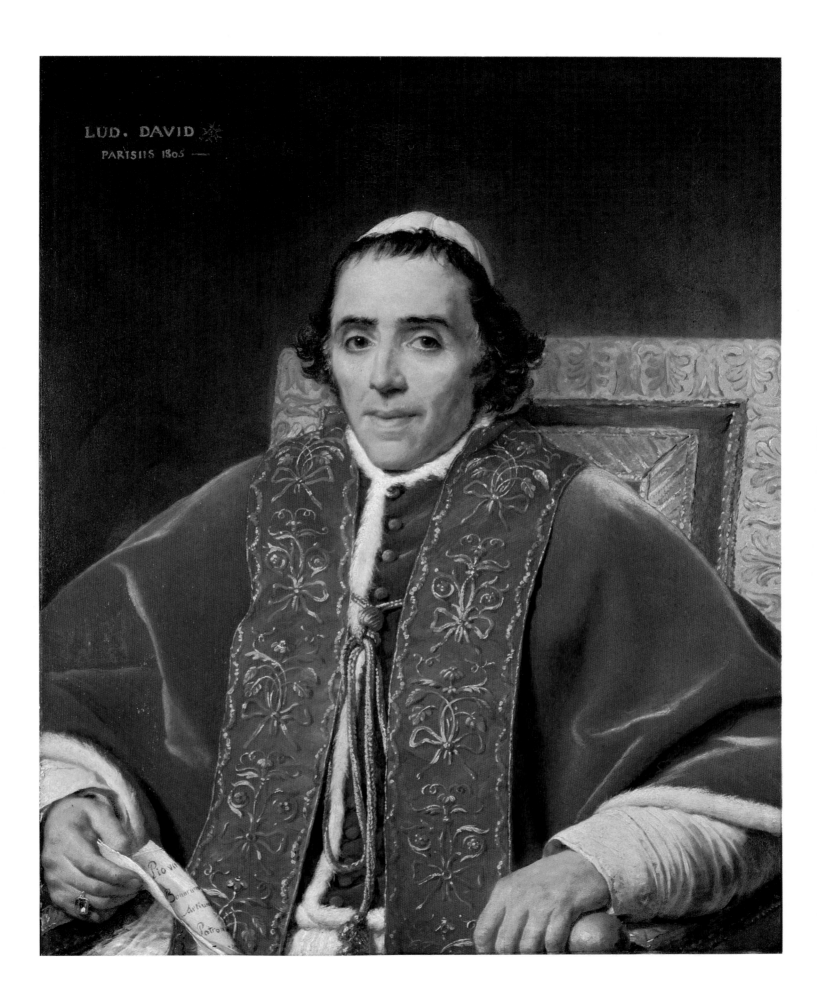

THE CORONATION OF
NAPOLEON AND JOSEPHINE

Oil on canvas, 20' × 30'6½"
Paris, 1805–07
Signed: 1805–1807, L. David f.
Musée du Louvre, Paris

It was to David that Napoleon addressed himself at the end of 1804 when he decided to have four large canvases executed in commemoration of the founding of the Empire. One of these was to be devoted to his Coronation Ceremony on December 2, 1804.

The Emperor had wanted to make this ceremony exceptionally brilliant. Renewing the tradition established by Charlemagne, whose moral successor he claimed to be, he asked the Pope to crown him but, unlike his distant predecessor, he did not go to Rome—he invited, or rather commanded, the Supreme Pontiff to come to Paris.

If David had remained within the confines of a literal conception of the Coronation, he would have had to position Napoleon at Pius VII's feet and relegate Josephine to a subordinate position. This would have conveyed a false impression of both the actual relationship between the Emperor and the Pope, as well as Napoleon's feelings toward his wife at that time.

Fortunately, David was familiar with another famous painting, *The Coronation of Marie de Médicis,* undertaken by Rubens to celebrate Henry IV's marriage to her. In this canvas, which is in the Louvre, the two sovereigns are facing each other: the King crowns the Queen. Napoleon, still very much in love with Josephine, agreed to this gracious and tender representation.

It was probably the need for clarity and order that impelled David—as in *The Tennis Court Oath*—to adopt a horizontal composition rather than an axial view or a view from above. His success is dazzling. The arrangement is spacious and perfectly balanced. He provides some space in the foreground, which he fills with the large green velvet rug dotted with the imperial bees. He lowers the group of dignitaries on the right to avoid having the composition look as if it were posed on an artificial stage. While, in reality, the figures could only have been distributed equally on either side of the axis of the nave, we see how bold and felicitous his choice was—he sweeps the static line of subjects slightly upward in a supple, almost gentle movement, that seems to place the major characters on an oblique plane without imparting to them an eminence that might seem artificial. There is something like an ascending movement, starting slowly on the left, more pronounced on the steps to the altar, and soaring upward on the right toward the large crucifix and the candles without, however, giving the religious elements of the scene any preeminence over the Emperor and Empress. These figures remain the focal points and are sufficiently distanced from each other so that our attention fixes on each in turn.

He leaves two-thirds of the space in his canvas free; the galleries can be glimpsed through the archways. The sumptuous decorations of the interior of the cathedral, faithfully reproduced, add to the solemnity of the spectacle.

For the colors, David borrowed certain formulas from Rubens and Veronese, but the tones are characteristically his: the whites, reds, golds, and blacks dominate, but the colors are still sober and they serve, above all, to enhance the natural brilliance of the materials: velvets and golds, damasks and satins, ermines and plumes. The light is golden with a honeyed hue; it is luminous and soft, warm and sacred. It reigns supreme over the scene with, as almost the only dark element, the broad, oblique band of shadow cast from the upper left portion of the canvas and extending in the direction of the Emperor.

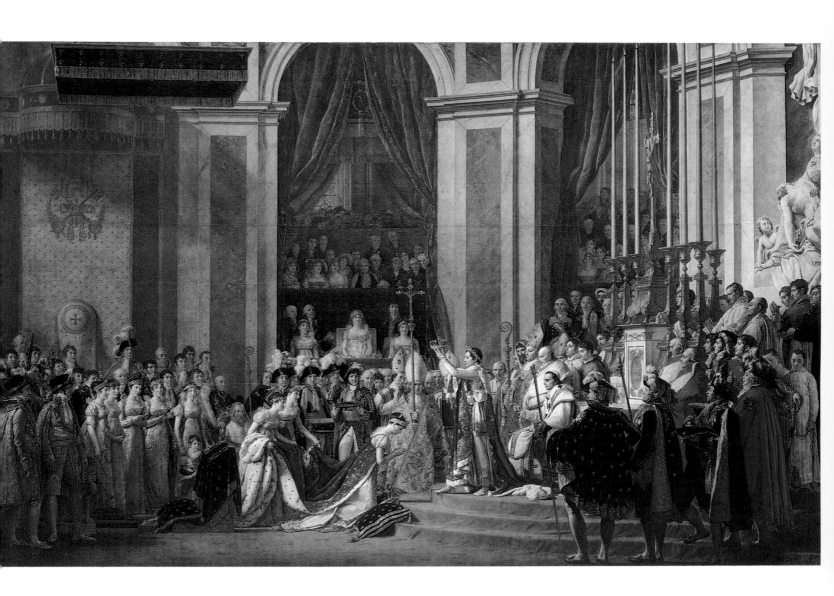

THE DISTRIBUTION OF THE EAGLE STANDARDS

Oil on canvas, 20′ × 30′6½″
Paris, 1808–10
Signed: David faciebat 1810
Musée National du Château de Versailles

This painting was intended to evoke "the distribution" by the Emperor of the standards to the regiments of the Army and the National Guard for the different *départements*. These standards bore the insignia of the eagle in memory of the Roman Legions—from whence came the title of the painting.

The ceremony was held at the Champ de Mars, on December 5, 1804, three days after the Coronation. Huge porticoes had been set up on the facade of the École Militaire and, in front of these, a platform upon which the Emperor took his place, surrounded by his family and the highest ranking men of state. The colonels of the regiments and the presidents of the electoral colleges stood on the steps of the platform with the flags already given them, which they offered to the Emperor as tokens of their esteem. In turn, Napoleon invited them to swear an oath of allegiance upon their eagles. The densely packed civil and military delegations, in column formation on the vast esplanade, advanced one by one to receive their standards and repeat the oath of the standard-bearers.

David shows the Emperor in the robes he wore for the Coronation Ceremony and crowns him with the same laurel wreath, but he makes him into an idol rather than presenting him as a human being. Majesty overshadows life. The figures from the Court have taken on a new gravity. Josephine, repudiated in 1809 when the painting was near completion, was removed from the final version; her two children, Queen Hortense and Eugène de Beauharnais, remain in their original positions, while David has filled the blank space to the Emperor's left, and on the steps to the platform, with secondary personages.

This group is depicted in a way that reflects the dual nature of the commission's original subject: spontaneous enthusiasm and official consecration. David succeeded in creating the impression of a living group only with the standard-bearers; his marshals gesticulate and form a sort of screen. The Court is stiffly articulated and the Emperor dominates the crowd with his imperial attitude, but stands out from it somewhat awkwardly.

It is regrettable that Napoleon, who had come to watch David execute the painting, insisted upon the elimination of the winged figure of Renown which, in the sky on the right, was distributing laurel wreaths to the soldiers; Napoleon obviously did not wish to have a rival in the picture. Her absence, however, unbalances the painting and deprives it of a certain freshness. Of the Champ de Mars, all that remains is an allusion to it in the form of a row of poplar trees at the bottom of the painting on the right. The true meaning of the setting, which is pompous and overwhelming with its porticoes, columns, and tapestries, is found in the vivid red, which, since ancient Rome, has symbolized the triumph of arms.

The weaknesses of the painting's composition, however, do not obscure the fact that, to a greater degree than in David's other paintings, this one displays a sumptuous harmony of colors. The tones that dominate are those of the tricolor flag, the red, white, and blue disposed so felicitously that it is only upon reflection that we put them together and grasp their symbolic significance. The warmth of the velvets, the brilliance of the gold touches enhance the magnificence of these colors without usurping their role, which is to sing of patriotic feeling and military glory.

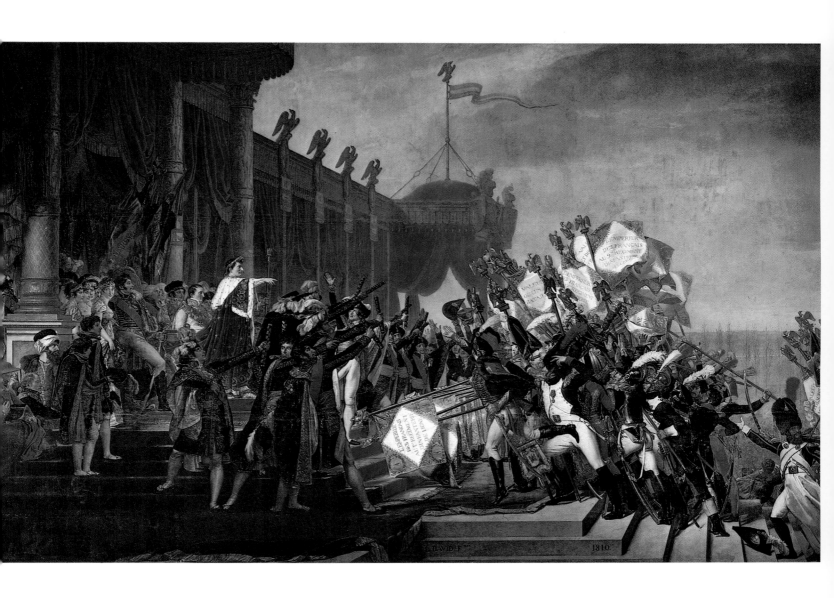

COUNTESS DARU

Oil on canvas, 28¾ × 23⅝"
Paris, 1810
Signed: David 1810
The Frick Collection, New York

Alexandrine Nardot (1783–1815) married Pierre Daru (1767–1829), one of Napoleon's most outstanding collaborators, in 1802. Pierre Daru was a workhorse, of a somewhat dry, unsentimental nature. Alexandrine was already the mother of his six children at the time this portrait was painted. She was twenty-seven years old.

Stendhal, who was Pierre Daru's cousin (and who was in love with his cousin's wife), heard about the portrait from her and came to observe one of her sittings. He noted in his journal: "I come from watching David paint. He is a collection of petty concerns, from the way to sign one's name to the differences between a history painter and a miniaturist apropos of a page's costume he sent to the Emperor. These people spend their souls in pettiness, it is not surprising that they have no soul left for great things. Moreover, David does not have the wit to hide this constant, petty vanity or to keep from demonstrating incessantly his importance in his own eyes. He signed the painting on the stroke of four, March 14, 1810."

Stendhal says nothing about the actual portrait, and, at any rate, even if he respected David's talent, his journal entry makes it quite clear that he did not like the man himself. Stendhal also reproached the painter, especially in the context of David's history paintings, for his coldness.

Illusion seems to have played a major role in Stendhal's courtship of his cousin-by-marriage—she never displayed anything but friendship toward him—coupled with a physical desire that he felt at the same time for many other women. Moreover, his desire may have been whetted by the very obstacles that separated them. In his more lucid moments, he was capable of observing that she was a simple, gay person who was friendly toward everyone, without the slightest trace of moodiness, but also without the slightest tendency toward abandon.

It is this temperament that David portrays for us; in the woman's eyes there is a look that is surprised, kindly, but also slightly indifferent; makeup gives some color to her cheeks and a smile plays around her lips. Her look is natural, almost playful, but she also seems somewhat limited, and it is difficult to detect any delicacy in her manner. She seems to be living a perfectly conventional life, and her gratifications would seem to be mainly material or moral.

The strength of the painting comes from the psychological truth David succeeded in capturing on canvas, from the superb arrangement, and from the harmony of the colors.

The model is admirably set off against a dark, smooth, green-gray ground which harmonizes with the flesh tones as well as with the tones of the clothing. Alexandrine Daru is wearing a formal gown of pearly white satin with tulle trimmings, a reversible green scarf with a pattern worked out in green, red, and yellow, a diadem of white orange blossoms, and a necklace of turquoises, pearls, and brilliants. With the fingers of her right hand she holds a fan. She is sitting on a mahogany chair with a gold sphinx mount and covered with blue-bordered yellow fabric. The relationships between the whites verging on gray, the reds verging on pink, and the light and dark greens are remarkable for their balance and elegance; and yet, it is not so much the portrait of a society woman we have before our eyes as an example of true, pure painting.

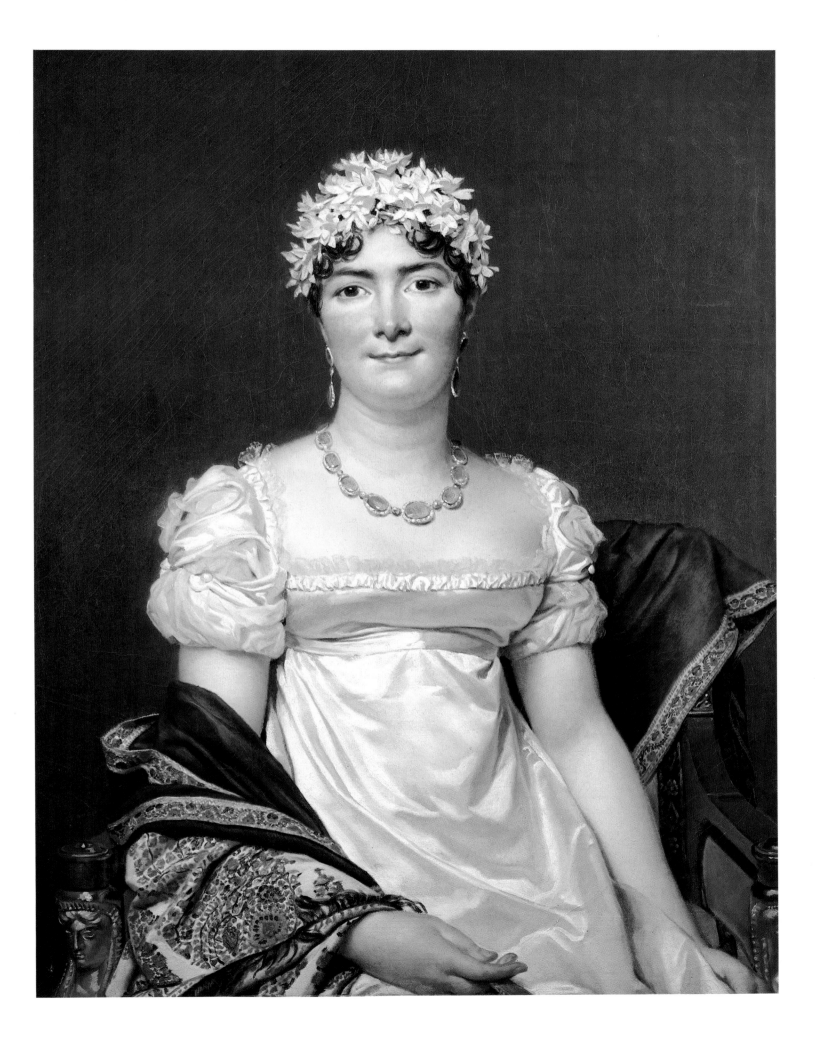

COUNT FRANÇAIS DE NANTES

Oil on canvas, 44⅞ × 29½"
Paris, 1811
Signed: L. David 1811
Musée Jacquemart-André, Paris

Antoine Français (1756–1836), from Isère, was the Director of Customs at Nantes—from whence his surname—at the beginning of the Revolution. Enthusiastic about the new political ideas, violently anticlerical, he was elected deputy from the lower Loire to the Legislative Assembly where his talents as a financier attracted attention. He was named President of the Assembly, and was close to the moderates. Under the Convention, he went into hiding in Isère and surfaced again in 1796 as a member of the Council of the Five Hundred, the legislative organ of the Directoire. After the 18th Brumaire, he supported Napoleon (although not without reservations), and embarked upon a new and brilliant career.

In succession, he was the Director of Hospitals, Prefect, Councillor of State, Count of the Empire, and Directeur Général des Droits Réunis; he also made a fortune. Stendhal described him as a "powerful financier" and an administrator the likes of which no despot had ever known, ranking him among men "of great intellect and shrewdness" and as one of the "leading Councillors of State," although adding that he "attracted ridicule." Français also had some literary talent and a reputation as a wit. He became deputy from Isère under the Restoration and Peer of France during the July Monarchy.

This portrait makes us wonder what the model was really like: his flushed face, his hooked nose, the condescending curves of his mouth, that gaze in which he tries to express self-assurance, but which demonstrates a kind of vague uncertainty—all point to a man satisfied with his career, who derives intellectual and moral comfort from his position, a position that serves as a substitute for greatness.

His magnificent uniform as Councillor of State bestows a sort of reflected glory upon him. The taffeta sash, the lace and velvet of the costume and the plumed hat ennoble his vanity. The ink-black background emphasizes his self-satisfaction. Count Français de Nantes may well be pleased with himself; he has all the gravity, the trappings of nobility, and the sumptuousness in surroundings that an Empire can offer its obsequious servants. The broad ribbon of Grand Officer of the Legion of Honor (which he had recently received), is prominently displayed upon his breast.

Almost magically, David has arranged the whites, blues, greens, and blacks to make this painting a velvety and satiny enchanted world. Moreover, what brilliance in this decor! In this involuntary self-searching before an invisible mirror, what pathos, what truth! What a masterful composition! To transform this grandiose, inflated bourgeois, this ennobled Revolutionary, this body awkwardly seated in a place of honor, this opera-buffa costume, into a grand and solemn pyramid fluffed out by the plumes, but draped as if with an altar cloth—what art!

It would be a serious mistake to try to see the history painter in David as separate and distinct from the portraitist. They complement and complete each other. In his respect for his models, in his intuitive grasp of their inner truths and their histories, and in the pleasure he takes in setting the stage—which is like a muted echo of the attraction glory always had for David—he discovers the elements for a synthesis that brings the individual and his epoch together in a breathtaking encounter.

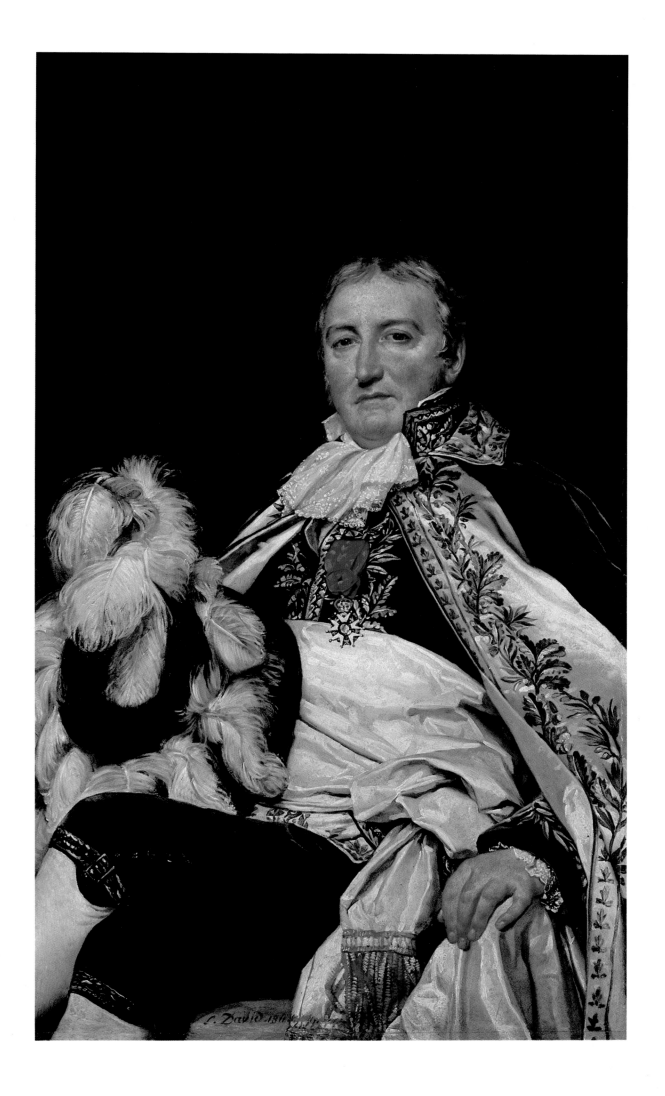

NAPOLEON IN HIS STUDY

Oil on canvas, 80¼ × 49¼″
Paris, 1812
Signed: Lud. David opus 1812
The National Gallery of Art, Washington, D.C.
(Samuel H. Kress Collection, 1961)

David's last painting of the Emperor was not commissioned by Napoleon, but by an Englishman, Lord Douglas, who was a great admirer of Napoleon in 1810, when England was at war with France. This commission might seem somewhat unusual, but Lord Douglas, future Duke of Hamilton, was a member of an old Scottish family, and Scotland had formerly been France's ally against England. Lord Douglas was himself a descendant of James Stuart. A friend of Pauline Borghese, Napoleon's sister, he entertained fanciful notions about Napoleon's support for the restoration of the Stuarts to the British throne.

No longer able to work directly for the Emperor, David, with a certain nostalgia, began to execute Lord Douglas's commission. It appears that he painted it over a three-month period from January to March 1812. Napoleon did not pose for this painting. David painted it after the already existing portraits of Napoleon and his observations of the Emperor at public appearances. He borrowed the details of the decor and accessories from information provided by acquaintances and from his own knowledge of the imperial furniture.

Napoleon, then only forty-two years old, already showed the signs of fatigue and of ill-health that would send him to his grave prematurely. It was his habit to rise between three and five o'clock in the morning to deal with important matters. It was precisely at that early hour that David has portrayed him—the clock shows 4:12.

David thought it inappropriate to portray the Emperor in a dressing gown, so he chose to represent him in his normal daytime attire, the uniform of a Colonel of the Grenadiers, ready to review his troops in the early morning hours; the usual medals have been added—the insignia of the Legion of Honor and the Iron Cross, the two orders Napoleon had founded, the second of which he founded as King of Italy. These details, all public knowledge, were faithfully reproduced by David.

Napoleon stands in front of his desk, his right hand tucked into his waistcoat in a characteristic gesture; his face is puffy, his gaze a trifle heavy, perhaps from fatigue. Something of his former brusqueness remains in his features, but it is so attenuated that one has to look closely for it in the aquiline nose and the thin mouth. His disheveled hair is a reminder that Napoleon cared as little about how his hair was dressed as he usually did about his attire.

The beauty of the picture is not only in its sober composition and the harmony of its colors, the gold and red of the furniture, the white of the clothing, the blue of the velvet; it also comes from the honesty of a very great portraitist. Forced to work without his model, David did not take the risk of attributing details to Napoleon's features or portraying nuances of facial expression that he could not verify personally; he merely wanted to record his own humble, sincere admiration.

Although Lenoir wrote that this portrait was the best likeness done of the Emperor at that time, the image seems to be a symbolic representation, no doubt inferior in spirit to the passionate model himself, but superior physically, given the ravages of fatigue and illness that were beginning to take their toll. It is no longer Napoleon the hero David is invoking but, rather, the leader whose burden he wishes to share. This weary and distant portrait is the farewell of an absent Emperor to a painter who is still moved and touched by the imperial image.

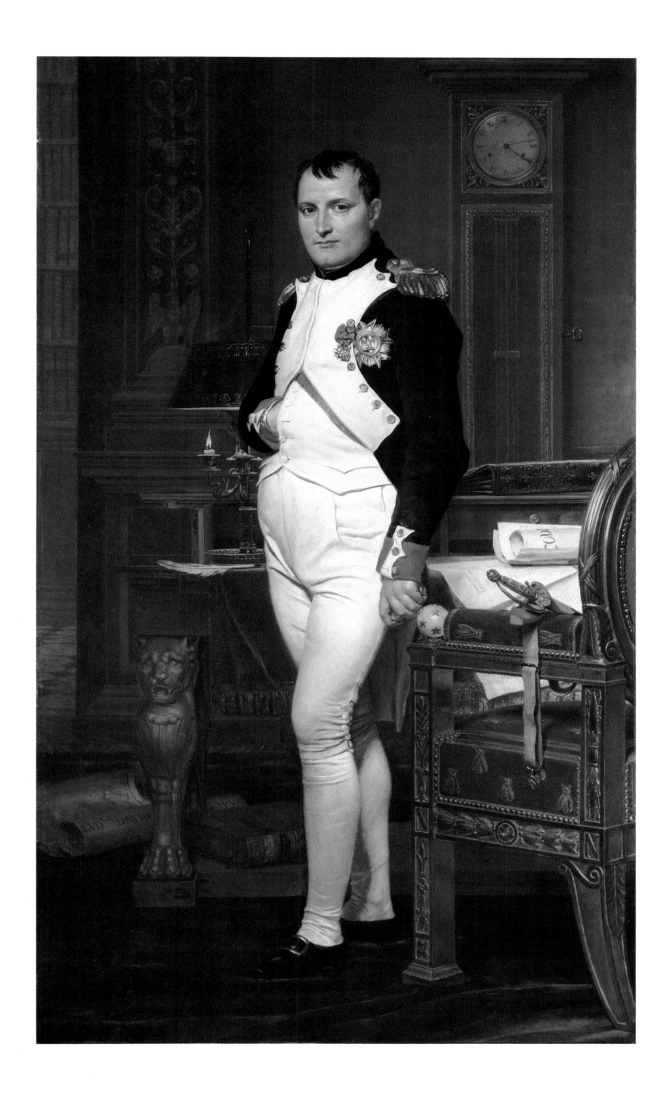

MONSIEUR AND MADAME MONGEZ

Oil on panel, 29⅛ × 34¼"
Paris, 1812
Signed: Amicos Antonium Mongez et Angelicam uxorem
 amicus Ludovicus David. Anno MDCCCXII.
Musée du Louvre, Paris

A former canon who had been defrocked, deputy to the Convention, Antoine Mongez (1747–1835) sat with David on the benches of the Montagne: passionately interested in history and the art of Antiquity, member of the Académie des Inscriptions in 1785, he was appointed Secretary-General of the Institut at the same time David was elected to that body at the end of 1795. His passion for numismatics was to win him the post of Administrator of the Currency in 1804, which he occupied until 1827.

His wife, Angélique (1775–1855), whom he married in 1796, was almost thirty years his junior; she was the daughter of an accountant who was also David's business advisor. David had given her painting lessons, it was said, to the point of correcting the paintings she sent to the Salon. She painted several portraits and history paintings and illustrated her husband's *Dictionnaire d'Antiquités* with numerous figurines.

David painted this portrait at a time when he felt unsure of Napoleon's favor as well as of the authority of his own School. He was also worried about the Empire's future and about the safety of one of his sons, who had followed the Great Army.

David has portrayed Antoine Mongez in his beautiful uniform as member of the Institut; his hand rests on a book, which must be his *Dictionnaire d'Antiquités*, and his fingers clasp the medal he engraved of Napoleon after an image done by David. His wife is wearing what would be called today a cape and an evening gown. The brocade folds are draped over her left arm. This could be a state portrait, but their finery does not change their simple manners. As usual, David presents them both against a neutral ground, although black is the dominant note that animates the background as well as their clothing.

The focus is on their faces: their vigorous coloring stands out sharply. The two faces look at the painter with parallel intensity. Held within the bounds of the painting, they look like a couple in a theater held within the frame of their box in the balcony; they offer themselves together, in parallel, to the painter's gaze to form, as it were, a single object.

They are different from one another, however, in several ways. He has short, disheveled hair and an authoritarian look, somewhat softened by his attentiveness, a strong nose and a thin mouth; in the way his hand is posed on his book, and in a certain sharpness of his features, we can see a fine and precise mind. He is a scholar and an expert, a lover of beauty, as well as a lover of precision—he has a strong mind, which could wax enthusiastic over either principles or passions. His wife has softer features, a friendlier expression: instead of closing on a thin mouth, her face opens up in the smile playing about her lips; her large eyes have a sensitive charm. She is more artistic than her husband; she is affectionate and she is curious in a way that is at once serious and cheerful. He must be dry and sometimes brusque in his speech; she is more pleasant and quite charming.

David paints them both as he sees them and as he loves them. He values the vigor of one and the childlike grace of the other. He wanted to pay homage to his friends and to their feelings for each other.

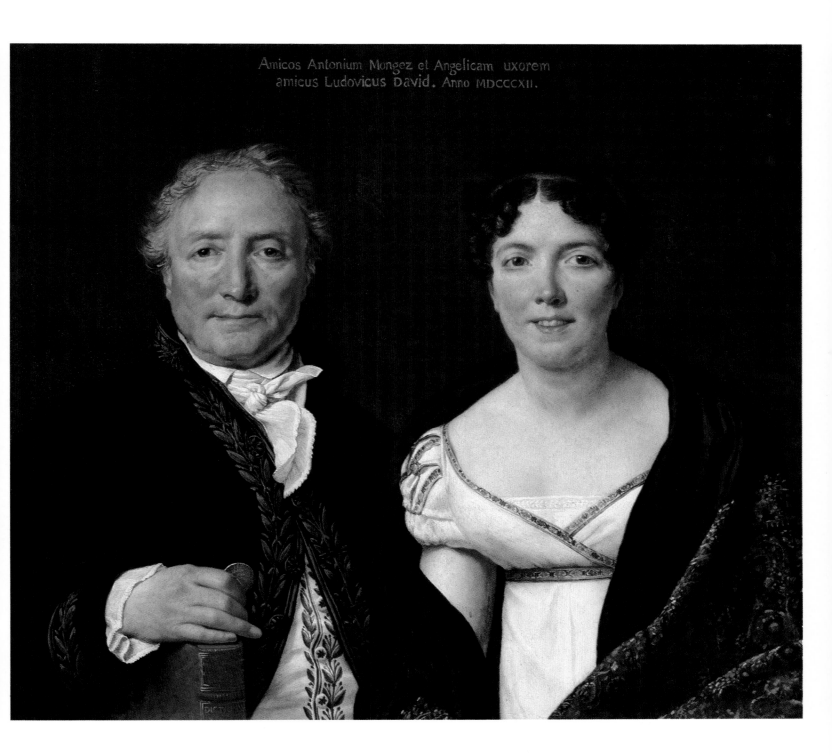

MADAME DAVID

Oil on canvas, 28¾ × 23¼"
Paris, 1813
Signed: L. David. 1813.
The National Gallery of Art, Washington, D.C.
(Samuel H. Kress Collection, 1961)

David painted almost all the members of his family and his wife's family, with the exception of his mother (with whom his relationship appears to have been somewhat distant), and one of his sisters-in-law, Constance Hubert (whom he did not like).

That he apparently did not paint a portrait of his wife, Charlotte (1764–1826), before 1813—after thirty years of marriage—while he painted portraits of his father- and mother-in-law soon after his marriage, and within the next few years, produced portraits of his wife's sister and his brother-in-law, Emilie and Charles Seriziat, may tell us something about David's wedded life.

However, the relationship between the Davids does not seem to have been troubled except during the Revolution. Evidently, David's political attitude was the cause of their quarreling in 1793, although Madame David subsequently confessed to *étourderies* (flightiness). Her father had remained a Royalist and she reproached her husband for having voted in favor of the King's execution. In March 1794, a divorce decree was issued and she moved into her parents' house at Saint-Ouen. But, immediately following the fall of Robespierre and David's arrest in August 1794, Charlotte took the first steps toward a reconciliation; she went to visit her husband with their children, and she made continual efforts to secure his release. David remarried her in November 1796 and their union thereafter was untroubled.

It was only progressively, however, and toward the end of David's life that their relationship became imbued with a reciprocally strong emotion. She had always loved David; he would increasingly come to feel more gratitude and tenderness toward her, and she would become the charm of his old age.

In this portrait we see a slightly awkward woman. David did not flatter her in any way but, at the same time, he did her justice. As usual in David's portraits, she is represented against a neutral ground and he has reduced the detail to a minimum. She is wearing her Sunday best, but aside from her cape and hat, she is dressed in the simplest satin dress. The hat is her only attempt at elegance. Madame David gazes at her husband with an embarrassed air. She barely dares to smile; she is snub-nosed, and behind her drooping eyelids we can see a rather faint attempt at animation.

She is very flattered that her husband is finally painting her portrait; she loves him; she would like to tell him so. She understands him and she admires him but, at the same time, she recognizes the differences between them. She has been a good wife and a good mother—that can certainly be said in her behalf. But she knows that she is no longer attractive; she is conscious of not having the gift of pleasing. She thought she might perhaps make herself a bit elegant. Was she right to put on her plumed hat?

David is accustomed to her. He appreciates her good qualities; he is conscious of how much he owes her, and is even touched by her devotion. He would like to show her his gratitude, so he paints her portrait, but he cannot make her sublime. He sees her as she is and he pays truthful tribute. This truth reveals to him the depth of his own personal attachment to his wife.

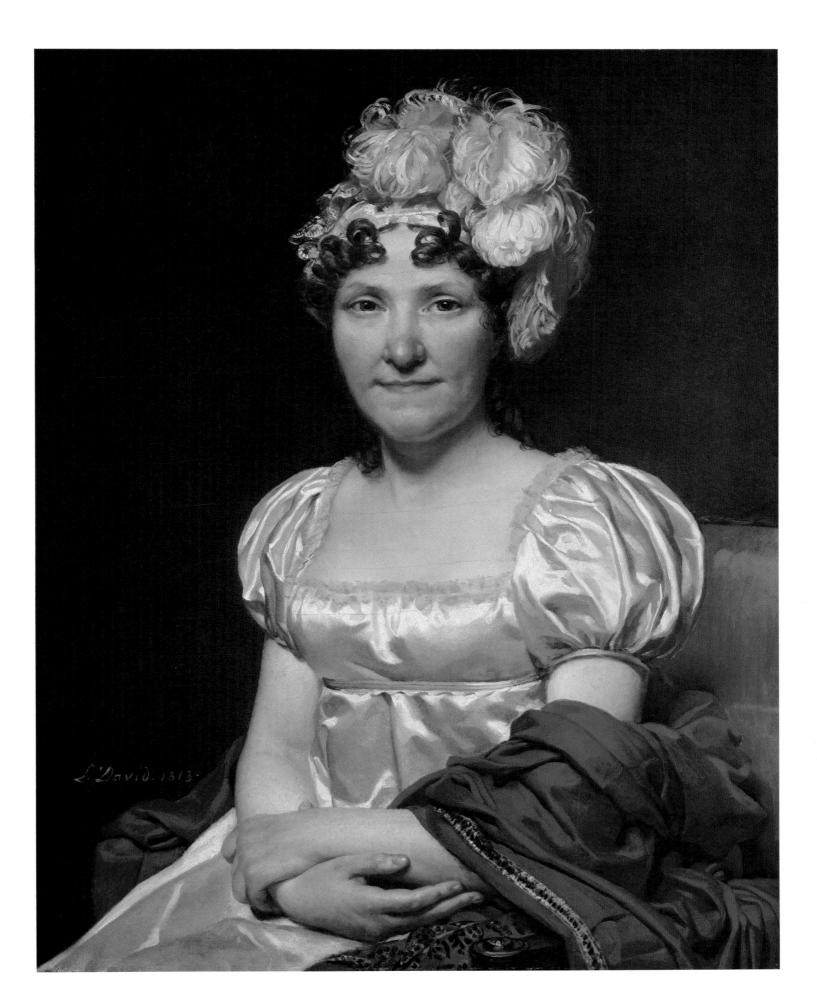

LEONIDAS AT THERMOPYLAE

Oil on canvas, 12'11⅜" × 17'5"
Paris, 1799–1803, 1813–1814
Signed: L. David 1814
Musée du Louvre, Paris

When David began to work on this painting in 1799, he was completely absorbed in ideas about "Greek Art," but the danger to France provided the inspiration for his subject. At the end of 1799, France was threatened by the Coalition of the European powers. The invasion was checked by Masséna, who forced Souvarov's Russian troops in Switzerland to retreat. The following spring, David was charged with supervising the execution of columns dedicated to those who had died in this battle.

In *Leonidas*, David chose to depict the sacrifice made by men for their country. At Thermopylae, which played a dominant role in the defense of Athens, the Spartan leader, Leonidas, delayed the invasion of Darius and the Persians in 480 B.C. by sacrificing himself and his men to give the Greeks the time they needed to organize an ultimately victorious resistance.

The painting was executed over two separate periods, a sporadic one from 1799 to 1803, and a steady one in 1813–14. During the first period, David worked out the general arrangement and painted in the first figures: the three young men pointing their wreaths in the direction of the soldier who engraves on the boulder the inscription: "Passerby, go tell Sparta that her children have died for her." At the same time, he also painted the father, to the left of the tree, embracing his son (who is holding his sword as if he were handling it for the first time), as well as the young man at Leonidas's feet, who is tying his sandal. David did not actually decide upon Leonidas's attitude until the second period and, at that time, he added a number of new characters: the man on the left, a tragic echo of Tatius in *The Sabine Women*; the seated soldier; the two young nude men on the right; and the figures in the background.

It is obvious that the figures from the first period have a sort of heroic tenderness, a lyricism that the others lack. They would probably have been sufficient by themselves; the addition of the later figures weakens the overall movement and belies David's avowed intention to prevent any "passionate movement" or "affectation" from becoming evident in this painting.

David's composition forms a star, as did the fresco compositions of Raphael, whom he so admired. He took pains to set off and even isolate the major figures, so that the viewer's attention would successively focus on each one, and to ensure that the feeling of admiration would begin at the center of the star—which is Leonidas himself. To the leader of the Spartans, David has imparted the inspired and determined air of a man contemplating sacrifice as he is about to leap into action.

As in *The Sabine Women*, the figures are mainly arranged in the lower half of the painting, but the landscape here plays a more important role: one glimpses, in the hollow, a fortified city which is supposed to represent Athens; in the center, a massive and sober temple serves as a reminder of the almost religious dimensions of the sacrifice; some stylized rocky masses, as in *Bonaparte Crossing the Saint-Bernard*, represent the gates of the pass; a tree which seems to have emerged from a sacred forest spreads its branches. The entire landscape is an echo of Poussin, but it has been simplified and is more intellectual than physical.

The reds and greens are once more prominent and are responsible for counterbalancing the sculptural pallor of the nudes: the harmony radiating from the colors softens the setting and adds a touch of tenderness and warmth to the scene.

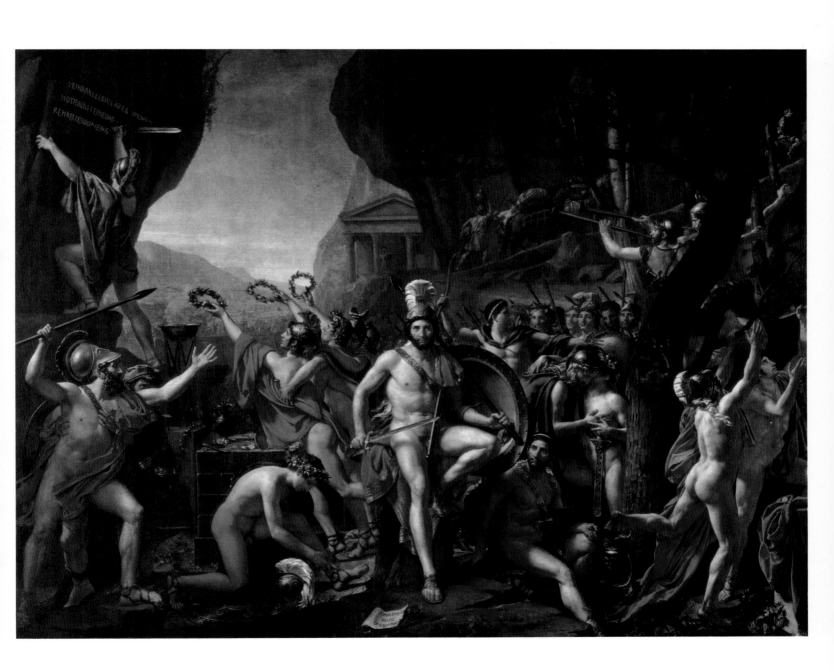

GENERAL GÉRARD

Oil on canvas, 77⅝ × 53⅝"
Brussels, 1816
Signed: L. David 1816–Brux.
The Metropolitan Museum of Art, New York
(Purchase, 1965, Rogers and Fletcher Funds, Bequest of Mary Wetmore Shively
in memory of her husband, Henry L. Shively, M.D.)

The long, slow, and steady rise of Etienne-Maurice Gérard (1773–1858), from aide-de-camp under Bernadotte to Brigadier-General and then Baron under Napoleon, from liberal deputy under the Restoration to President of the Council and Field-Marshal under Louis Philippe, and eventually, Senator under Napoleon III, can only be explained by a combination of bravery, prudence, and shrewd intelligence.

In this portrait he is only forty-three years old and already stout. With his ruddy complexion, short hair, and bright, shrewd eyes, the General looks more like a politician than a military man. Nevertheless, he was determined to remind us of his title of Commander-in-Chief (probably of the Fourth Corps at Waterloo), which can be deciphered on the back of an envelope with a broken seal that he is holding in his hand, as well as to include the distinctions he had received—he wears an assortment of decorations. Next to those awarded him by Napoleon, we can see the Croix de l'Ordre de Saint-Louis, conferred upon him by Louis XVIII; the Grand Cordon of the Legion of Honor—which he wears across his chest—was also given to him by Louis XVIII during the First Restoration. His general's uniform is not a full-dress outfit. It is cut from a dark blue fabric and has fitted trousers. His cocked hat is adorned with white plumes. Having formerly served in the cavalry, he is wearing spurs.

The setting is sumptuous: a wide expanse of red brocade curtain (inspired by the Venetians, Rubens, and especially, by Van Dyck), with a large floral pattern and moiré reflections, is lifted on the side to set off the balustrade, as well as the view that unfolds behind it. The landscape David has painted here is almost realistic, with houses and towers, which no longer are antique constructions, as was once his custom, but rather the type of dwelling found in the Roman countryside among pine trees and rolling hills. The winding path of the stream flowing at the foot of the hills can be seen through the bars of the balustrade. The elements, if not the details, of the landscape recall Raphael's landscape in the famous *Alba Madonna* in Washington's National Gallery. It is still an imaginary landscape, but it has a dreamier quality than David's earlier landscapes, coming closer to some sort of poetic intent, as in *Cupid and Psyche.*

David has renewed his interest in Flanders, in the decorative style and joyous colors of the great painters of Antwerp; one finds an echo of their influence in this painting, up to and including the elaborate decor with its checkerboard floor of blue, yellow, red, and green marble tiles and the alternating pattern of yellow marble from Provence and blue-gray marble from Carrara on the balustrade and its base. This is a picture that could have been painted in the studios of Rubens or Van Dyck.

It is not, however, so much the elements of detail that give the interior decoration its brilliance, as the luster of the coloring: the dazzling splendor of the reds, the warmth of the ochres in their blue-gray frame and, standing out against this sumptuously unfolding spectrum of colors, the determined, broad-shouldered form of General Gérard with his bright eyes and his ruddy face stiffly emerging above his coarse blue uniform. The reds, blues, and grays are repeated in the face and especially in the hands, with their reddish, pale skin. The different tones of the marble tiles are a toned-down echo of the dominant colors in the upper part of the painting.

This is how David depicts General Gérard, magnificent and good-natured at the same time, proud, but not smug; he could be a character out of a Venetian or Flemish scene, brilliant and even glossy under the bright, shadowless light.

L. DAVID 1816
BRUX

COUNT DE TURENNE

Oil on panel, 44⅛ × 32⅝″
Brussels, 1816
Signed: L. David 1816. Bruxelles
Ny Carlsberg Glyptotek, Copenhagen

Henri-Amédée-Mercure, Count de Turenne (1776–1852), was born into the old nobility from the province of Limousin. His ancestors had traditionally pursued military careers; he was not related, however, to the famous Maréchale de Turenne.

His father had been an officer in the cavalry and he himself had joined the army at a very early age. He attached himself to Napoleon and became the latter's first Chamberlain and Officer of the Regiment. Elevated to the rank of Colonel for his brilliant maneuvers during the Russian campaign, and made a Count of the Empire in 1813, he rejoined the military ranks after the One Hundred Days. He distinguished himself at Waterloo. In the *Mémoires d'Outre-Tombe,* Chateaubriand described an episode involving the Count de Turenne: "At the end of the battle, Turenne pressed Bonaparte to retreat to avoid falling into the hands of the enemy; Bonaparte, looking up from his thoughts as from a dream, became angry at first, then, suddenly, in the midst of his anger, jumped on his horse and fled."

Banished after the second return of the Bourbons, Turenne went into exile in Brussels where he became acquainted with David. He was himself passionately interested in painting. In 1817 he received authorization to return to his homeland, and in 1831 he was made a Peer of France.

In this painting, David portrays his subject in civilian dress. Count de Turenne, forty years old at the time of the portrait, is wearing his street clothes: trousers cut from a coarse cloth and a fur-lined, long-sleeved coat opening to reveal a silk waistcoat, and a loosely-knotted cravat. Tucked beneath his left arm, resting against his hip is a top hat whose crown faces us so that we are given a broad glimpse of the family's coat-of-arms. Its simplicity testifies to how far back in time his noble lineage extends.

He is sitting on a mahogany chair covered with a bright green fabric, at the foot of a marbled column that stands out against the lighter green of the background. The stiff folds of a table covering of blue velvet on the left fall halfway to the ground.

David reduces the decor to a few simple tones applied to forms of even greater simplicity. He uses very few colors and does not invent a single detail, but the workmanship is finely wrought. We can feel the suppleness and textures of the flesh and of the fabrics.

The man we see here has a caustic sense of humor; he is proud of his name and astonished at his present run of bad luck. He sits in his chair with an air of self-importance, concerned about making a good impression upon his famous friend, much as he had once striven to please an even more famous master.

The painter has treated him sympathetically and truthfully. The hair, the whiskers, and the fur are endowed with a vivacious charm, but the shortsighted eyes cannot conceal their apprehensiveness. Finally, we see a thickset figure, with coarse hands that are treated with a roughness that is an odd finishing touch to this psychological portrait.

This is an honest and direct painting, which draws its beauty from veracity, as well as from the broad and sumptuous harmony of a few simple colors, its solid modeling, and its scrupulous attention to telling details, as demonstrated by the spread of the thick fingers and the nuances of the face.

CUPID AND PSYCHE

Oil on canvas, 72½ × 95⅛"
Brussels, 1817
Signed: L. David 1817. Bruxelles
Cleveland Museum of Art, Ohio
(Purchase, Leonard C. Hanna, Jr., Bequest)

This painting was commissioned by an Italian art collector, Count Sommariva, a great admirer of Napoleon, a businessman and patron of the arts, who intended to hang the painting in his villa on Lake Como alongside other neoclassical works.

The theme is the conquest of Psyche by Cupid. Psyche was the daughter of a king and her beauty was so great that Venus became jealous and sought to destroy her. She was led to a boulder to be devoured by a monster, but Cupid, or "Amour," became infatuated with her, went to her rescue and took her to an enchanted palace. He visited her in secret every night and promised that her happiness would last forever, provided she made no attempt to see her lover's face. Unable to contain her curiosity, Psyche lit a lamp one night in order to behold him. Awakened by a drop of oil which had fallen from the lamp, Cupid fled and the enchanted palace disappeared. Psyche had to endure a number of trials and obtain Jupiter's intervention, as well as the forgiveness of Venus, before she could be reunited with Cupid again. Finally, she was made immortal and joined him for all eternity.

As in his other paintings—such as the *Horatii, The Tennis Court Oath,* and the *Coronation*—David elected to represent the beginning, rather than the conclusion of the legend; this is the common thread linking this work to the inspiration for some of the earlier works. David loved to represent beginnings: it is the future that attracted him. In this picture, youth and tenderness offer their freshness to the blossoming of a happy love, to the promise of happiness that will endure. The young lovers are resting in the enchanted palace on a stately bed upon which David represents Psyche's emblem, the butterfly. Light glows faintly beyond the mountains that can be glimpsed on the right through the open window looking out onto a classical landscape. The bed is rumpled; Psyche sleeps contentedly, while Cupid's happy smile is reminiscent of an adolescent after his first conquest.

Raphael and Titian had already represented Venus and Cupid. David has used some of the details from his predecessors' paintings, namely the window opening out onto a landscape and the stately bed.

If Belgian visitors admired the painting, the Parisian public to whom the painting was exhibited before being sent off to its Italian destination, proved more difficult to please. Some French critics were astonished that David had chosen to paint a picture so different from the heroic representations to which he had accustomed them.

That which is particularly enchanting, however, about the old master's painting, is the youthfulness and fullness of his talent. The symbols in the picture are simple, the allusions broad. Love reigns over a decor of magnificent richness and the two lovers, in a loose embrace, offer the perfection of their young bodies to the viewer's gaze; their gestures are as natural and deliciously fresh as those of young lovers everywhere in the midst of a night of love, when one is dreaming and the other is musing, both happy in their shared tenderness. The color is translucent on the smooth, almost enamelled bodies; it is iridescent in the fabrics, and velvety in the landscape.

Lovers, happy young lovers, your love is grace and pleasure—this is what the old painter is saying. Weary of glory and fiery passions, he placed his limpid talent in the service of that which had become his lasting ideal: Youth and Beauty.

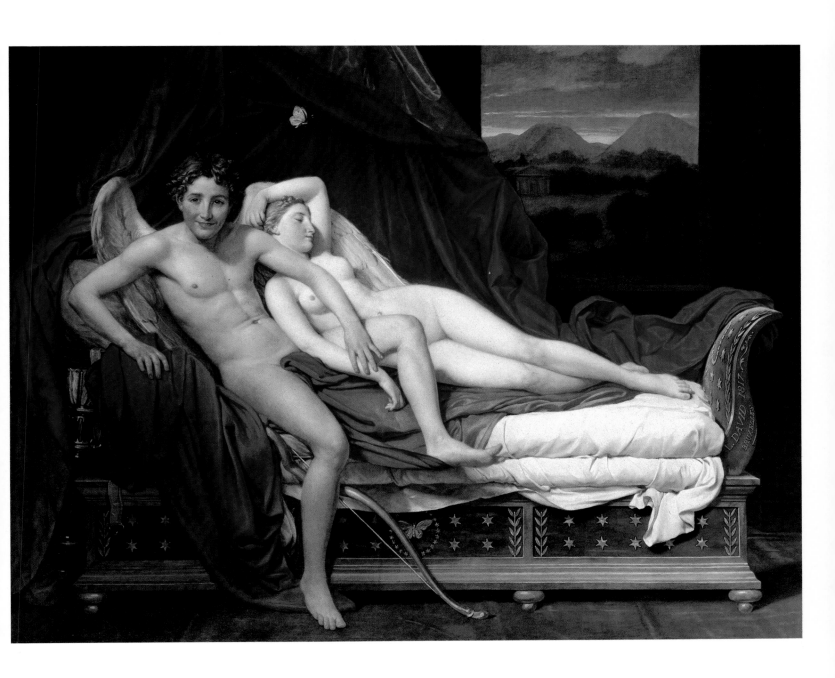

MARS DISARMED BY
VENUS AND THE THREE GRACES

Oil on canvas, 10'1⅛" × 8'7⅛"
Brussels, 1822–24
Signed: L. David. Brux. 1824
Musées Royaux des Beaux-Arts, Brussels

This is the last great picture David painted. He began work on it in 1822 and completed it the year before his death.

David wanted to outdo himself once more. In December 1823, he wrote: "This is the last picture I want to paint, but I want to surpass myself in it. I will put the date of my seventy-five years on it and afterwards I will never again pick up my brush."

The subject is taken from Greek mythology. Mars and Venus were the names given by the Romans to Ares and Aphrodite, the god of war and the goddess of love. The legend of their love affair corresponds to the charming idea that Beauty seduces and disarms Force. Aphrodite had a child, Eros, also called Cupid, and then had three girls, the Graces—Euphrosyne, Thalia, and Aglaia. The attributes of Mars were the lance and the sword, while Venus was represented by the turtledove, among other attributes. The three Graces were traditionally portrayed nude, entwined, or holding each other by the hand and dancing.

David was faithful to the legend, even down to these details, but his primary intention was to compose a sort of allegorical apotheosis. The scene takes place in a celestial Olympus, high above the famous mountain, in the midst of clouds. The faces are graceful and the feminine bodies very beautiful, especially that of Venus, which might be considered the most exquisite female nude ever painted by David. Mars looks very much like Leonidas, although his pose is much less contemplative.

The coloring is translucent and pearly, like painting on porcelain. The attitudes are conventional, the setting elaborate.

It was first exhibited in Brussels and then sent to Paris. Thiers, a journalist at the time, praised the color which "astonishes by its brilliance." "Never," he wrote, "has colored fabric been so perfect, so finely executed." He also praised "the beautiful lines," but he wondered "if the painting did not mark the end of the path on which David had set out." He added that "if one does care for style to turn into academic pretentiousness, for drawing to turn into an imitation of statues, for color to be pushed to a tiresome clash of hues, to a studied transparency and the sheen of glass," then, "one will consider David's painting to contain some beautifully executed parts, but perhaps dangerous to propose as a model and, finally, the last word of a system that was good when it served as a corrective, which it can no longer be when it tends towards excesses that need to be corrected in turn."

But David's former pupils flocked to see the painting and were full of admiration. The exhibit brought in, after expenses, 13,000 francs, which means that there were more than 10,000 visitors, an enormous number for the time.

How could anyone not be moved by this famous old man's farewell to painting—this is an enchanted world dedicated to grace and beauty, to their supreme victory over matter and force. What does it matter if the composition is theatrical? The smiles are lighthearted, the attitudes graceful, the gestures exquisite—and the female nudes are quite simply sublime. The aging painter dreamt a final dream of beauty, more chaste than in his youth, but physically more perfect than ever, and this is how we shall remember him.

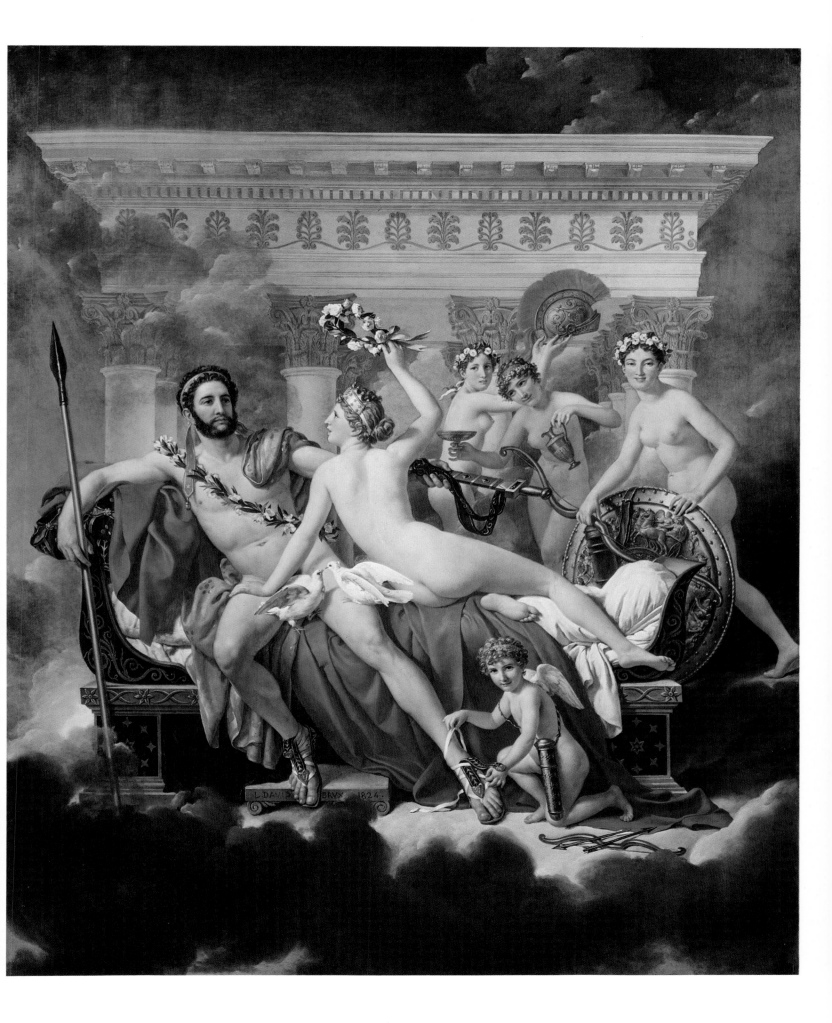

SELECTED BIBLIOGRAPHY

Adhémar, Jean and Cassou, Jean, *David, naissance du génie d'un peintre*, Paris, 1953.

Anon., *Notice sur la vie et les ouvrages de M. J.L. David*, Paris, 1824.

Baudelaire, Charles, *Curiosités Esthétiques: le Musée classique du Bazar Bonne Nouvelle*, Paris, 1846.

Brookner, Anita, *Jacques-Louis David*, London, 1980.

Cantinelli, Richard, *Jacques-Louis David*, Paris–Brussels, 1930.

Chaussard, Pierre, *Sur le tableau des Sabines par David, An VII*, Paris, 1800.

———, *Le Pausanias français*, Paris, 1806.

Chénier, André, *Le Jeu de Paume. A Louis David*, Paris, 1791.

Coupin, M.P.A., *Essai sur J.L. David, peintre d'histoire*, Paris, 1827.

David, J. L.J., *Le peintre Louis David 1748–1825, Souvenirs & Documents inedits*, Paris, 1880.

Delecluze, Etienne, *Louis David, son école et son temps*, Paris, 1855. New edition, Paris, 1984.

Diderot, Denis, *Salons*, ed. Jean Seznec and Jean Adhémar, Oxford, 1957–67.

Dowd, David Lloyd, *J.L. David. Pageant-Master of the Republic*, Lincoln, Nebraska, 1948.

Florisoone, M., *Catalogue de l'Exposition David*. Musée de l'Orangerie, Paris, 1948.

Gonzales-Palacios, A., *David e la pittura napoleonica*, Milan, 1966. French-language edition, Paris, 1967.

Hautecoeur, Louis, *Louis David*, Paris, 1954.

Herbert, Robert L., *David, Voltaire, Brutus and the French Revolution. An essay in art and politics*, London, 1972.

Holma, Klaus, *David, son évolution et son style*, Paris, 1940.

Humbert, Agnès, *Louis David, peintre et conventionnel. Essai de critique marxiste*, Paris, 1936.

———, *Louis David*, Paris, 1947.

Lenoir, Alexandre, *Explication du tableau des Thermopyles*, Paris, 1814.

———, *David. Souvenirs historiques*, Paris, 1835.

Maret, Jacques, *David*, Monaco, 1943.

Maurois, André, *J.L. David*, Paris, 1948.

Romero-Brest, Jorge, *David*, Buenos Aires, 1943.

Rosenau, Hélène, *The Painter Jacques Louis David*, London–Paris, 1948.

Rosenblum, Robert and Schnapper, Antoine, *Catalogue de l'Exposition: De David à Delacroix*, Paris, Detroit, New York, 1974–75.

Rosenthal, Léon, *Louis David*, Paris, 1904.

Saulnier, Charles, *Louis David*, Paris, 1903.

Schnapper, Antoine, *David témoin de son temps*, Fribourg, 1980.

Th., A. (Thibaudeau?), *Vie de David, Premier Peintre de Napoléon*, Brussels, 1826.

Valentiner, W.R., *Jacques David & the French Revolution*, New York, 1929.

Verbraeken, René, *Jacques-Louis David jugé par ses contemporains et la postérité*, Paris, 1973.

Wildenstein, Daniel and Guy, *Louis David. Documents complémentaires au catalogue complet de l'oeuvre*, Paris, 1973.

PHOTO CREDITS

The author and publisher wish to thank the libraries, museums, and private collectors for permitting the reproduction of works in their collections. Photographs for the Colorplates and the Black-and-White Illustrations have been supplied by the owners or custodians of the works of art or by the following, whose courtesy is gratefully acknowledged:

Colorplates:
J.-E. Bulloz, Paris (32); Copyright the Frick Collection, New York (31); Giraudon, Paris (30); Claude O'Sughrue, Montpellier (6); Georges Routhier (Studio Lourmel), Paris (3); Service de documentation photographique de la Réunion des musées nationaux, Paris (8, 11, 12, 13, 14, 16, 18, 19, 20, 21, 23, 24, 25, 26, 27, 28, 29, 30, 34, 36); Daniel Wildenstein, Paris (22).

Black-and-White Illustrations:
Ph. Besacier, Toulon (62); J.-E. Bulloz, Paris (18, 37, 61); Gab. Fotografico Soprintendenza Beni Artistici e Storici di Firenze (1); Giraudon, Paris (42); IFOT, Grenoble (12); A.F. Madeira (13); Musées de la Ville de Paris (32); Claude O'Sughrue, Montpellier (10); Photo Etienne, Bayonne (22); Georges Routhier (Studio Lourmel), Paris (3, 21, 24, 31, 35, 38, 45, 56); Savary, Tourlaville (11); Service de documentation photographique de la Réunion des musées nationaux, Paris (7, 9, 14, 19, 25, 27, 28, 30, 33, 34, 36, 39, 43, 47, 50, 51, 55, 57, 63); Vneshtorgizdat, Moscow (58).